FRANK C. McCARTHY

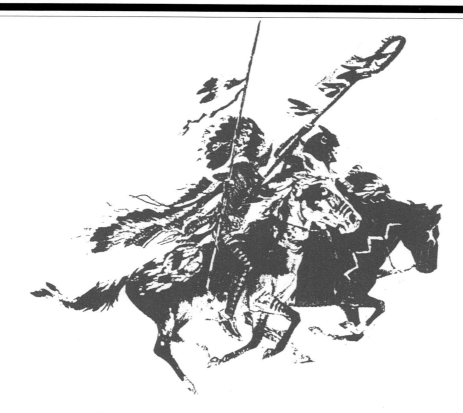

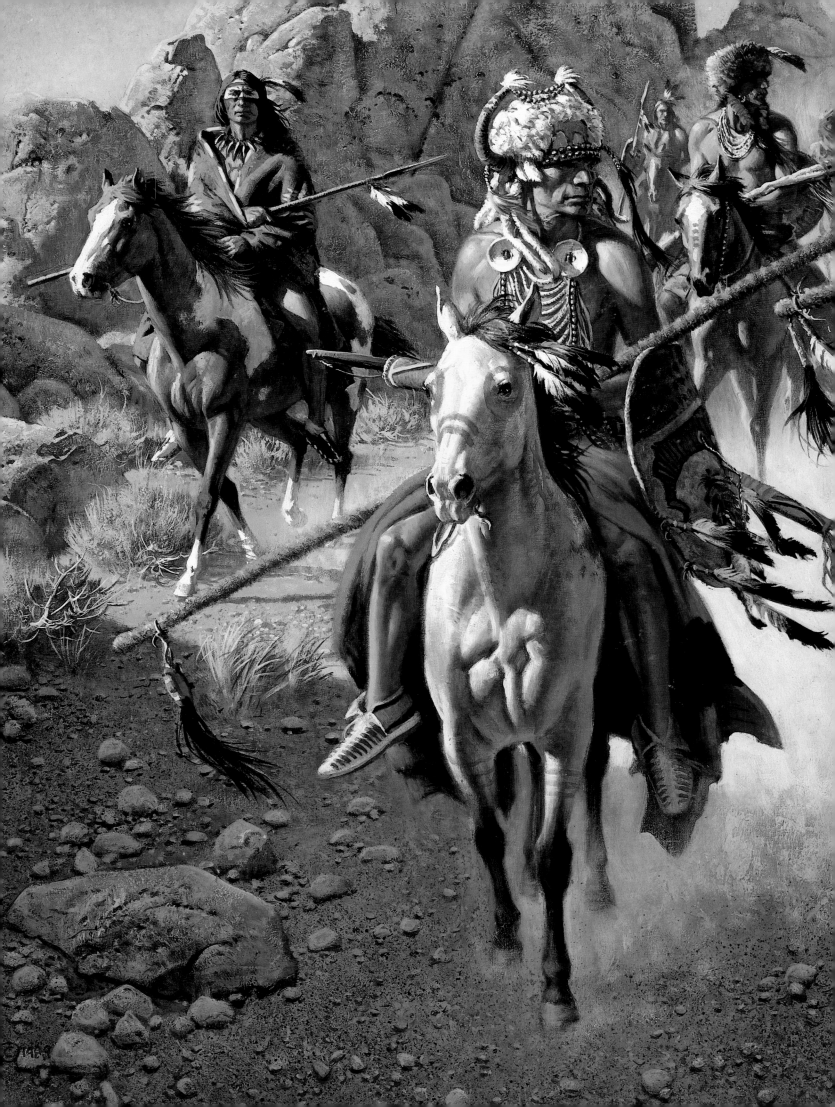

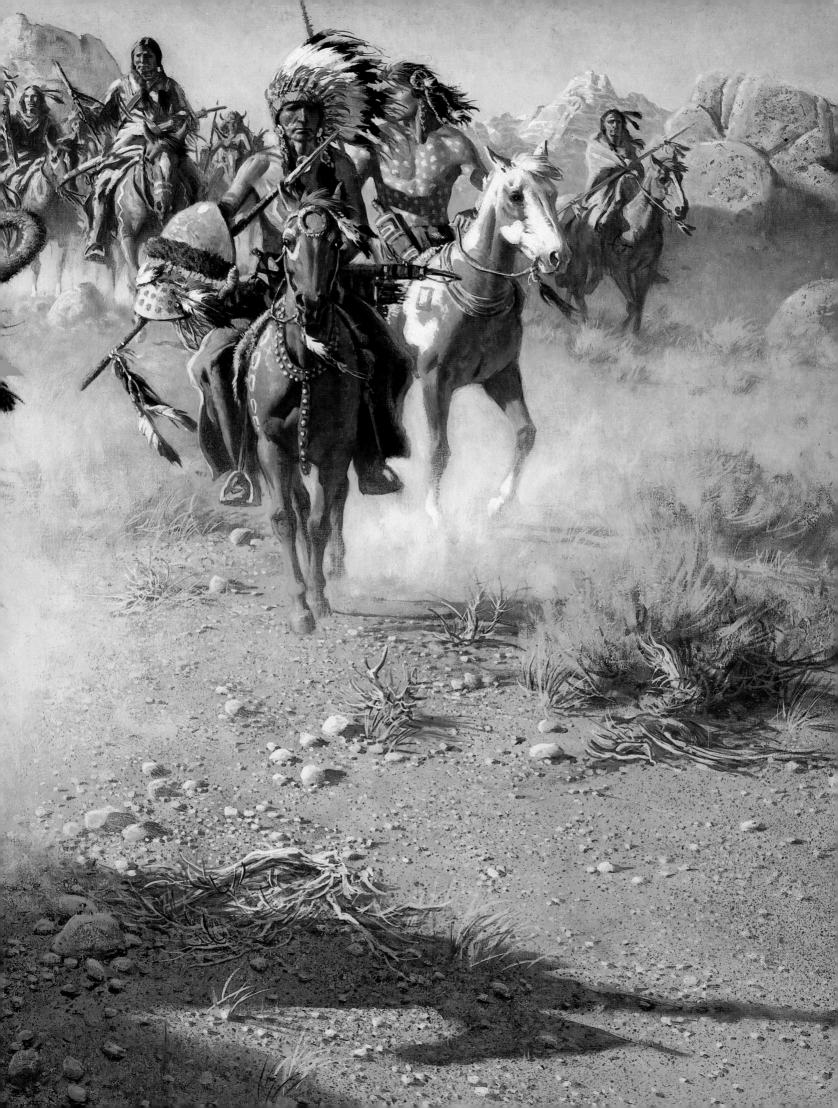

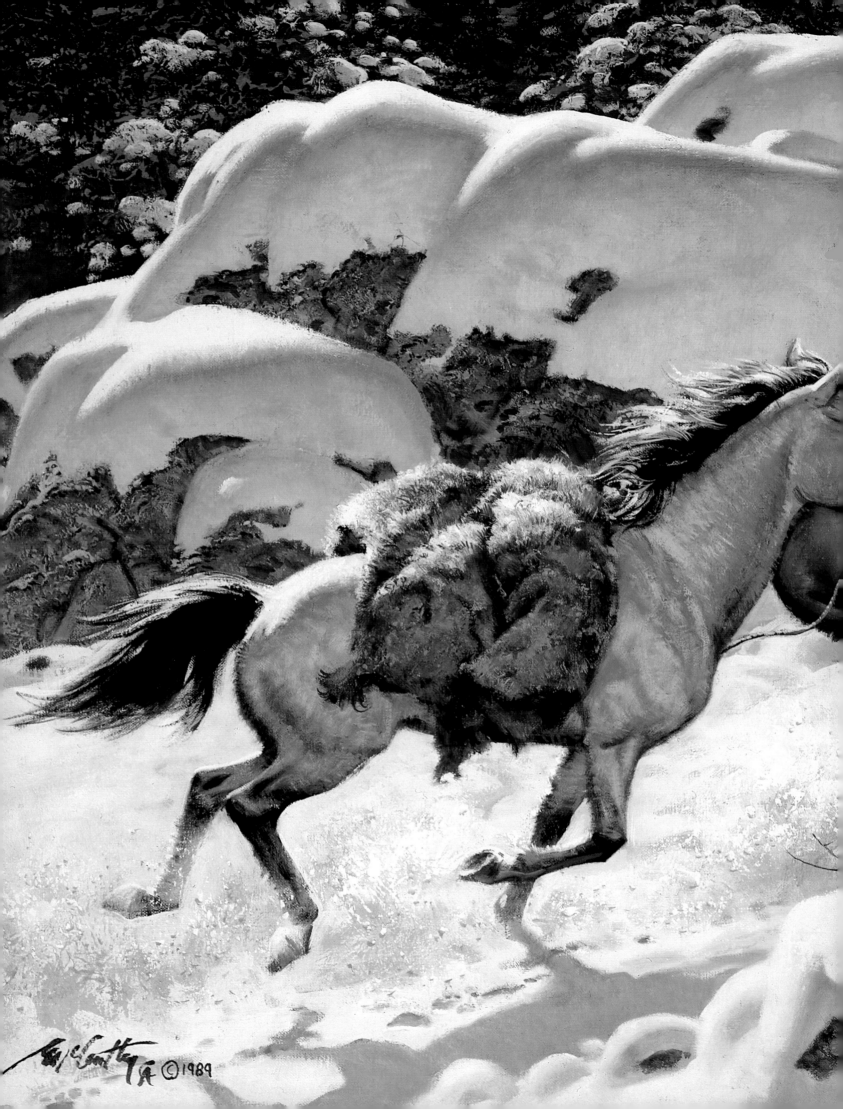

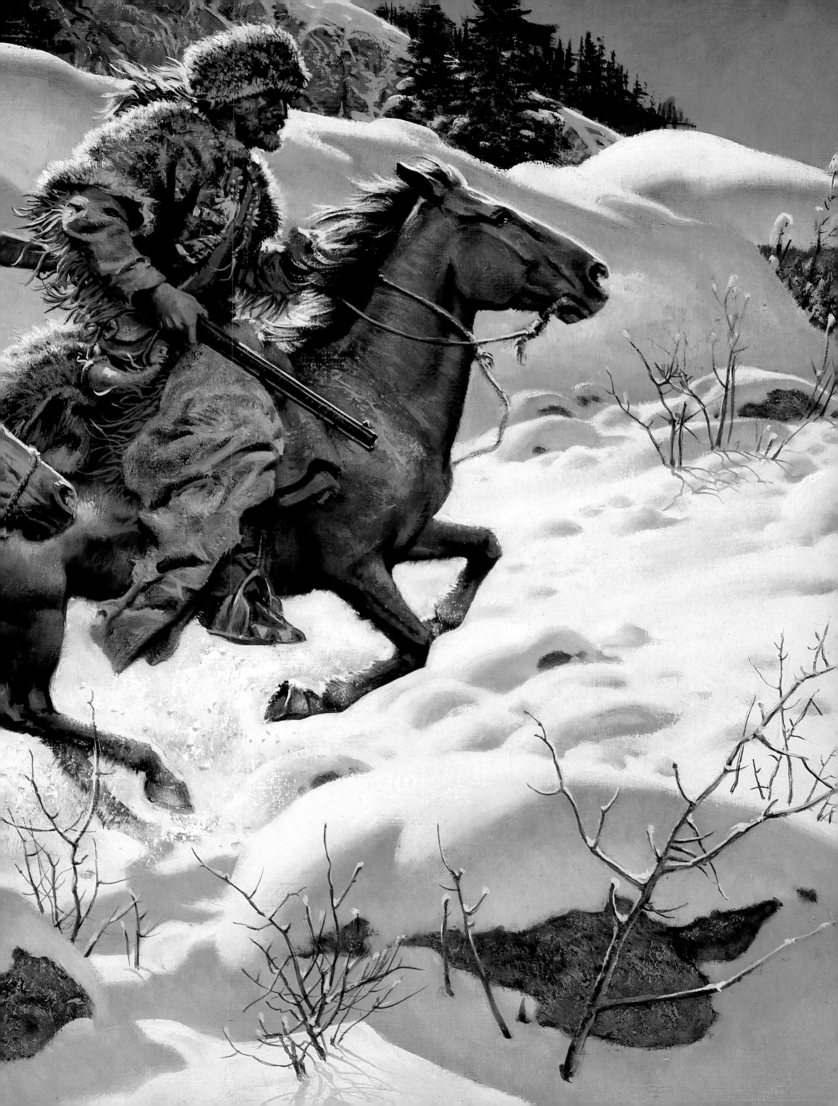

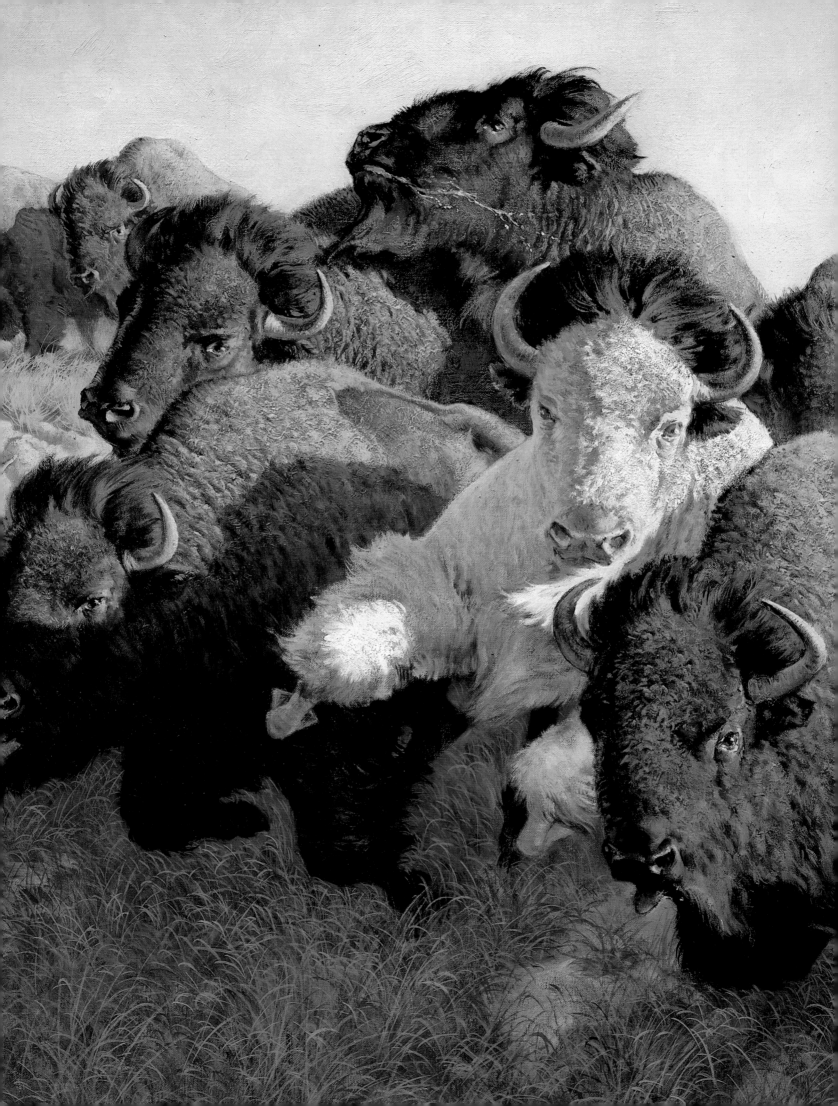

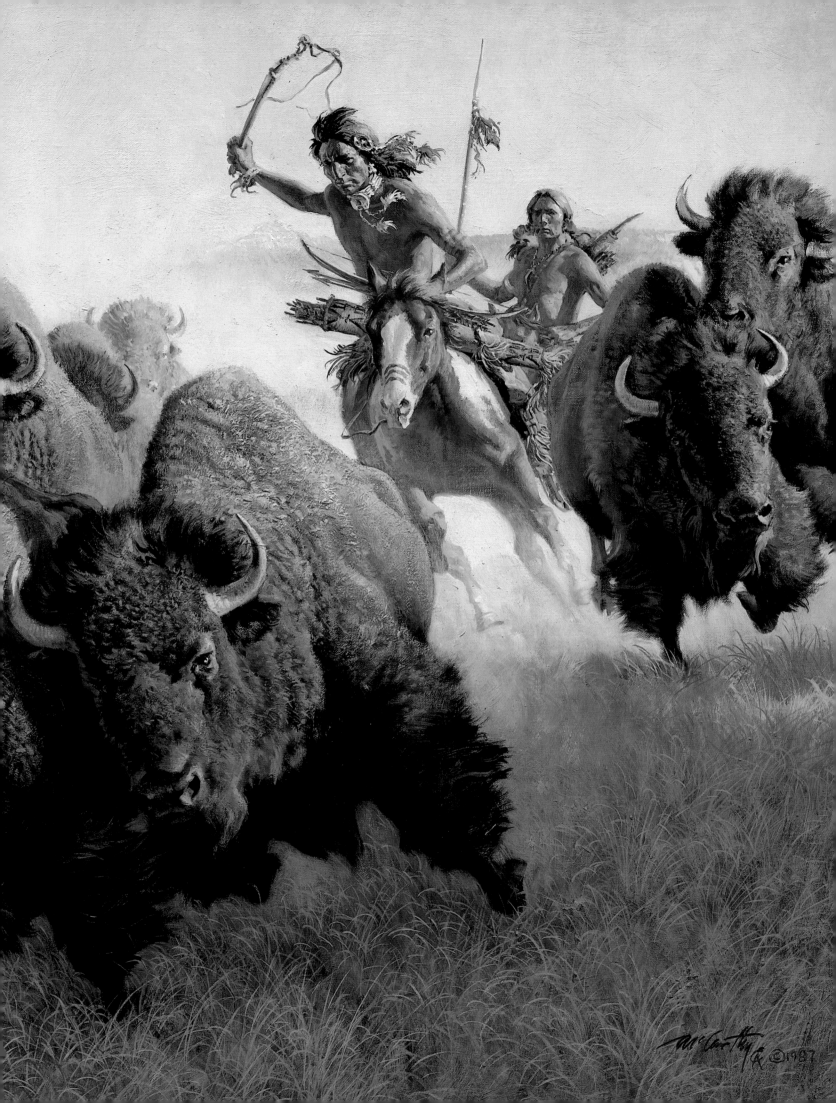

The Art of
FRANK C. McCARTHY

TEXT BY
E L M E R K E L T O N

INTRODUCTION BY
J A M E S K. B A L L I N G E R

WILLIAM MORROW AND COMPANY, INC.

New York

DEDICATED TO MY MOTHER AND FATHER

A WILLIAM MORROW AND COMPANY, INC., BOOK
PRODUCED BY THE GREENWICH WORKSHOP

Copyright © 1992 by The Greenwich Workshop, Inc.

LIBRARY OF CONGRESS
CATALOGING-IN-PUBLICATION DATA

McCarthy, Frank C., 1924-
 The art of Frank C. McCarthy / text by Elmer Kelton
ISBN 0-688-11883-6
 1. McCarthy, Frank C., 1924- —Exhibitions. 2. West (U.S.) in art—Exhibitions. 3. Indians of North America—Pictorial works—Exhibitions. I. Kelton, Elmer. II. Title. ND237, M16A4 1992 759.13—dc20
CIP: 92-9609

ACKNOWLEDGMENTS

The author and publisher have made every effort to secure proper copyright information. In the case of inadvertent error, the publisher will be happy to correct it in the next printing. (pp. 102-103) *Under Attack* painting by Frank McCarthy featuring John Wayne, used with permission of Michael Wayne for Wayne Enterprises and BATJAC Productions, Inc.; (pp. 158-159) painting by Frank McCarthy for the movie, "The Train," copyright 1965, United Artists; (p. 158) painting by Frank McCarthy for the movie, "Thunderball," copyright 1964 United Artists/Eon Productions, Ltd.

Book design by Peter Landa and Diane Kane
Printed in Italy by Amilcare Pizzi S.P.A.
First Edition
1 2 3 4 5 6 7 8 9 10

CONTENTS

INTRODUCTION

The vision of the American West Frank McCarthy creates in his art is one to which entire generations have responded. For over twenty years, he has drawn inspiration for his paintings from the heroic "types" of the West—mountain men, cavalry troopers, native Americans, and cowboys. Throughout most of this century, the history of Western America has been told through important actions accomplished by each of these groups. McCarthy focuses on these groups and their activities for his visual imagery. His is a West of action. Whether he depicts a long, arduous cattle drive, a column of troopers approaching a skirmish, a buffalo hunt, or trappers returning with their pelts, he pushes his subject directly at the viewer by carefully selecting an episode of contrasting forces which results in tumultuous action.

McCarthy's work continues a traditional imagery established during the last two decades of the last century. Frederic Remington and Charles Russell are often credited with establishing most of the Western American visual stereotypes. Their depictions of the cavalry, the cowboy, and the tribes of the northern and southwestern plains established a perception of heroism, making the West safe for American settlement and entrepreneurship. When combined with the efforts of writers, such as, Owen Wister, and entertainers like Buffalo Bill Cody, a great cultural mythology developed. A continuum of artists and writers, including Charles Schreyvogel, N.C. Wyeth, Will James, and Zane Grey helped to set the image of the West as a place of rugged independence, opportunity, and high moral values. This view of the American West reached its zenith in the films of John Ford, often starring John Wayne. This was the West Frank McCarthy knew during his youth and during his formative years as an art student and later as an illustrator. And, these are the qualities he brought beautifully to his mature paintings beginning during the late 1960s and 1970s.

McCarthy's career is unlike most artists painting in the United States after World War II. Most contemporary artists developed their careers painting for themselves with little concern for patronage. McCarthy, conversely, developed his career as an illustrator with an audience in mind. Working for specific magazines, book publishers, and film companies, the demographics of his audience were known, and it was his job to communicate with his audience on their terms, as well as his own. Thus, at the age of forty-four, when the artist freed himself from the pre-

dominantly commercial side of art to move his career toward independent work, he strove to continue with roughly the same audience. To say McCarthy has met with success during the past twenty years is an understatement. Joining the nationally recognized Cowboy Artists of America in 1975, his work has been acquired by American collectors from coast to coast, and he has had numerous exhibitions of his work in addition to the annual exhibition of the Cowboy Artists of America at the Phoenix Art Museum.

Realism is perhaps the only stylistic term which can be applied to McCarthy's painting. Following a tradition established by landscape artists of the mid-nineteenth century, his attention to each detail in the landscape and main subject is carefully delineated. The clarity of space and sharpness of light sets McCarthy's work apart from any other painter of his day. Whether the subject of a painting is a stampede occurring out front of a thunderstorm, or a buffalo hunt taking place on a clear summer day on the high plains, the event seems to exist in a vacuum. This technique allows no interference between the subject and viewer, providing the painter the opportunity to report the details of the stampede or hunt with tremendous immediacy.

Action is the second trademark of Frank McCarthy's paintings. Few artists exceed his ability to seize an instant of excitement. The methods McCarthy utilizes to capture such an instant are sev-

eral. The most obvious is the tilting of the horizon line of a composition in its relation to the foreground slant. The tension between these angles helps to heighten the sense of the implied motion of the image. A second use of angle is the slope of the foreground toward the viewer, allowing the action of the painting to spill out of the picture plane toward the viewer. A third use of angle is in the composition of the figures and animals which comprise the central subject of McCarthy's pictures. Through either thrusting weapons or simply forming the composition around a "v" shape, the artist is able to quickly move the viewer's eye through his image, heightening the sense of movement.

The clarity of McCarthy's pictures combined with his ability to capture action led the artist into a specialized segment of the art market in an attempt to make his work more available to a broad, popular audience. Limited edition color prints were made popular beginning with Frederic Remington at the turn of the century. McCarthy's clean, simple color and strong sense of linearity make his work especially adaptable to this medium. During the past fifteen years, he has met with tremendous success through collaboration with The Greenwich Workshop.

Looking at Frank McCarthy's Western American paintings over the years, one would tend to think he is set in his style and subject matter. Very recently, however, a subtle shift is apparent in many of his canvases. A greater sensibility is being given to the landscape itself as part of his work, which remains narrative. This awareness on the part of the painter will allow him to be continually challenged and to build on his previous success. This extremely facile interpreter of the historical American West will continue to fascinate the viewer of his exquisite scenes.

James K. Ballinger
Director, Phoenix Art Museum

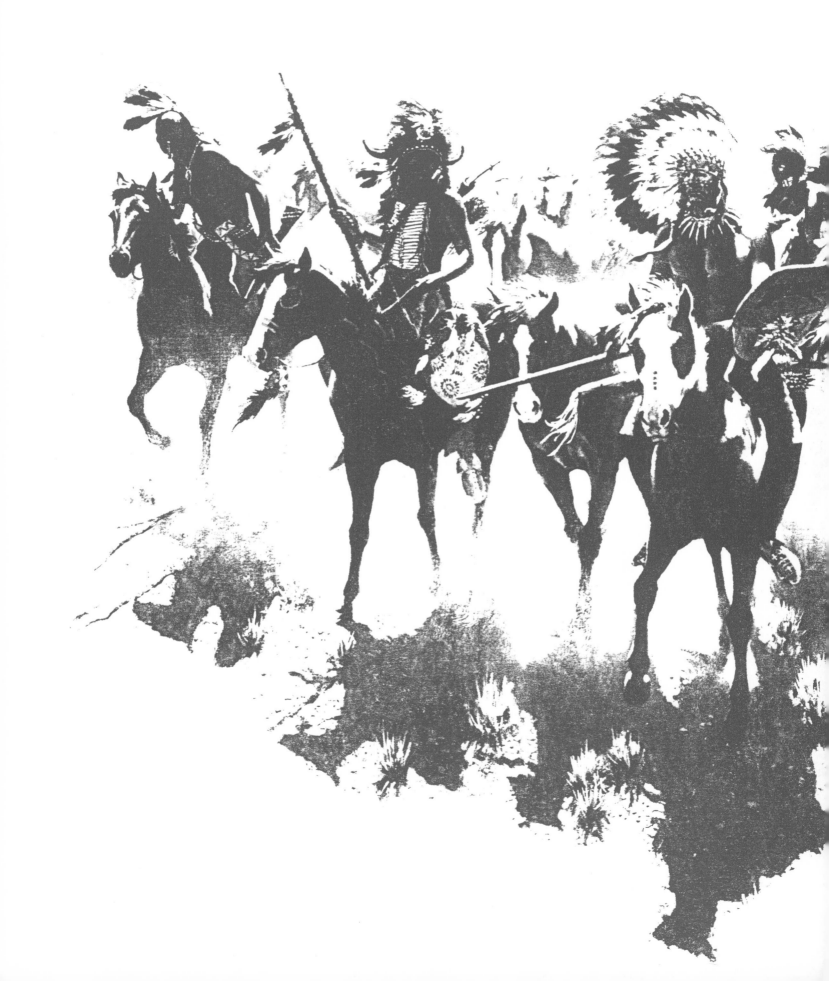

THE PLAINS INDIAN

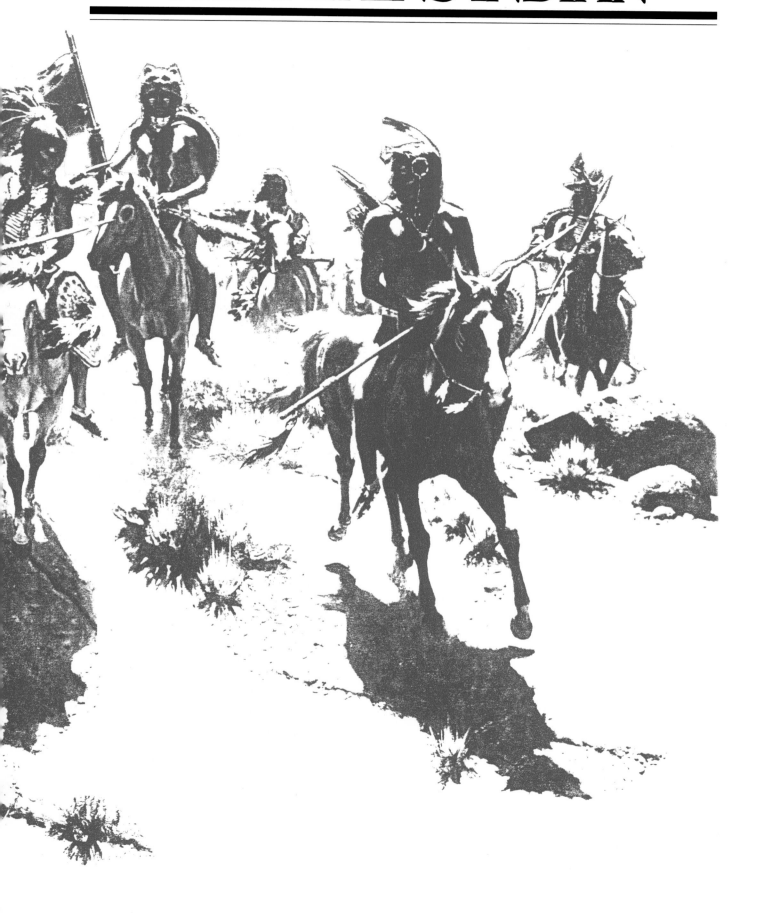

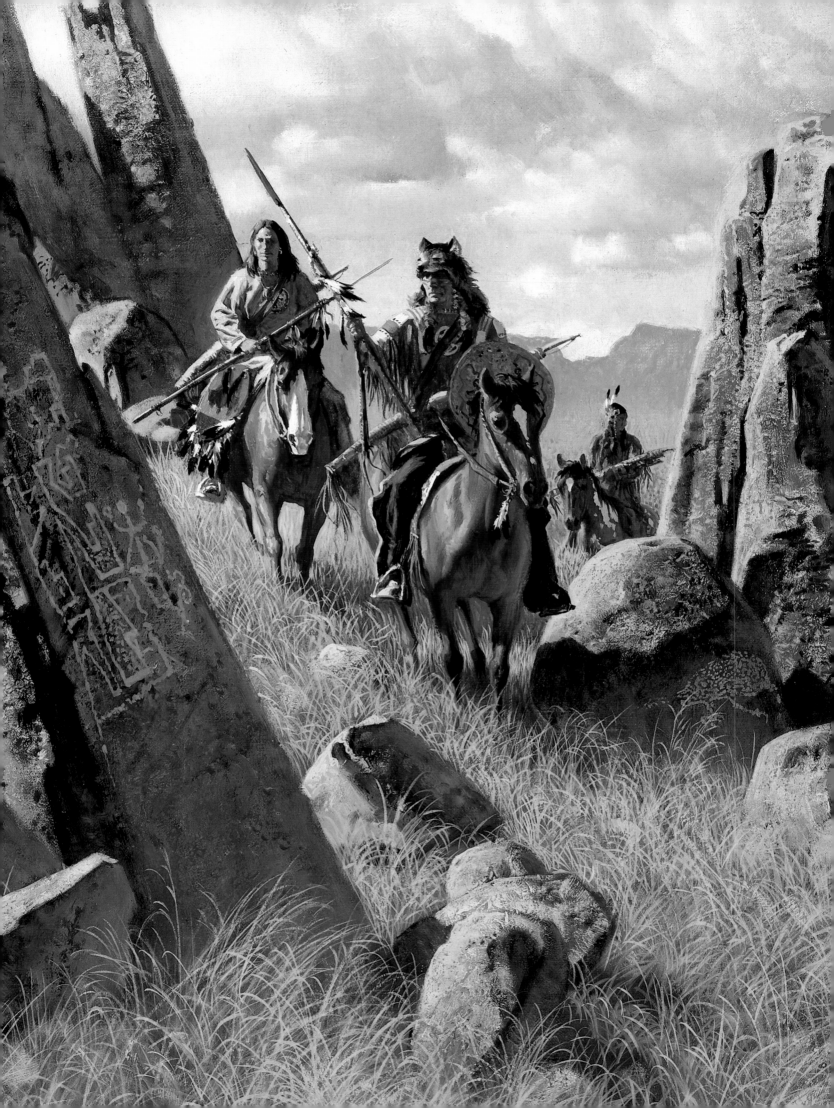

THE PLAINS INDIAN: MYSTIC VOICES

We still see him today in the collective memory of our national folklore: the proud, bold, graceful warrior-hunter on horseback, the Plains Indian in brilliant panoply of paint and feathers, shouting a blood cry as he charges headlong against his enemy. We see him as a mystic soul living close to nature, moving his tepee villages at will to follow the migrations of the buffalo, the life-giving rains, the greening grass, and leaving the land as he found it.

The image is real. It flourished during a brief and colorful period in the American past. It is a favorite image of painter Frank McCarthy, whose works evoke its spectacle and drama, its heroism and its tragedy.

Like other stages in the history of the West, the glory days of the free-roaming Indians on horseback were relatively short. For most, little more than a century and a half elapsed from their acquisition of the horse and transformation of their lifestyle until white expansion and a relentless military blew out the light of freedom. But this golden era for the native American has been burned into the national consciousness. We have come to honor it as an indelible though irretrievable part of our American heritage.

The Indians of the plains were highly varied in look, in customs, in language. They belonged to separate linguistic stocks, which suggested their geographic origins in a far earlier time. Ironically, some of the strongest enmities arose among peoples whose languages indicated they had been kin in the distant past. The Sioux spoke in a manner which had much in common with the Crows, some of their bitterest enemies. The Siouan language bore certain similarities to the Iroquoian of the Northeast.

The Blackfeet, Cheyenne, and Arapaho languages were Algonquian, stemming from the Atlantic coast and the Great Lakes region. Comanche and Shoshoni languages were very similar to each other, the two tribes having split apart in relatively recent times. They were of the same original stock as the Ute, Paiute, Hopi, Pima, and even the Yaqui of Mexico. The Apaches spoke an Athapascan language akin to the Navaho and to tribes of Alaska and Northwestern Canada, indicating they had drifted down from the cold North to the dry, hot Southwest in the not distant past.

Though their spoken languages differed, the Plains Indians developed a universal sign language understood equally well by Blackfeet along the Canadian border or Comanches in Western Texas. With movements of hands and arms, they could convey almost any message. Lengthy conferences were conducted and complex agreements made by sign between tribes which understood not a word of one another's speech.

To communicate at long distances, they might ride specific patterns on horseback to describe movements of an enemy or the whereabouts of game. Indian arm signals relaying information from afar inspired development of the Army Signal Corps' semaphore system. Smoke signals could be read even farther.

It is difficult to imagine the Plains Indian without the horse. The two are firmly interwoven in the fabric of the nation's tradition. And it would be difficult to overstate the effect the horse had on the native American.

From the time the first fur-clad wanderers followed ice-age game animals from Siberia across to the American continent, the hunter had been limited to the ground he could cover on foot. Nomadic tribes could acquire and take with them only as much as they could hoist upon their backs, and that which their wolflike dogs could carry or drag on travois poles behind them. Hunting depended upon stealth and cunning because the buffalo, deer, and pronghorn antelope they sought for meat could easily outrun them. The ever-present specter of hunger lay like a chill shadow over the hunter and his people.

Vast distances made the plains inhospitable, even menacing. Water was hard to find, its sources far apart for a people who had to walk. A majority of those later regarded as Plains Indians built earthen lodges or wood huts along lakes, streams, and rivers like the Missouri, at the edges of the open grasslands. They planted squash, corn, and beans to supplement their meat diet and to help them survive the lean times when weary hunters trudged home with empty hands from the fringes of the plains.

Adding to the hardship was the frequent threat of enemy raids. Competition for accessible hunting grounds and living space created a state of perpetual war among peoples defending their homes or invading those of their neighbors. The principal constraint upon these sometimes brutal conflicts was limited mobility.

The horse burst upon the Indian world like a blaze of summer lightning. In a man's lifetime or less, it spread from the Spanish Southwest to the Canadian border. It was a liberating force for those who learned to master it, for it gave them speed and range beyond the dreams of the ancient ones who had gone before.

Suddenly the Indian could outrun the buffalo and even give the swift-legged pronghorn a good chase. Instead of hunger, he often enjoyed surplus. Because the horse could carry or drag far more than the dog and cover vastly more distance in a day, its owner could venture wherever he wanted across the plains and high into the mountains. He and his family could afford to have a larger tepee and comfort-giving furnishings because the horse could transport them as far as they wished to travel.

Many tribes abandoned traditional farming and fishing villages to take up the nomadic life of the hunter. They ate the last of their planting seed and lived by arrow and lance. Cheyenne storytellers, in relating the legends of their prehorse ancestors, would sometimes say, "That was before we lost the corn."

Though the white man was to find the Cheyennes mostly on the central plains, they had probably originated north of the Great Lakes. There they had farmed and fished until pressure from stronger Eastern tribes forced them westward to the Missouri. Similarly, the plains Sioux had lived in the woodlands and along the lakes of Minnesota before edging out onto the grasslands to challenge others already there.

Long before they saw a white man, these tribes felt his influence. As hair-faced invaders from Europe pushed inland from their first coastal settlements, the Indians they displaced crowded upon those to their immediate west. Eastern tribes acquired firearms, giving them a deadly advantage over their western neighbors. Displacements created in the East rippled like falling dominoes all the way to the plains and mountains.

By the time the Lewis and Clark expedition mapped the locations of Western tribes in 1804 to 1806 and gave some their first look at a white man, a

vast resettlement had already taken place. But the situation remained fluid, heavily dependent upon the fortunes of war. Tribal affiliations and enmities were already well established.

The Sioux had taken a firm foothold as far west as the Black Hills. The Crows claimed a magnificent hunting ground along the Yellowstone and were challenged for it by virtually all their neighbors. The Blackfeet, with whom Lewis and Clark had their only violent encounter, fiercely held the upper Missouri and lands northward beyond the Canadian border.

All had the horse, and they used him to splendid effect both in the hunt and in warfare. The Indians became, in the words of an awed observer, the Cossacks of the plains.

Whatever their differences in language and appearance, and however much they might war among themselves, Plains Indians had two important elements in common: a deeply spiritual view of the world around them and a profound love for the land upon which they roamed.

Religion was animistic. Living close to the earth, the Indian felt the influence of spirits in everything around him: the animals, the birds, the water and the wind, the trees and the rocks. All living things had souls not unlike his own. He sought friendship with benevolent spirits and asked their protection against the evil ones. The wolf, the buffalo, the eagle were revered. By contrast, to some tribes the owl was an agent of darkness, to others, the bear.

The Indian's close kinship to the elements was demonstrated in the common pipe-smoking ritual which preceded many councils, many prayers. He would blow smoke to the earth, to the sky, and to each of the four winds. Most plains folk disliked digging in the ground, for that scarred the face of their mother the earth. In camp, tepee openings faced east so the first light of the rising sun fell into the lodge and blessed it.

In troubled times, such as war or a shortage of game, the Indian called upon his own guardian spirits or those of the band, seeking their guidance through a vision or dream.

The sun dance was practiced by most plains tribes. Form varied by tribe, but essentially the dance was a plea to the spirits for power, for the necessities of life, for rainfall to grow the grass which would fatten the buffalo and the horses.

It was a manifestation of the Indian's deep spirituality, his faith in the guardian spirits which he sensed in the natural world around him. He was, truly, a man of the earth, and of the unseen mystic realm.

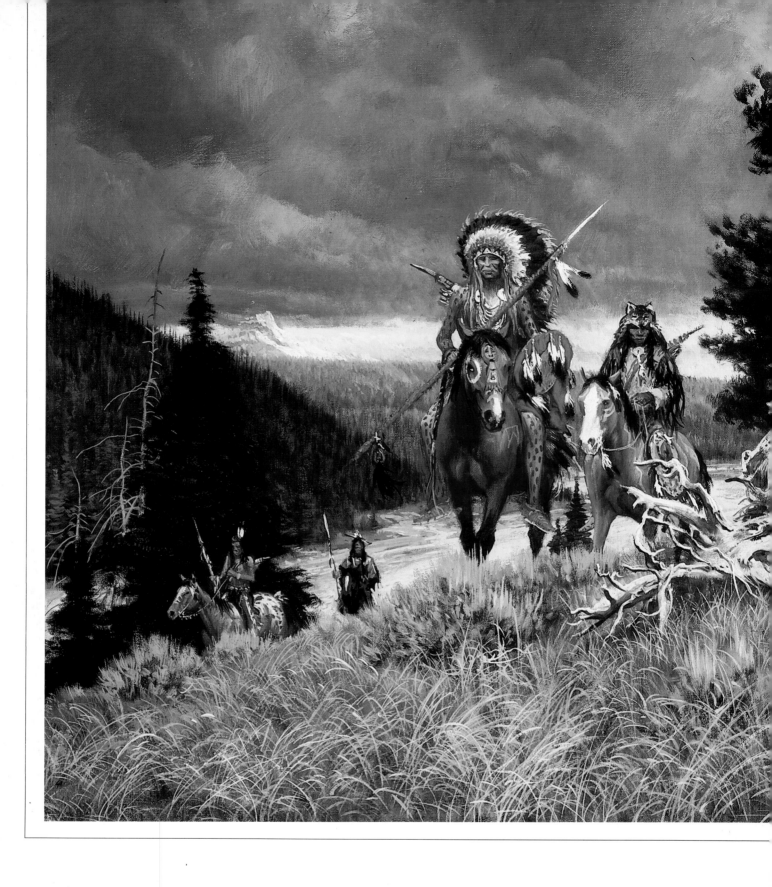

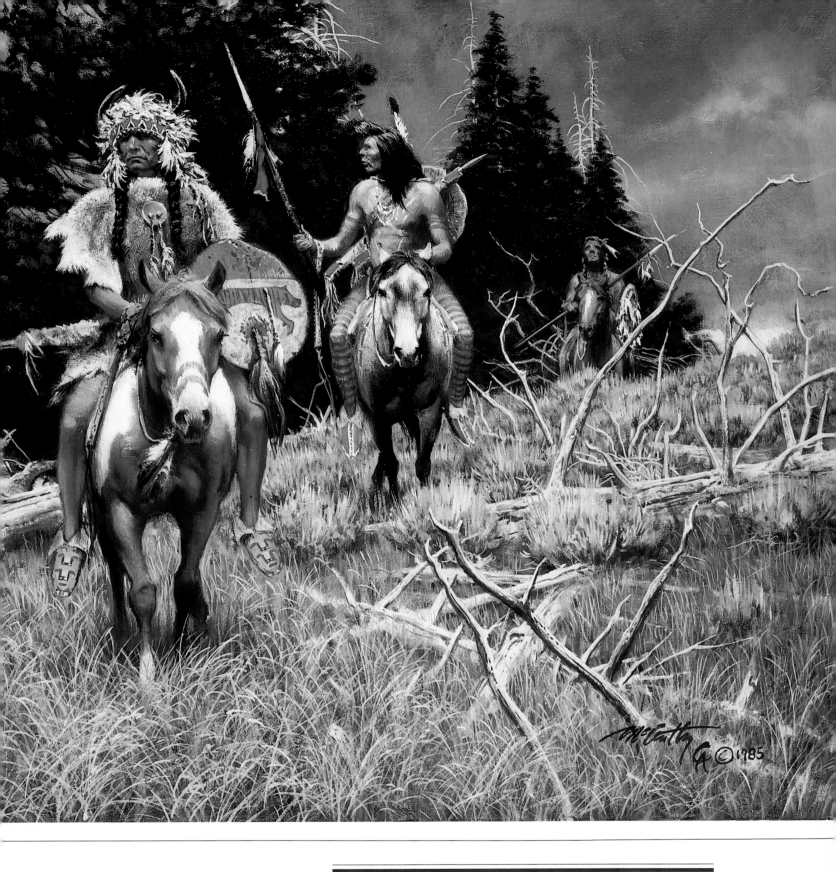

CHILDREN OF THE RAVEN

Grimly prepared, a well-armed party of Crow Indians advances across a mountainside overlooking a beautiful river valley. The Crows called themselves Absaroke, in loose translation "the Raven People." Because their hunting grounds were so rich, most of their neighbors' hands were perpetually turned against them.

IN THE SACRED BLACK HILLS

Sioux cross a rushing mountain stream in the Black Hills, sacred ground guaranteed to them by treaty. Discovery of gold brought a rush of prospectors, guarded by the army in violation of the government's promise. Indian reprisal raids resulted in massive military operations and the battle of the Little Big Horn.

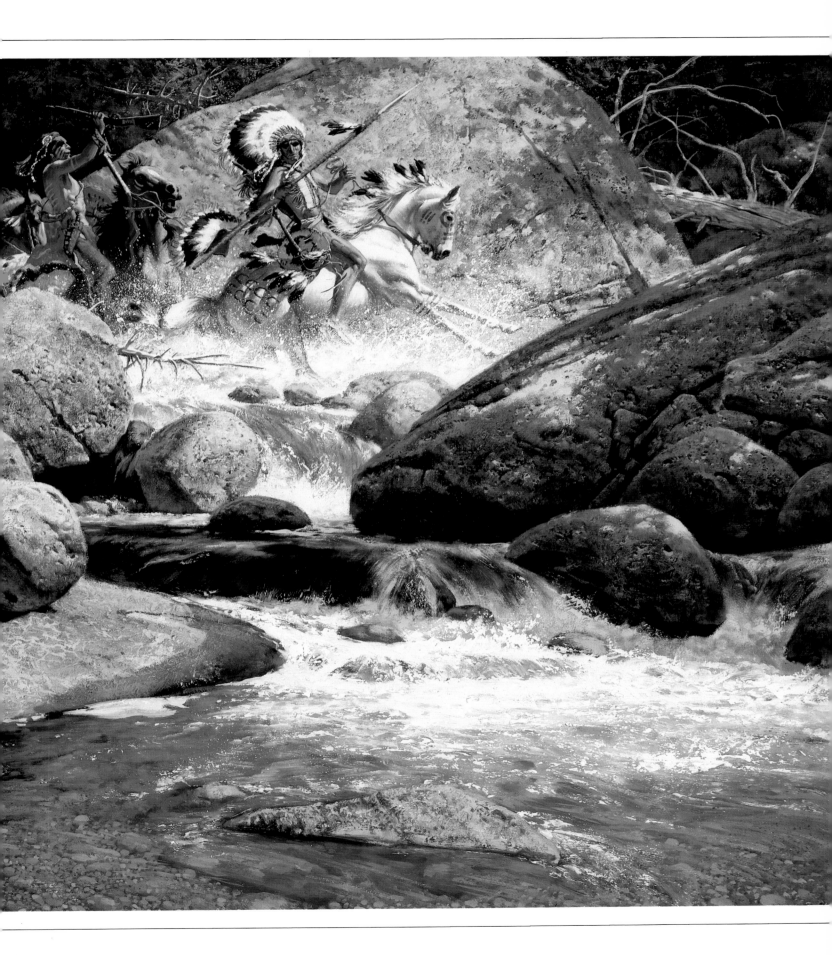

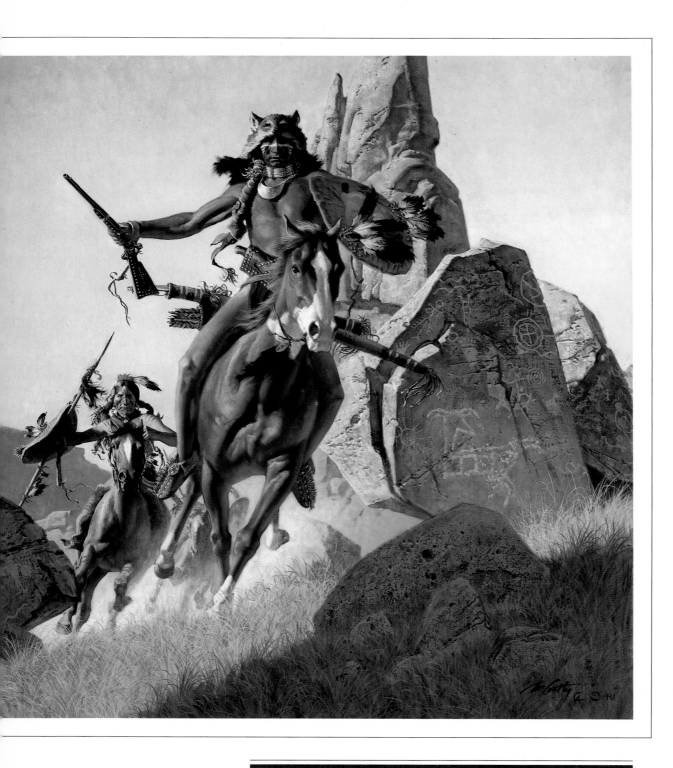

WHERE OTHERS HAD PASSED

At some other time, these war-bent Comanches might pause to study the petroglyphs and speculate about those who passed this way before them, but today their attention is focused on a more urgent mission: defeat of a waiting enemy. The leader, in wolf headdress, has painted his face and body black for battle.

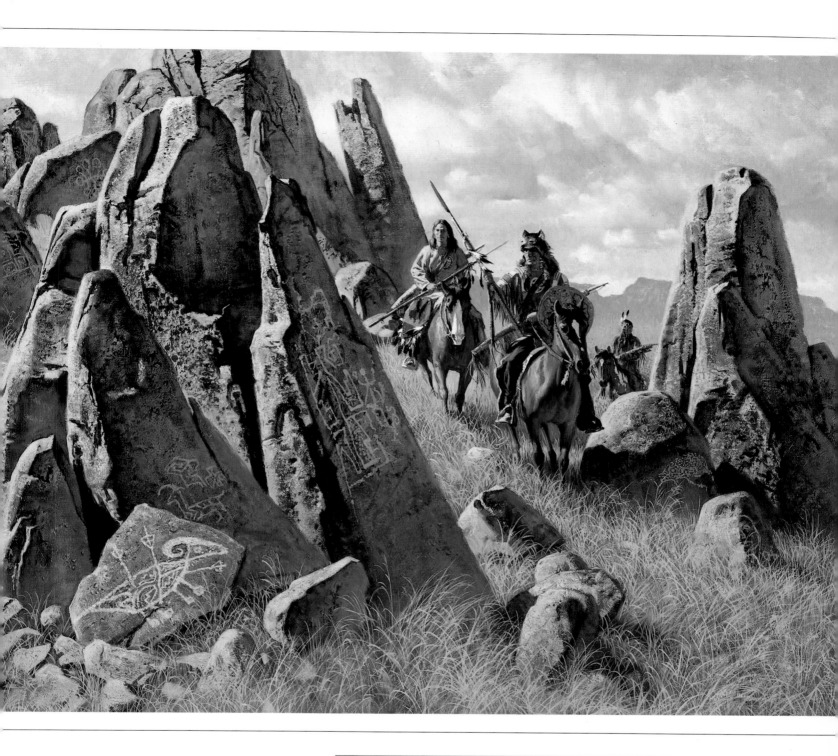

WHERE THE ANCIENT ONES
HAD HUNTED

Long before the dawn of history, Indian tribes came and went,
leaving no trace of their passing except the images they painted or
chipped into stone. Later hunters, like these Cheyennes, would
marvel at the works and wonder if the ancient ones' spirits still
hunted bighorns like the one pictured with three arrows in it.

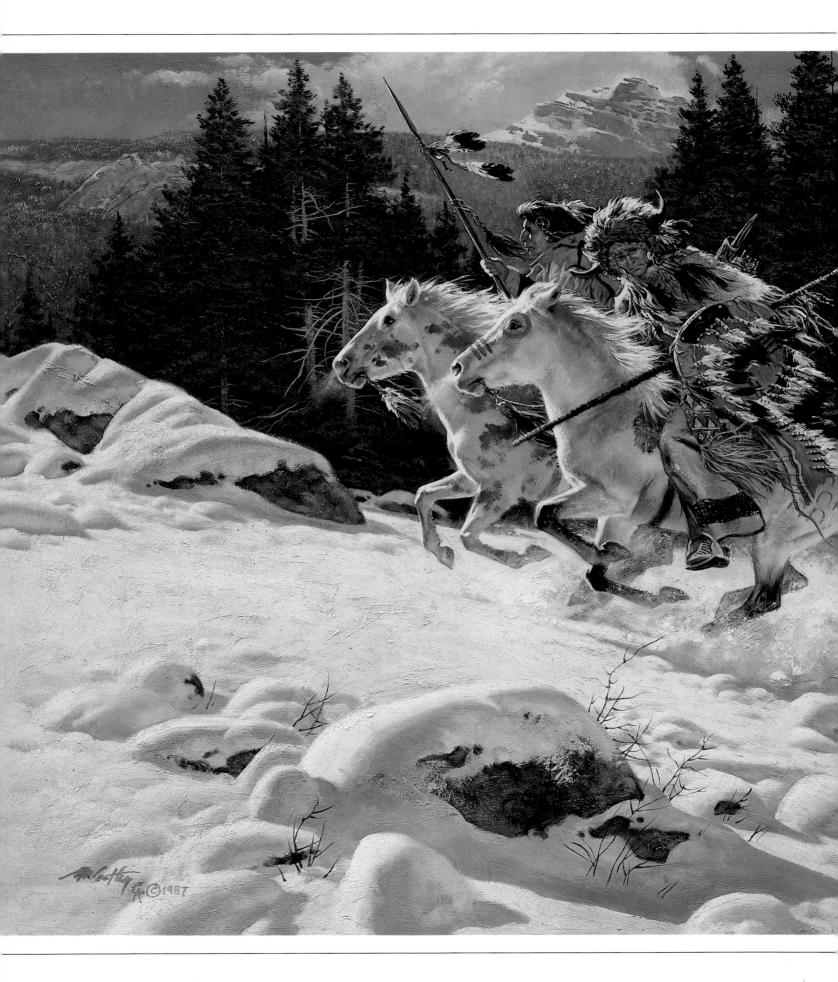

IN THE LAND
OF THE WINTER HAWK

Two Blackfeet raiders race war-painted horses the color of the deep snow through which they ride. Hoofbeats and the breathing of men and mounts are the only sounds to break the winter silence. For more than a century, the nomadic Blackfeet were regarded as the most militant tribe on the northwestern plains.

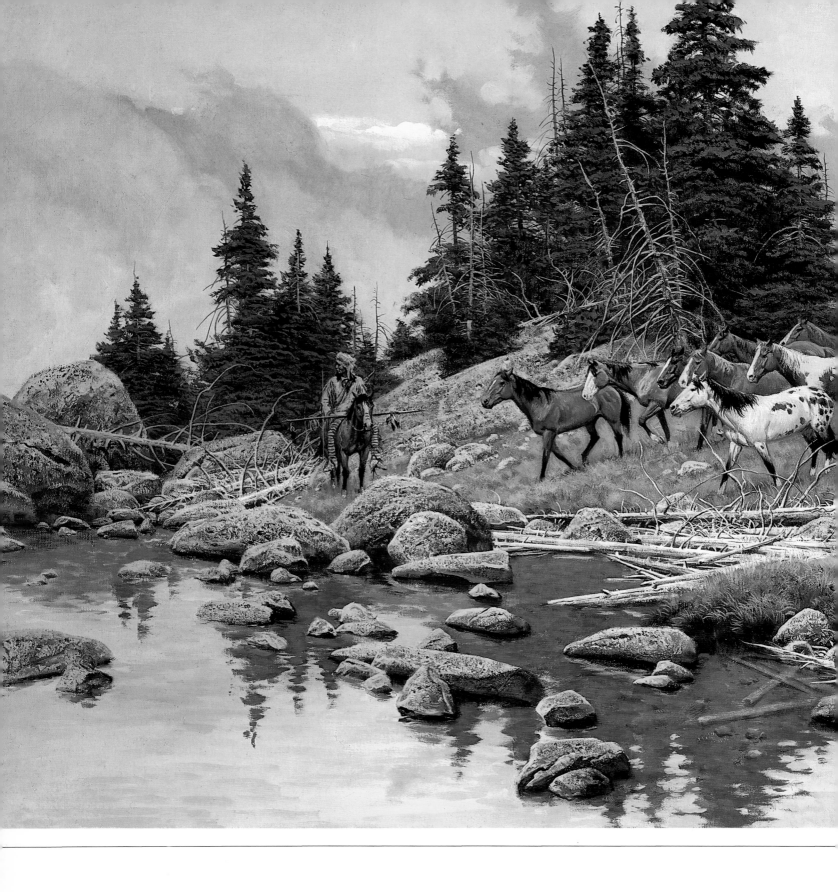

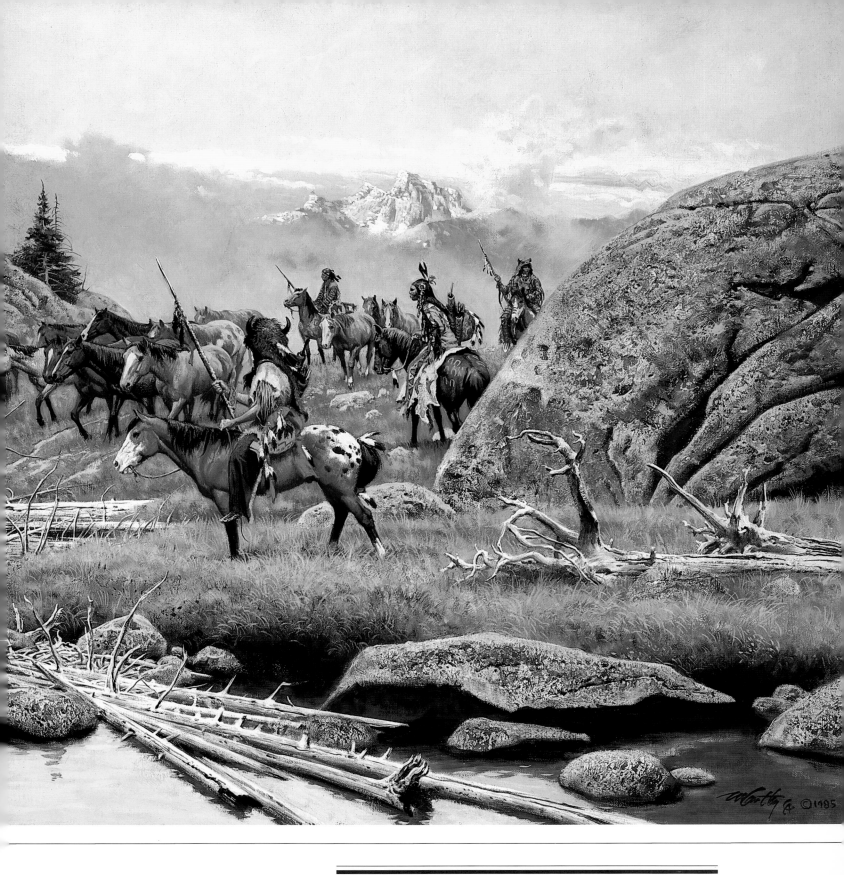

WHERE TRACKS WILL BE LOST

As mist rises from the stillness beyond a shallow lake in the Beartooth Mountains, keenly watchful Blackfeet marauders prepare to push stolen horses into the water to hide their trail from pursuing Crows. But the Crows, expert trackers, can read much in an overturned underwater stone or disturbed aquatic vegetation.

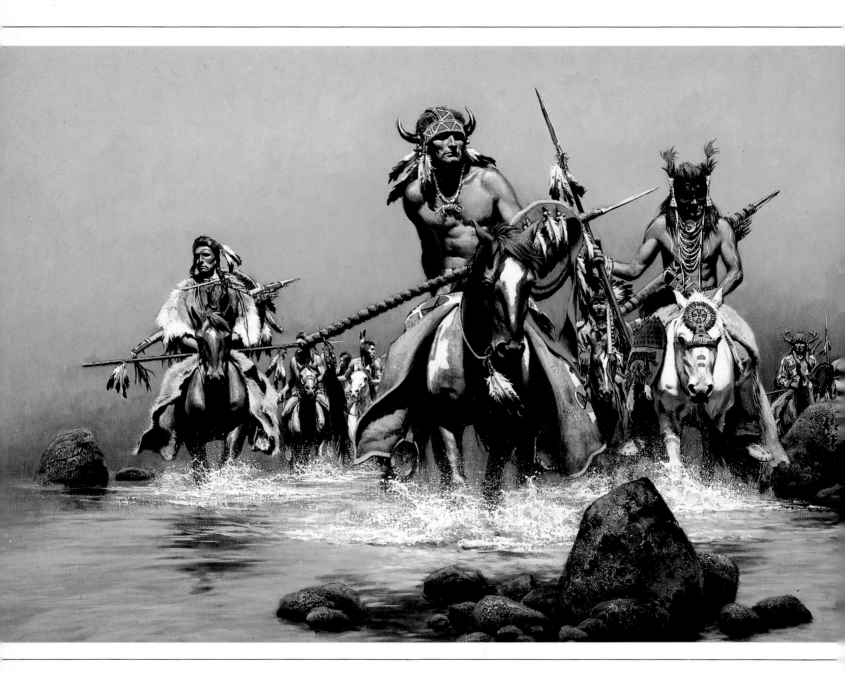

WARRIORS OF THE BEARTOOTH

Bright colors demonstrate the innate sense of pageantry in a Crow war party crossing one of the sparkling-clear shallow ponds that dot Beartooth Pass. A red square on his horse's right shoulder identifies the leader. Artistic beadwork livens the buffalo head-dress, the quivers, and a horse's headpiece.

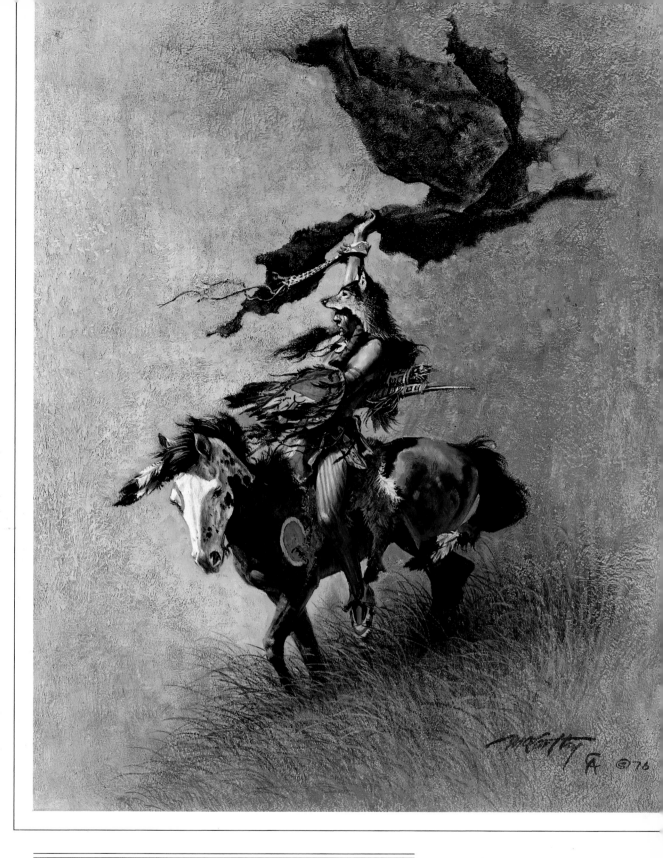

ROBE SIGNAL

A Cheyenne warrior, wearing a wolf's head to signify his status as a scout, waves a buffalo robe to signal distant comrades. The robe served as a blanket to keep him warm, as a means to communicate from afar, and occasionally to stampede an enemy's horses and make them his own.

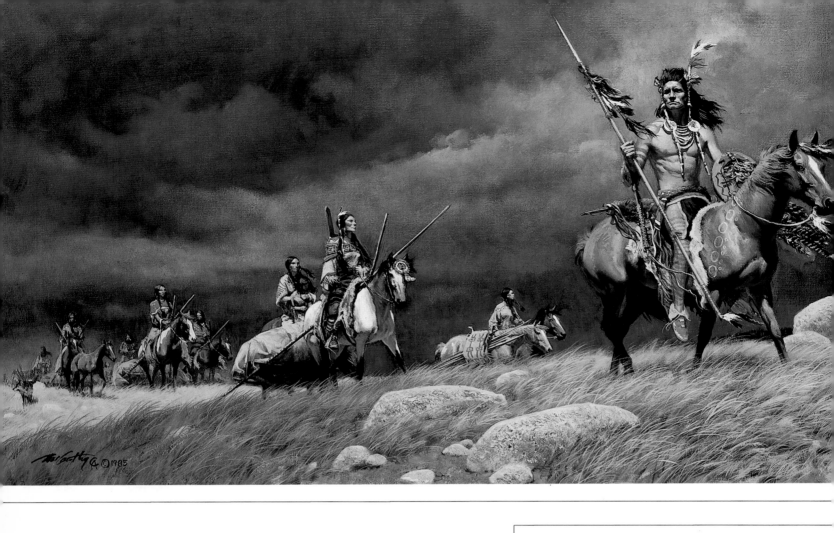

AFTER THE COUNCIL

Their grand tribal council finished, bands of Sioux on the Yellow-stone River disperse toward individual camping grounds. Designated warriors watchfully take the lead while others serve as outriders, guarding the flanks. Belongings are packed on horse-drawn travois in the care of the women.

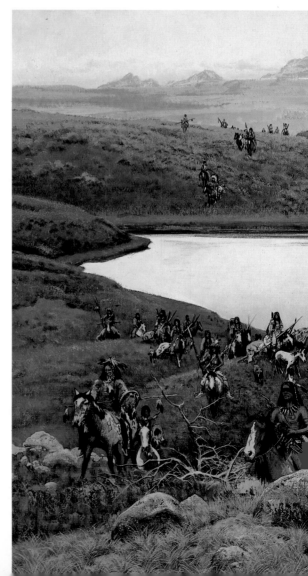

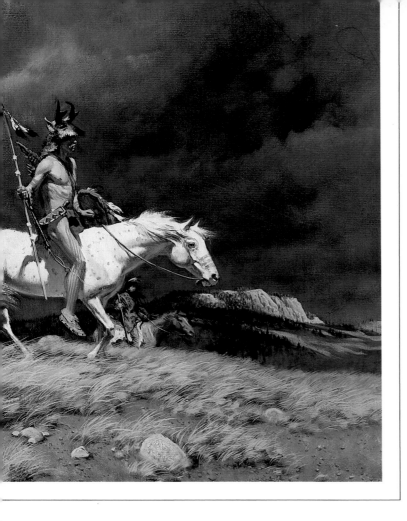

FOLLOWING THE HERDS

Accompanied by their families, Crow hunters follow the migrating buffalo upon which they depend for food, for the clothing they wear, the robes upon which they sleep, and the tepees that shelter them. Acquisition of the horse gave the Plains Indians mobility, transforming their hunting methods and their style of life.

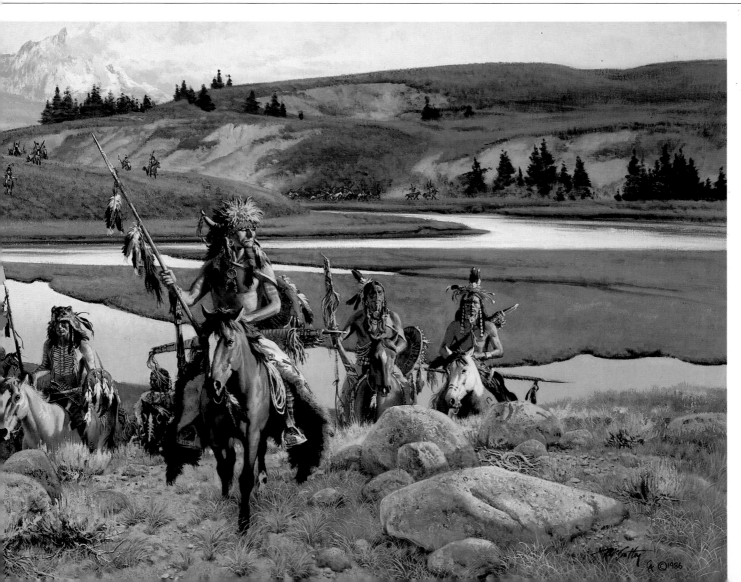

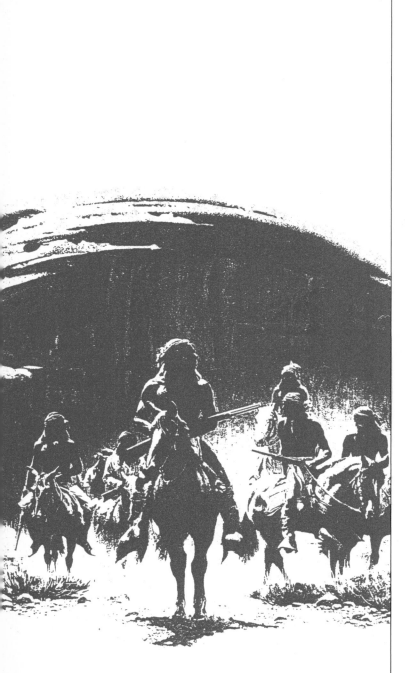

THE WARRIORS

A war-bonneted chief signals distant riders with a war party's flag: a strip of red blanket and a solid row of feathers. The style of beadwork and the blanket patch on the leggings of the warrior at right mark these as Crows. Tracks painted on the animals' rumps signify successful horse-stealing raids in the past.

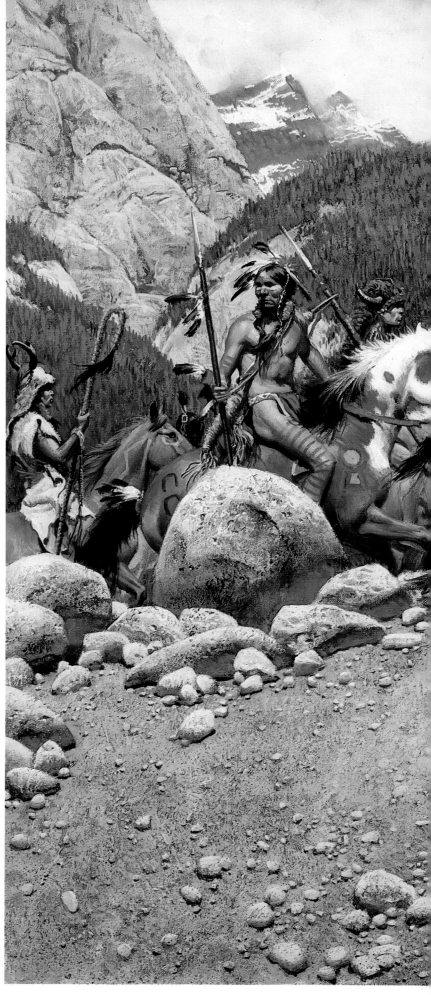

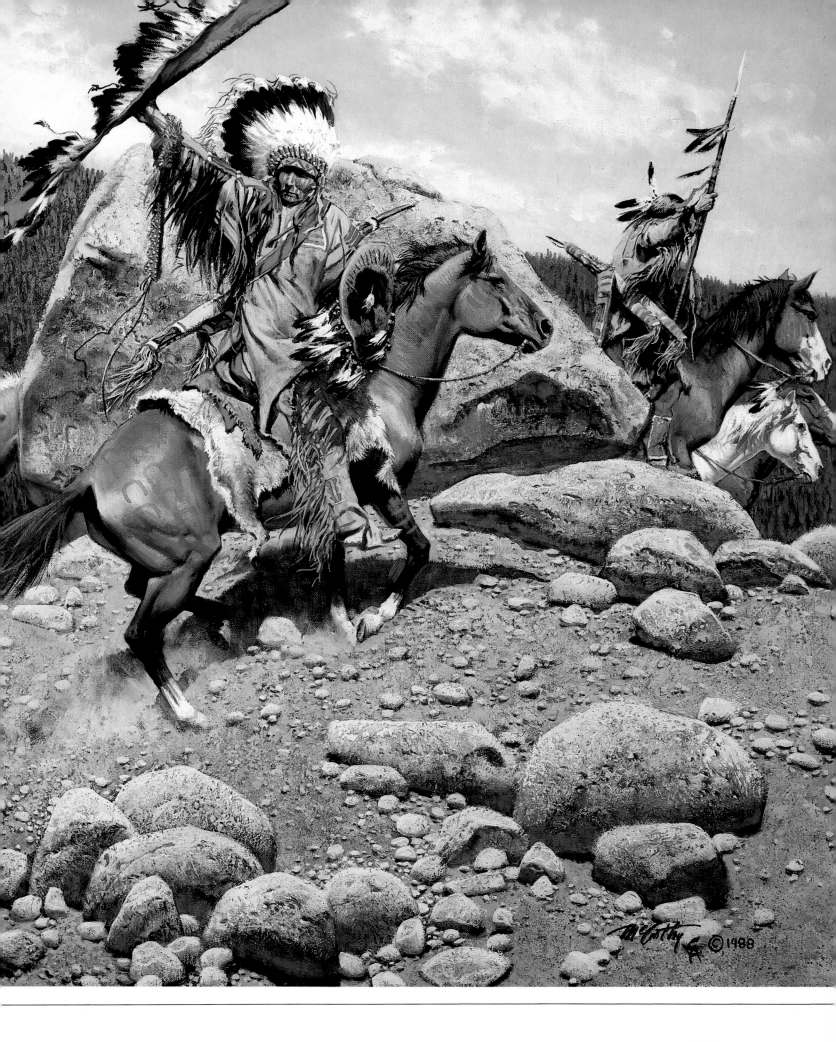

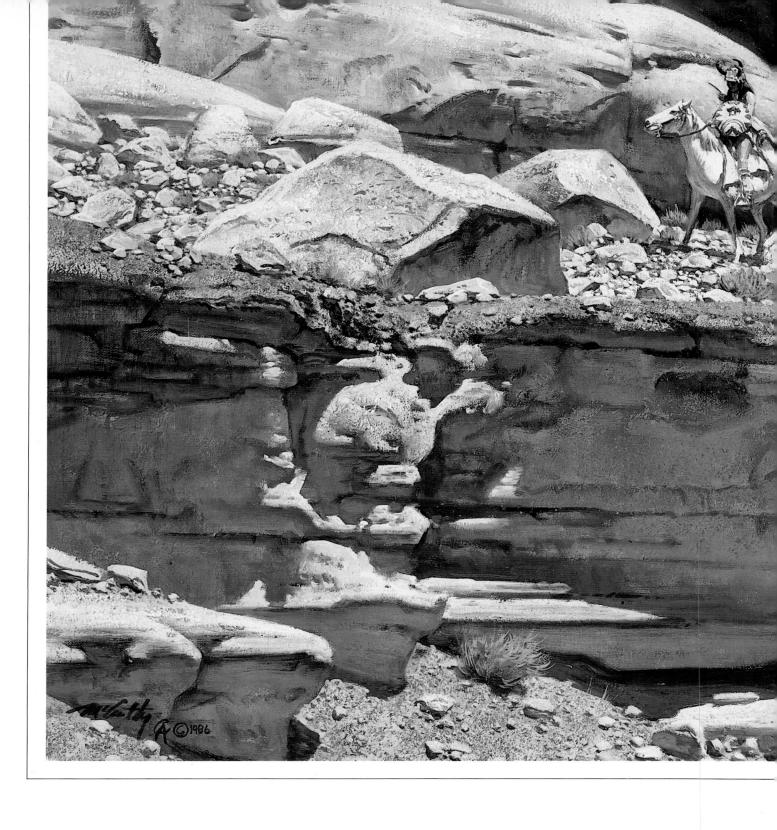

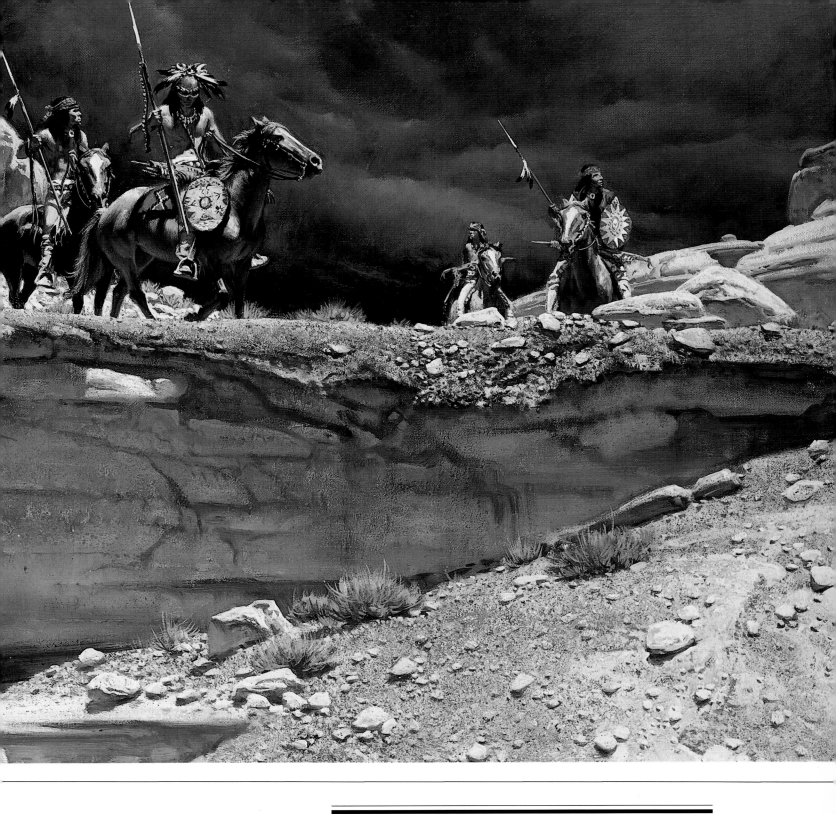

THE HOSTILE LAND

Beneath a sky darkened by an approaching storm, Apaches tensely search along a deep and treacherous rock shelf for a sign that one of their many enemies has passed this way. The Apaches' long southward migration dispersed them from the desert mountains of Arizona to the plains and the timbered Texas hill country.

A CROOKED TRAIL

Dwarfed beneath a high slickrock formation, an Apache kneels to study the ground for a telltale overturned rock or crushed grass stems that might indicate someone else has been here before him. Indians were quick to learn the use of articles acquired in trade or taken in battle, like the white man's saddle and bridle.

LONE SENTINEL ▶

War pony well concealed nearby, a Northern Cheyenne sentinel squats atop a weather-slickened rock outcrop that gives him a splendid vantage point. Wearing little more than a buffalo headdress, breechclout, and beaded moccasins, he is ready to ride quickly into battle.

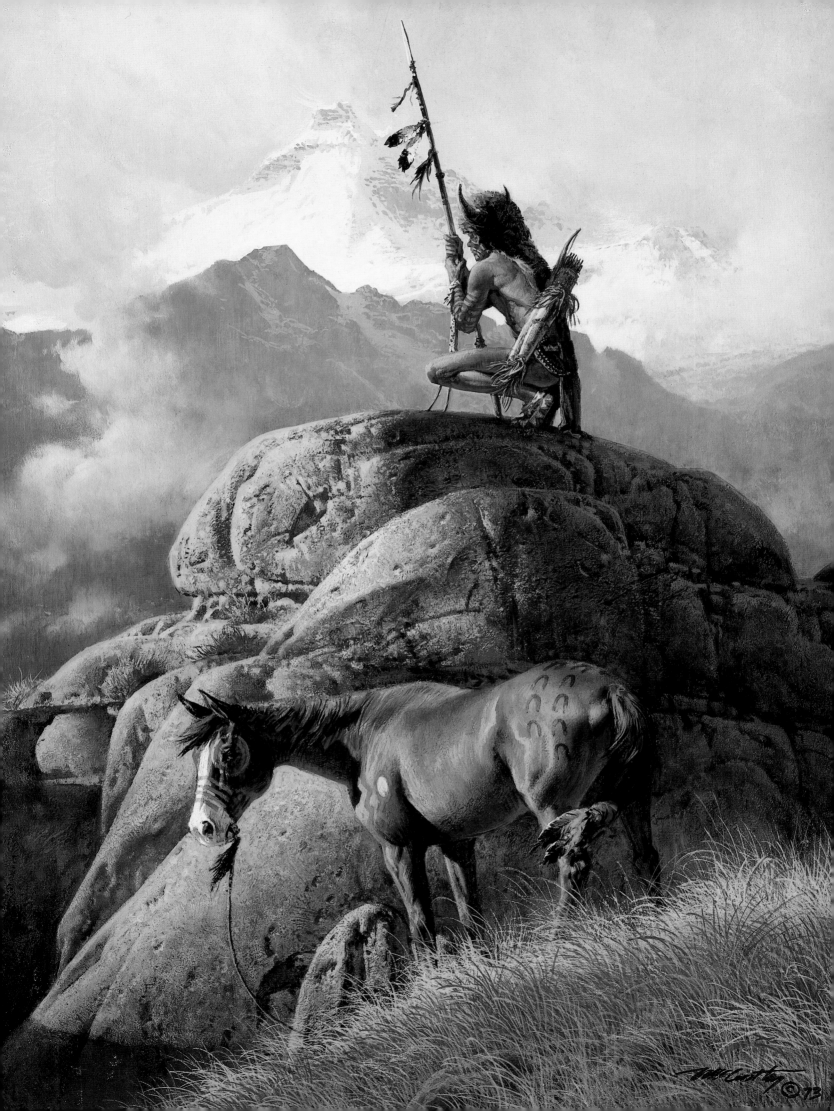

MOUNTAIN MEN

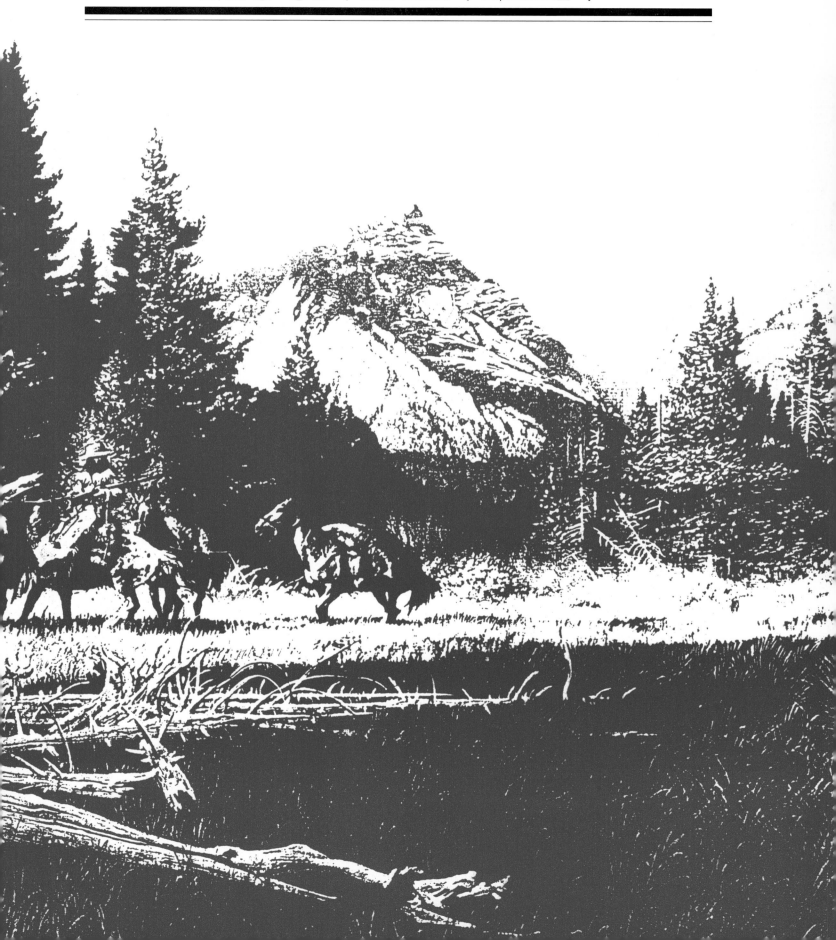

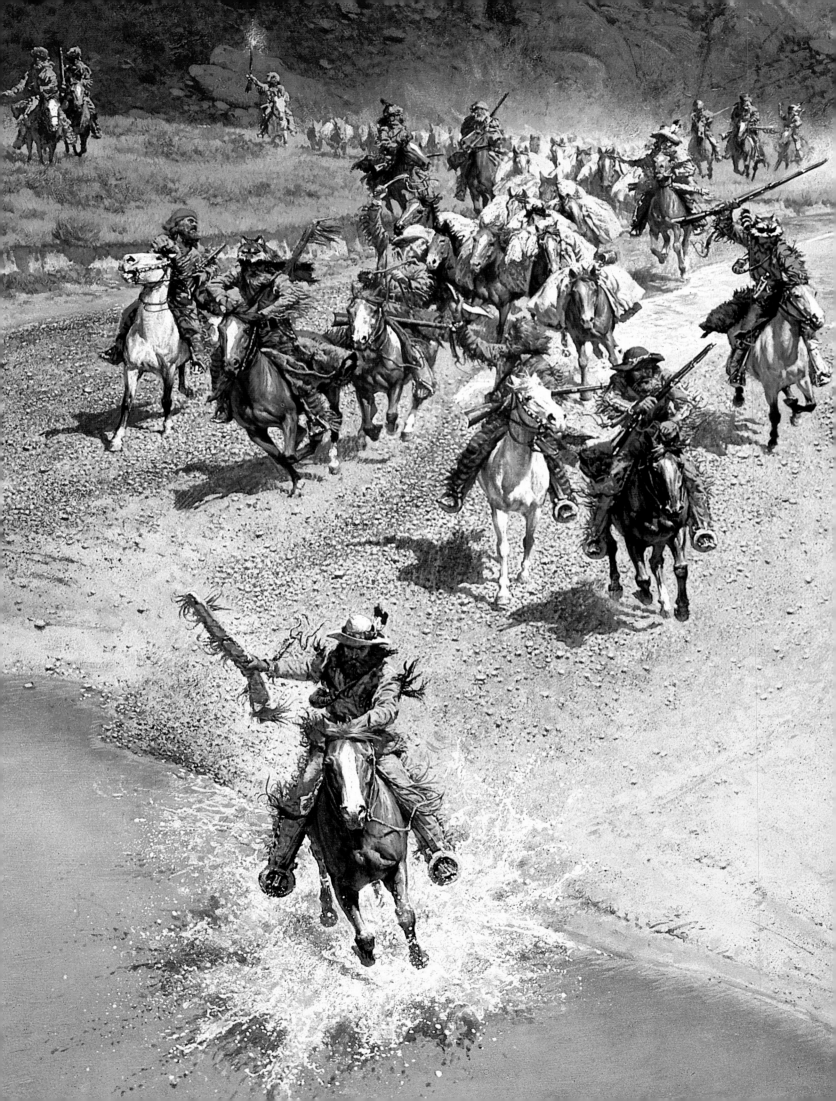

MOUNTAIN MEN: A KINGDOM OF BEAVER

Boldly they ventured west into a wilderness vigorously guarded by militant Indians and became much like Indians themselves. These buckskin men of the mountains would enjoy a few years of high glory, then, like the Indians, find that a restless, changing world had passed them by.

The rough mountain men of the American Rockies owed much to French and English who had first set a pattern for adventuring into unknown lands. The annual trapper rendezvous of 1825 through 1840 was similar in some respects to Canadian fur fairs in Montreal two centuries earlier.

It was the dam-building beaver that drew these men west. Europe paid a high price for the magnificent felting qualities of its fur. For two centuries, first for the French and then for the English, brigades of *voyageurs* moved these pelts by canoe. Strong, self-reliant, they carried hundred-pound packs on their backs during long portages between streams, around rapids and waterfalls. Their hardy, independent lifestyle — often more Indian in nature than white — set a challenging course for the American mountain men.

Chartered in 1670 by the British government, the Hudson's Bay Company dominated trade for most of the 1700s and into the early 1800s. Long after the United States won independence, the company sternly maintained a near monopoly on furs in the American West, as well as in Canada, but determined Americans began picking at the edges by the late 1700s. Lewis and Clark, exploring the West for President Thomas Jefferson, found two American trappers on the Yellowstone River in 1806.

The first large-scale American attempt at staking a claim in the Western fur trade was launched in 1810 by John Jacob Astor on the Oregon coast. He failed, but he would keep trying, and so would others.

John Colter, who left the Lewis and Clark expedition to join the two trappers on the Yellowstone, found the trapping good. Meanwhile, in Saint Louis, an enigmatic trader named Manuel Lisa outfitted a trapping party and set out up the Missouri River with keelboats in the spring of 1807. Along the way he met Colter, coming downriver to sell his winter's catch. Colter turned around and went back with him as a guide. At the junction of the Big Horn and Yellowstone rivers, they built a fort.

While others trapped, Colter set out upon a lengthy exploration, seeking more beaver. In a circle that carried him through parts of Wyoming, Montana, and Idaho, he marveled at the geysers and hot springs along the Yellowstone. Listeners scoffed at his descriptions of these natural wonders. Though he told the truth, he was setting a precedent for later mountain men, like Jim Bridger, who would gain a reputation for spinning magnificent tall tales.

In the main, the English had encouraged Indians to do the trapping, then traded for the furs. The American mountain men did most of the trapping themselves and cut out the middleman. This competition did not sit well with Indians who considered the land their own, its bounty their birthright.

Colter was among the first American trappers to feel the fury of the Blackfeet, who tolerated no intrusion. Captured on the upper Missouri, his partner killed, Colter was stripped naked and then, for sport, given a short head start in what was expected to be a futile run for his life. Though barefoot amid thorns and sharp rocks, he outran his pursuers some six miles to the Jefferson River. Jumping in, he hid beneath driftwood while the Blackfeet angrily scoured the riverbank. He eventually made it back to Lisa's fort naked, nearly starved, his feet lacerated.

Undeterred, he continued trapping in Blackfeet country for two more years until another narrow escape convinced him that he had seen enough. He returned to Saint Louis, where he gave his old commander, William Clark, an account of his experiences and helped fill in blanks on Clark's map.

After Lisa's death in 1820, William Ashley of Virginia joined a former Lisa partner, Andrew Henry, and organized the Rocky Mountain Fur Company. He recruited a brigade of adventurers who had no prior experience on the Indian frontier but whose names would become synonymous with the term *mountain man.*

One was Bridger, an illiterate young apprentice blacksmith. William Sublette was a Missouri constable who, with his brother Milton, would become a

major figure in the fur business and take the first trade wagons into the Rockies. Jedediah Smith, who had been a clerk on a vessel plying Lake Erie, would blaze many new trails across the mountain and desert West. Tom Fitzpatrick was a well-educated immigrant from Ireland who suffered terrible hardships to become, in the words of a leading historian, one of the principal "openers of the West."

Among the oldest of the Ashley men was Hugh Glass. He would survive a ghastly fight with a grizzly, be left for dead by his frightened companions, and make a remarkable journey alone, on foot and unarmed, to safety on the Bighorn. He was reputed once to have been a pirate with Jean Lafitte.

Edward Rose, of Cherokee-Negro blood, had indeed operated as a river pirate on the Mississippi and had served with Lisa's first expedition upon the Missouri. He had later lived among the Crows and Arikaras, so Ashley hired him as an interpreter for his venture up the Missouri in 1823.

Near the border of North and South Dakota, Ashley and his seventy men were attacked by some six hundred Arikaras and driven back with a loss of a dozen killed. Closed off from the upper river, Ashley decided to strike out overland, using horses and mules to pack trade goods and furs. This historic innovation freed the trappers from the earlier necessity of remaining on or near navigable rivers and streams. They could go anywhere that a horse or mule could travel.

Though their immediate goal was personal profit, what these trappers did was to prove of inestimable value to later generations of white settlers. They penetrated previously unexplored regions of the West, amassing knowledge that would aid immigrant wagon trains in reaching Oregon and California, guide the military in its campaigns against hostile tribes, and allow telegraph lines and railroads to span the continent.

At the time, however, the mountain men probably gave little thought to making history. They were absorbed in trapping beaver and preserving their lives in a hostile land that seemed bent on snuffing them out. They were by nature risk-takers, or they would not have been there. They were strong individualists, often nonconformists who did not fit comfortably into so-called polite society. In the vast solitudes of the West, they could cut loose and be themselves.

Many took on the trappings of the Indians, aligning themselves with one tribe or another, taking Indian wives to cook their meals, share their labors, and warm their blankets in the bitter cold winters of the Rockies.

A highlight of the mountain man's life was the annual rendezvous, a month or so long. William Ashley organized the first at Henry's Fork on the Green River in 1825. He brought supplies so trappers could trade their furs and not have to transport them all the way southeastward to Saint Louis. The first rendezvous was modest. Ashley recorded only two sales of liquor. But later ones were grander, attended by throngs of white men and Indians.

Curiously, though enmities were strong and many rendezvous participants tried vigorously to take one

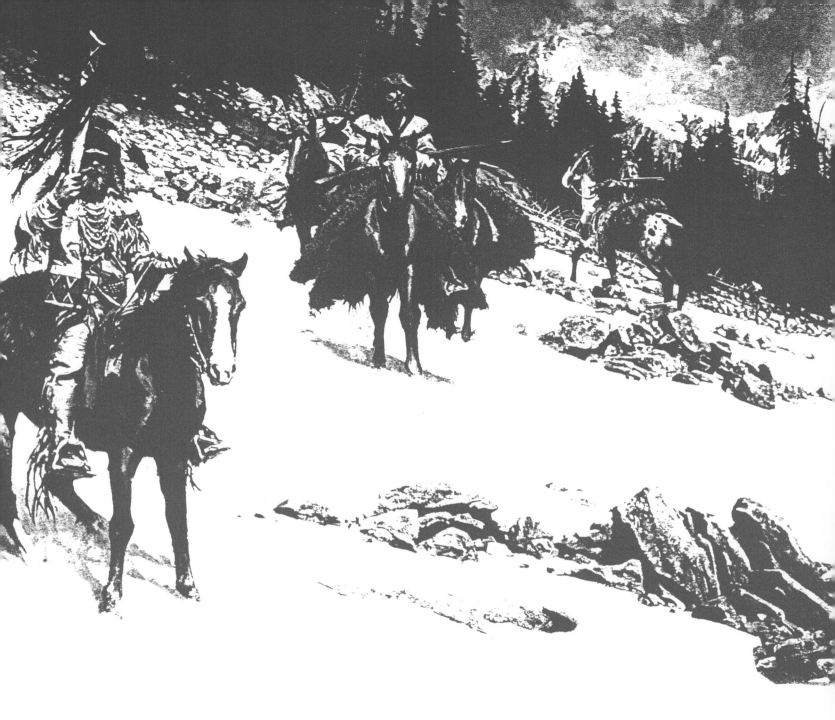

another's scalps the rest of the year, they recognized an unofficial truce. They might attempt murder on the way in or out, but bitter enemies regarded the rendezvous site as neutral ground and tolerated each other for the sake of trade and recreation.

And what recreation it was! They danced; they drank copious amounts of whiskey; they gambled, sometimes losing a whole winter's work playing cards on a blanket spread upon the grass. Sober and drunk, they risked life and limb in horse racing and shooting contests. They enjoyed the temporary company of Indian women. By the end of the rendezvous, the less provident were reduced to signing away their next season's catch to outfit them for a return to the mountains. They took it in stride. There would always be another year, unless they were unlucky enough to have their hair lifted, in which case money would have been of no use anyway.

Inevitably, the time came when there would not be another year. Beaver were harder and harder to find. The better streams had been trapped out. And though the buckskin men in their primitive environment would seem far removed from the fashions of New York, Paris, and London, they were at the mercy of fads created in those distant places. The beaver hat fell out of favor as the silk hat became the choice of the dandy. Prices plummeted. The last rendezvous was but a shadow of earlier ones. Those mountain men who had not "gone under" — and a great many had — strayed down to the lower country, searching for a more profitable way of life.

Many found it as guides. Others took up farming and livestock raising, or built trading posts to deal with the newcomers flocking west. Ironically, in so doing, many of these men, who had lived like Indians and had become most sympathetic to the native American's point of view, would set in motion the destruction of the Indian's way of life.

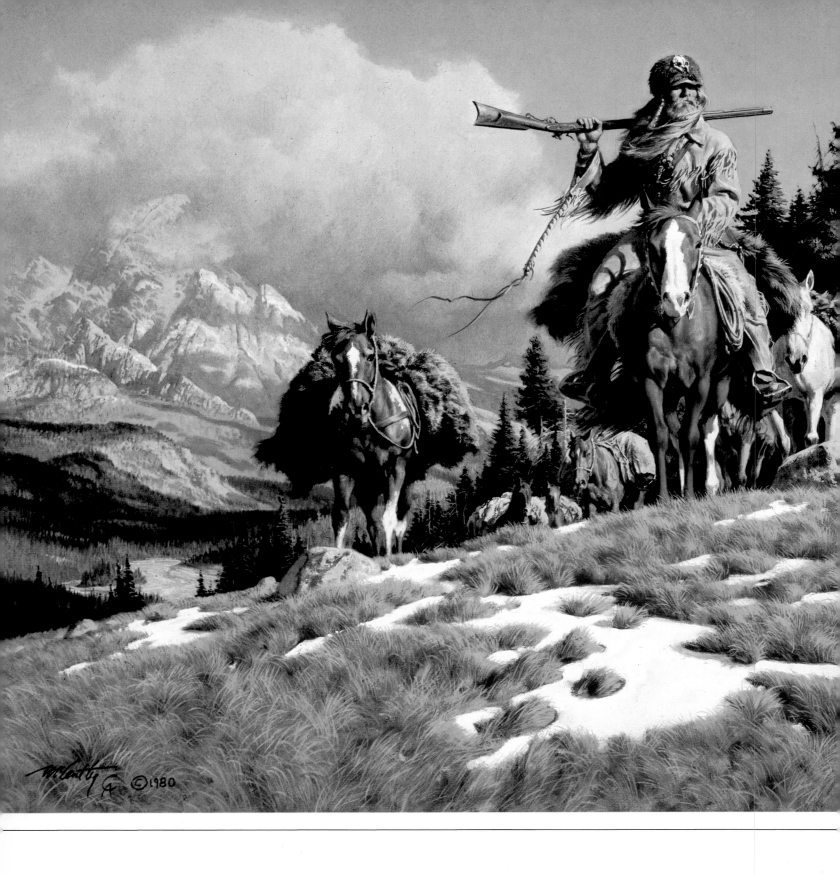

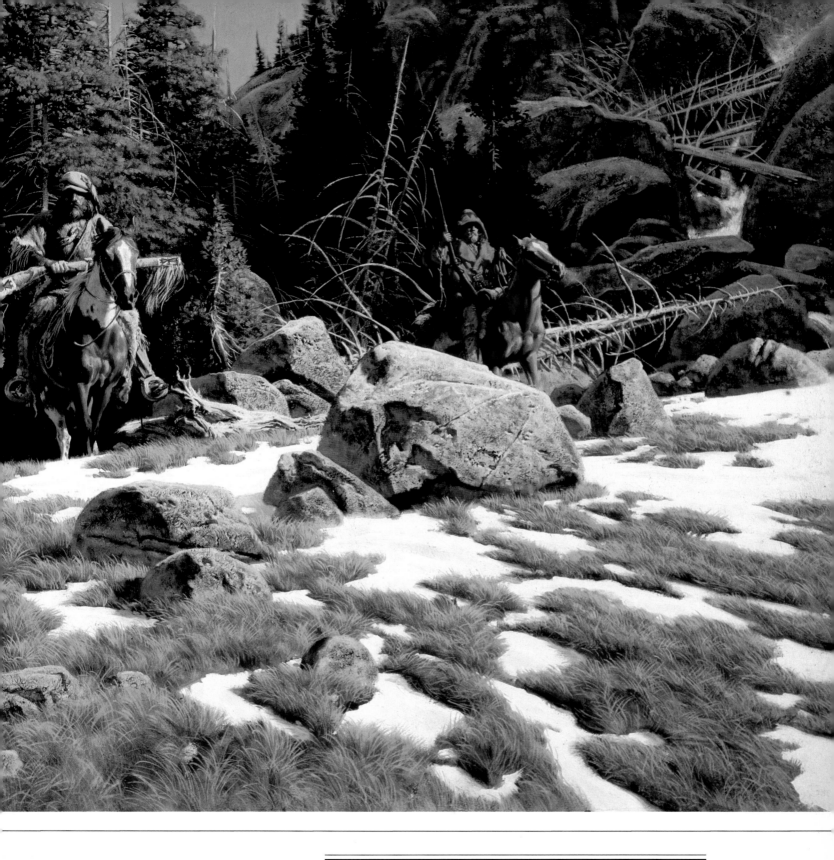

BRINGING OUT THE FURS

Trappers, their pack animals laden with pelts, cautiously make their way across a snow-patched mountain pass in search of virgin waters for their beaver traps. These adventurers were often the first whites into unexplored territory, putting themselves in harm's way but acquiring a valuable knowledge of the land.

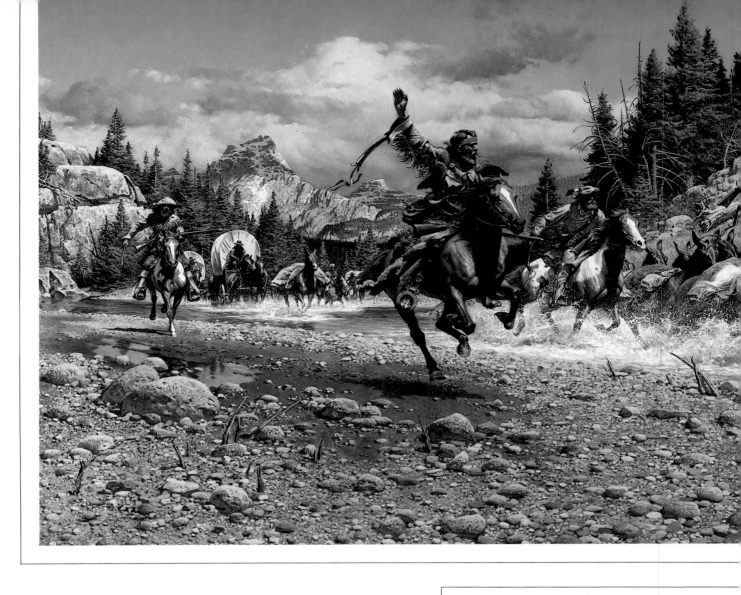

WINTER TRAIL

Traveling at night to avoid discovery, a mountain man hurries through freshly fallen snow on his way to a new camp or to a safe haven among friends white or red. His rein is tied in the horse's mouth Indian-style, and his footwear is beaded. He has lived among friendlies and taken on some of their ways.

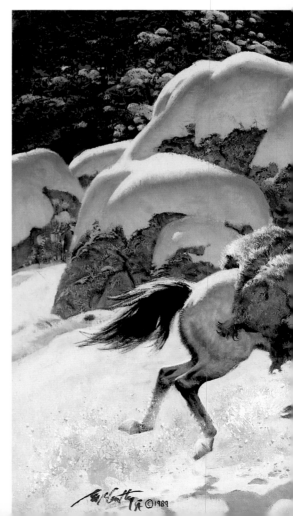

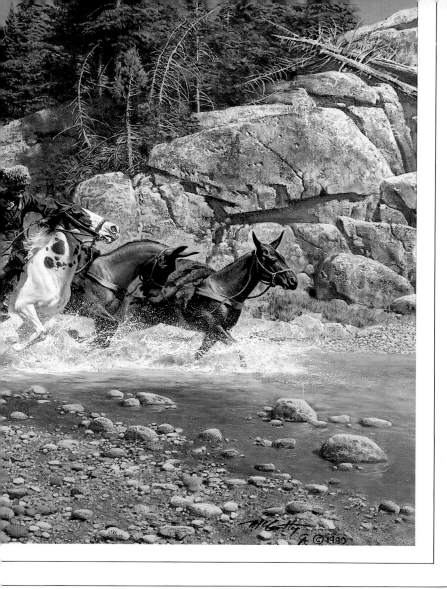

THE LAST CROSSING

After a long winter's isolation and hard work, buckskinned trappers have joyously joined a wagon train bringing trade goods to exchange for their season's catch of pelts. The summer rendezvous began in 1825, flourished a few years, then declined as streams were trapped out and the beaver hat gave way to silk.

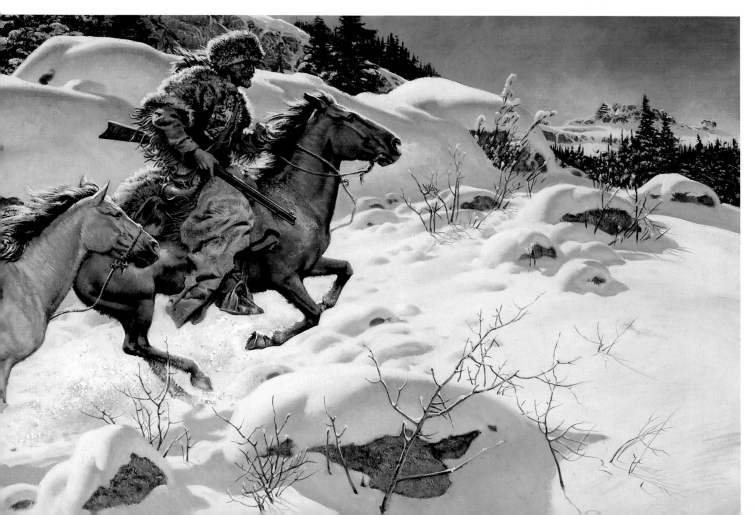

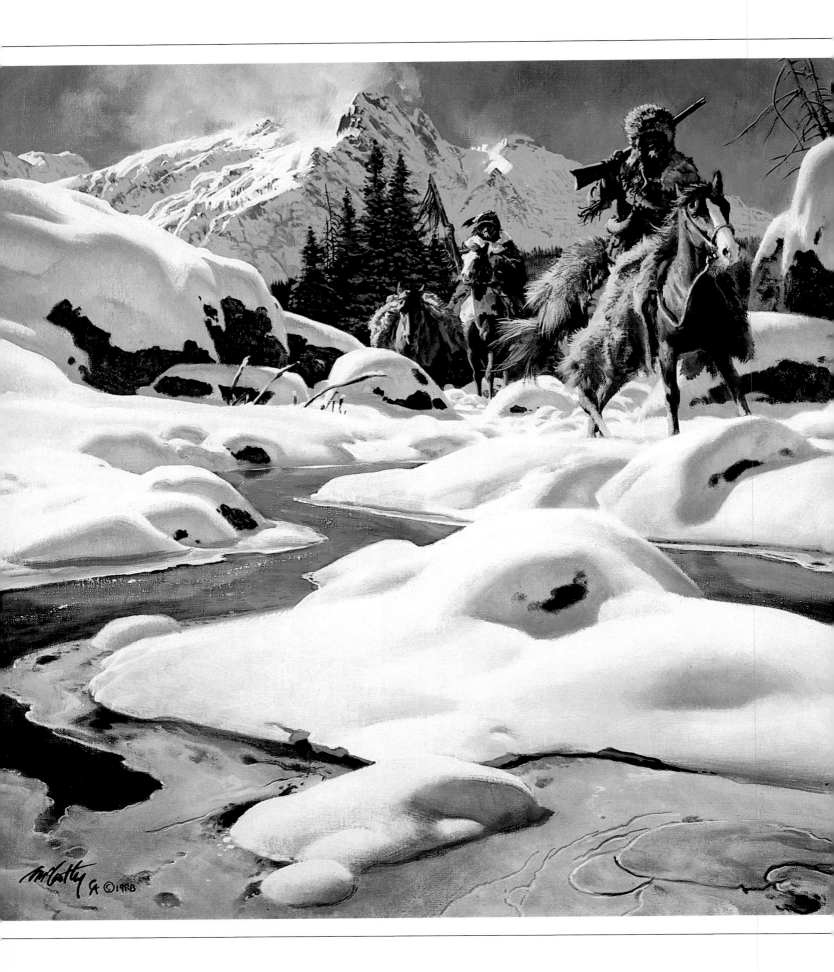

LAND OF THE EVER-WINTER

One of the worst hazards for beaver trappers, aside from hostile Indians, was weather. Because pelts were prime during winter months, trappers did much of their work under the worst possible conditions. Wading in frigid streams induced rheumatism. Soaked, a man could freeze before he got a fire built.

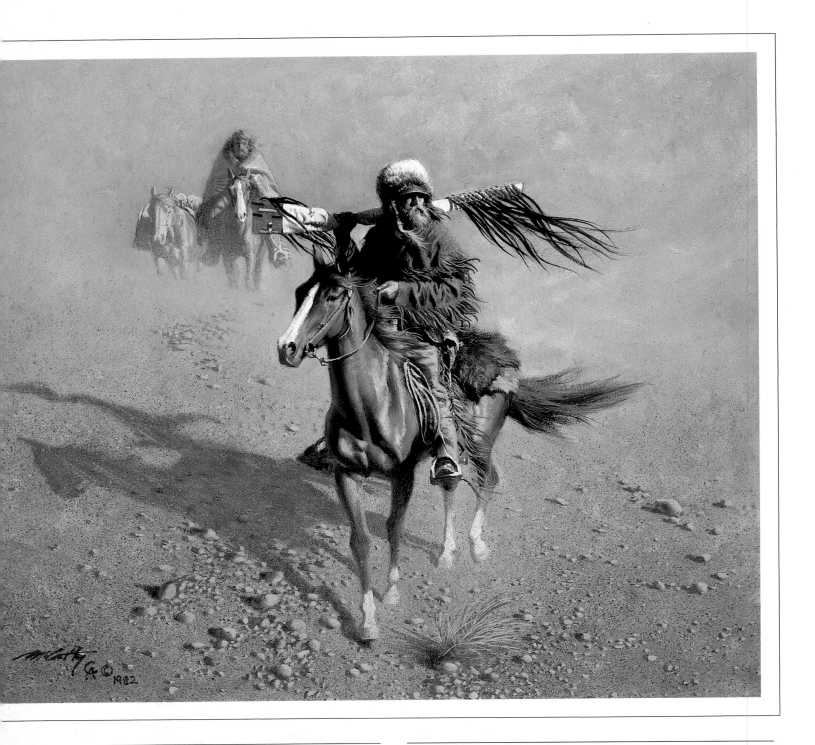

THE DUST STORM

Hidden by a provident dust storm but still vigilant, two mountain men move to a new trapping site, a pack animal carrying the pelts they have harvested so far. They are in dangerous country. The lead rider can whip his long rifle out of its Indian-beaded protective leather case in the blinking of an eye.

ALONG THE WEST FORK ▶

The rugged beauty of the mountain West was not lost upon the trappers, who were usually its first white invaders. However, they must remain ever mindful of dangers, which may lurk in the shadows of the tall pines or behind the gray boulders, as they travel in the shallow snow-melt stream, hiding their trail.

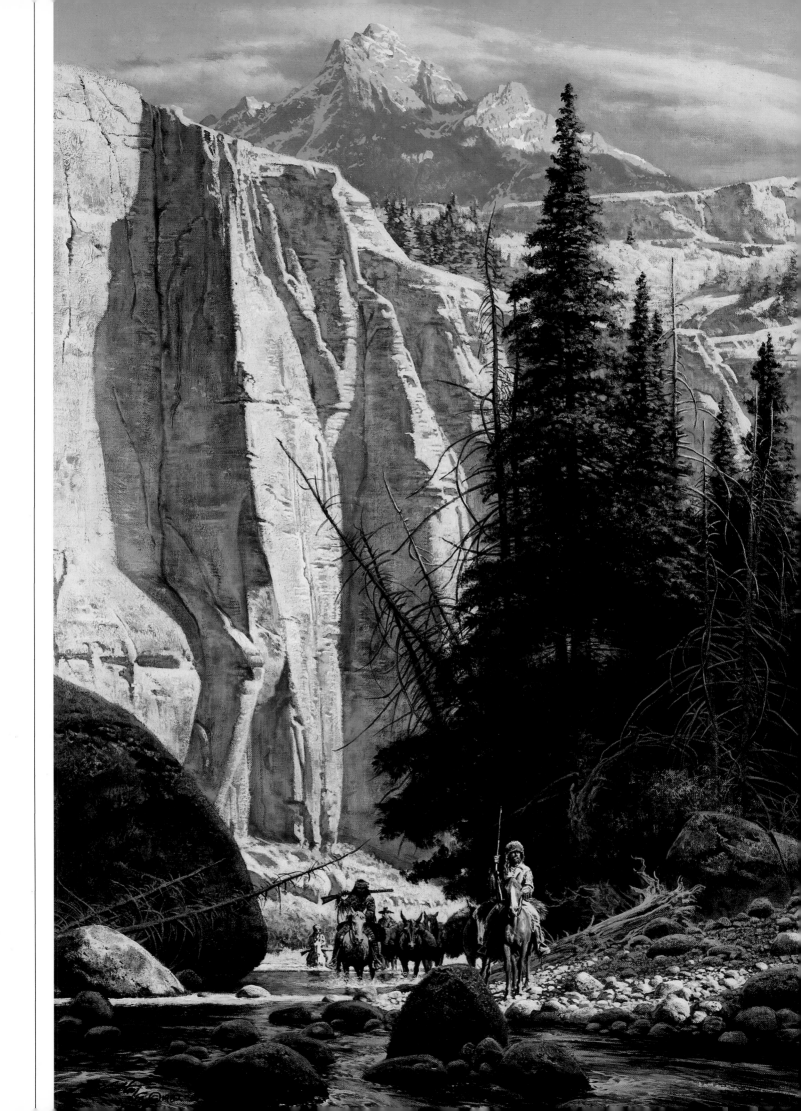

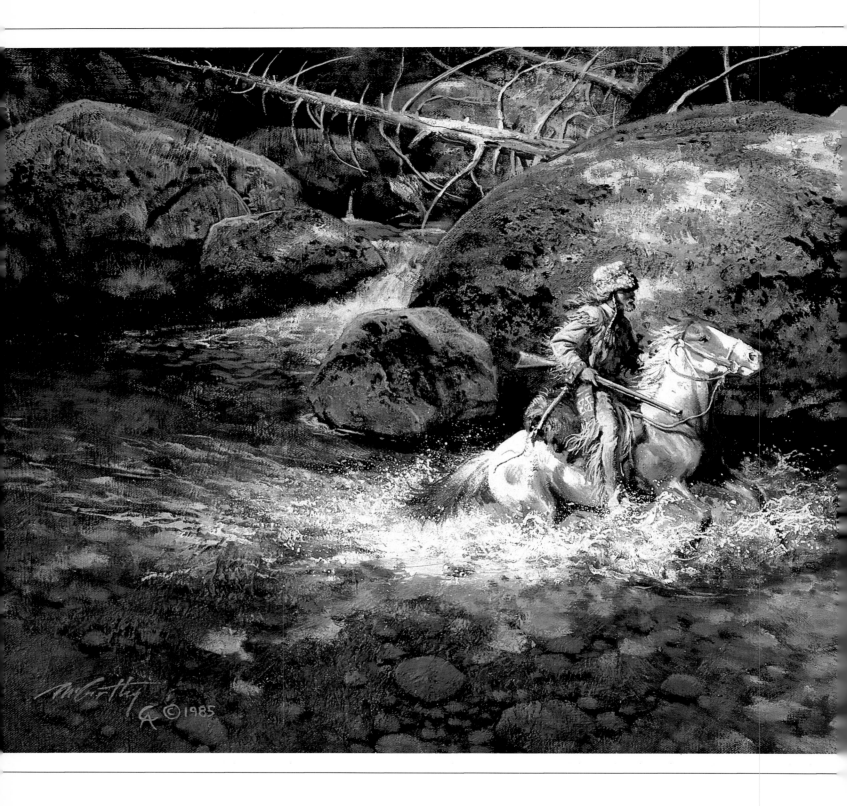

COVERING HIS TRAIL

Rifle ready for quick action, a mountain man rides his horse in a
stream to avoid leaving tracks that might alert hostile Indians to his
presence. For a beaver trapper in jealously guarded lands, keeping
one's hair on his head instead of on a warrior's scalp pole
depended upon remaining undiscovered in the enemy's midst.

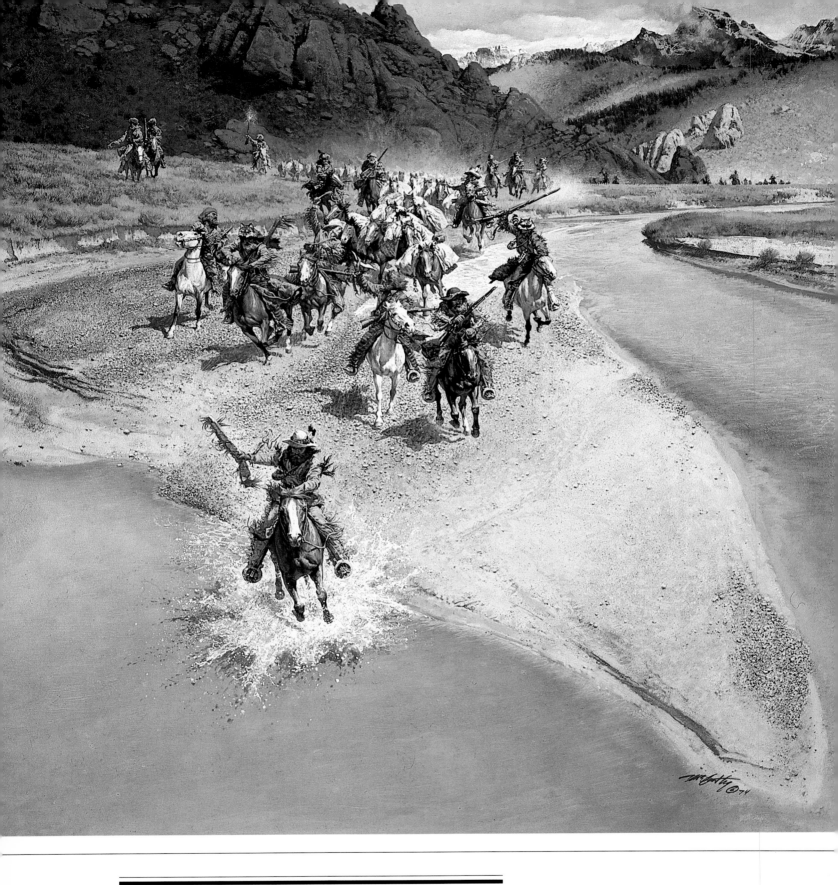

THAR'S RENDEZVOUS!

Wild exhilaration grips these mountain men as they race their mounts and pack animals across a sand bar toward rendezvous. They have spent a hard winter in the deep snow of high country, wading in frigid streams to set their beaver traps. They look forward to a few days of carnival-atmosphere camaraderie.

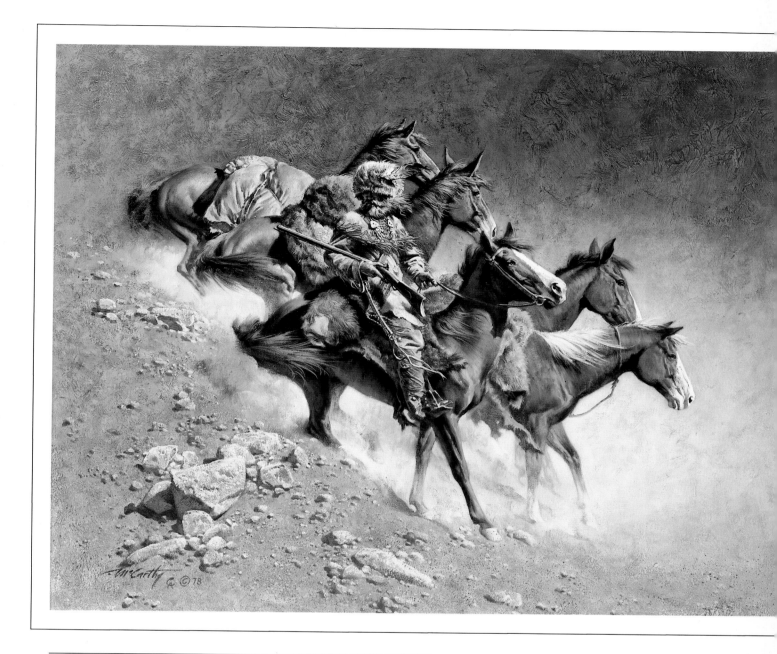

THE LONER

Looking over his shoulder, aware that someone most unfriendly may be following, a bearded mountain man makes his way down a steep hillside with his pack animals, his camp goods, and his peltry. Only a special breed of man could tolerate that often solitary life. Many had been misfits back home. Isolation suited them.

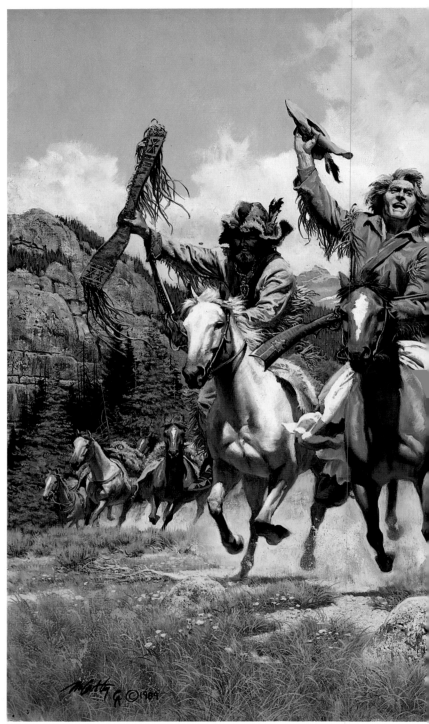

DOWN FROM
THE MOUNTAINS

Shouting in jubilation, waving hats and rifles, mountain men gallop into rendezvous for a riotous round of pelt trading, horse racing, card playing, whiskey drinking, and an all-around good time. After frenzied celebration, many will have to go into debt to outfit themselves for a return to the mountains.

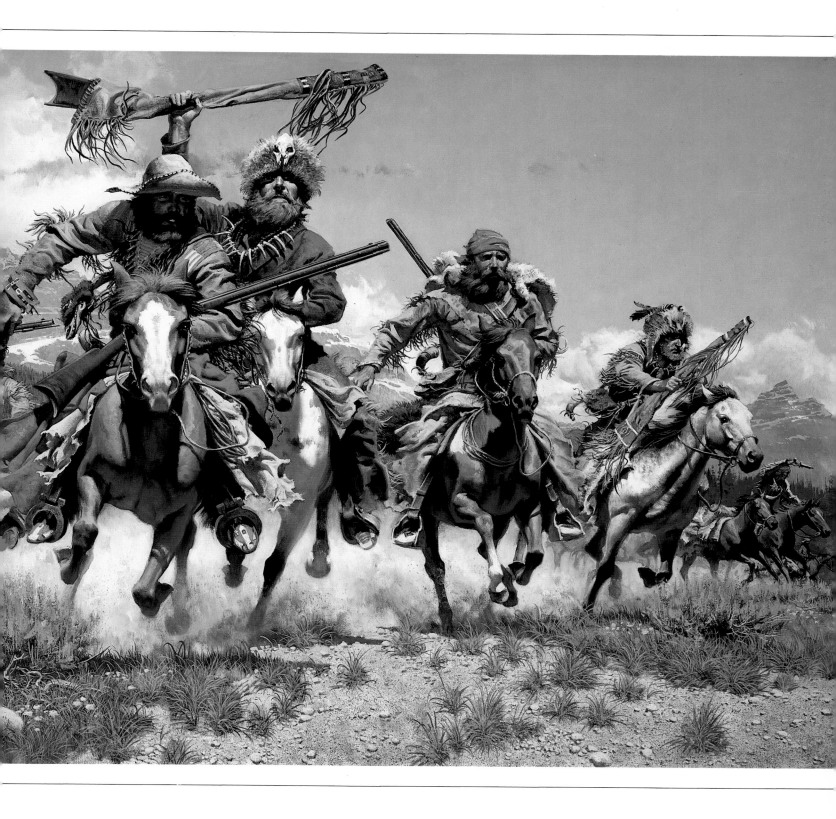

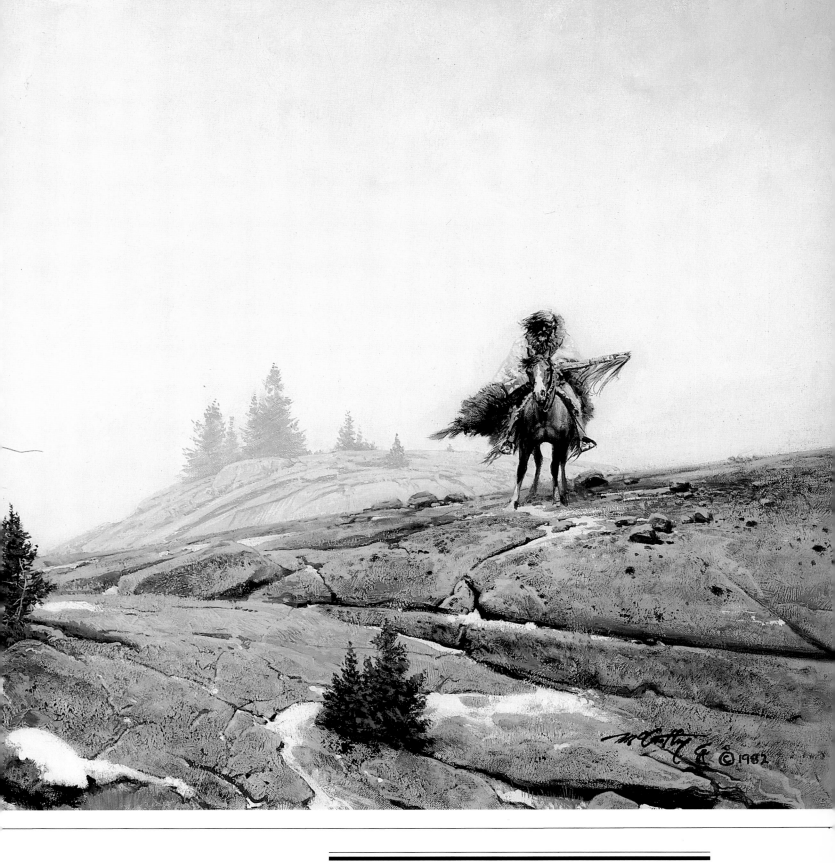

THE TREK

A lone mountain man rides across a windswept rock face high up toward the timberline, hoping that in such a bitterly cold environment he will not confront hostile Indians. They should be gathered in timber-sheltered valley encampments far below, enjoying the warmth of their lodge fires.

THE HUNTER-WARRIORS

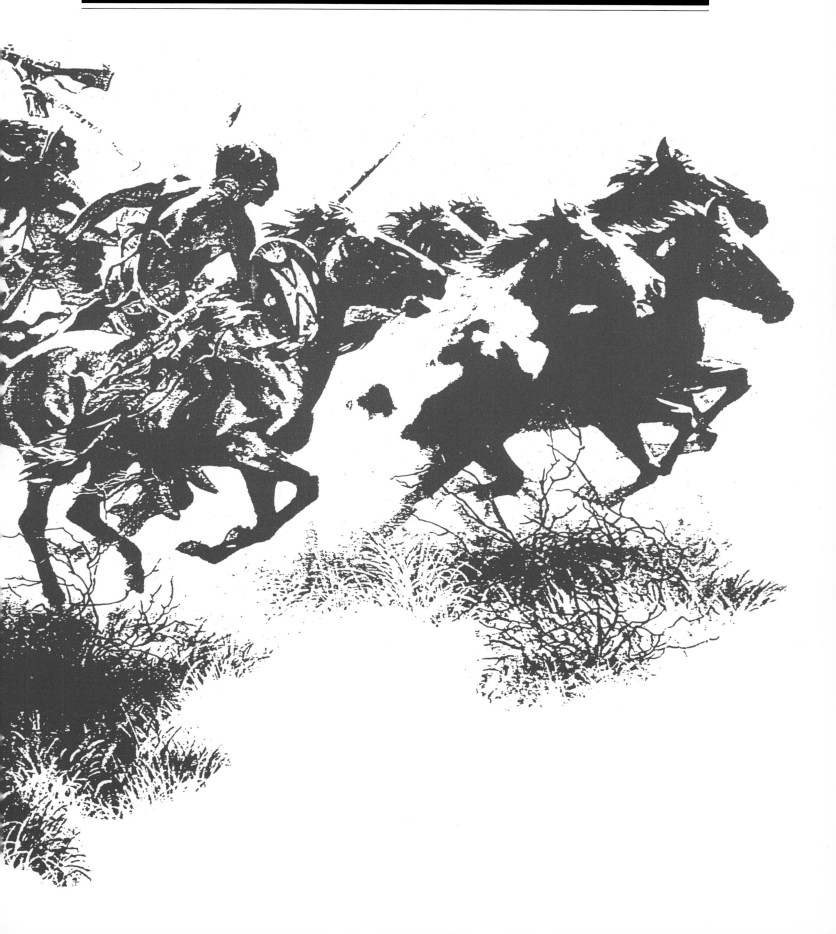

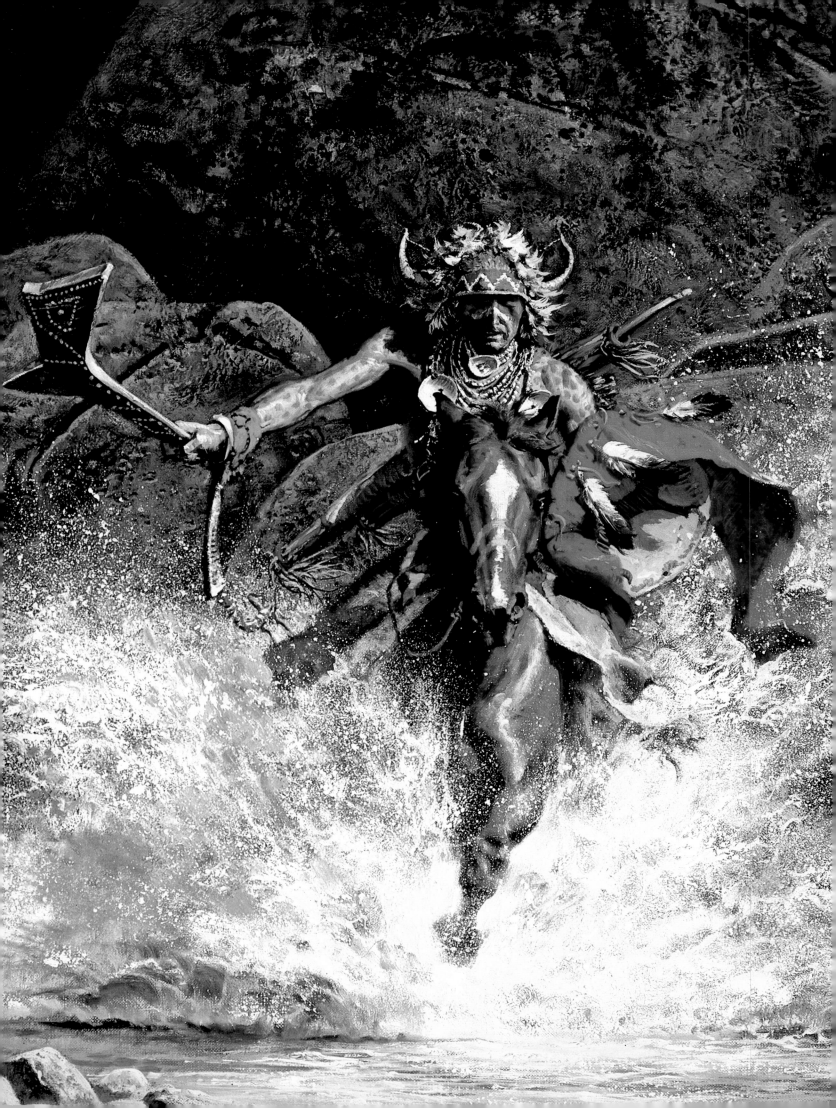

THE HUNTER-WARRIORS: SWIFT RIDERS OF THE PLAINS

For the Plains Indian, life revolved around two primal elements: hunting and war. One meant sustenance for the body, the other, honor to warm the soul.

Some planted crops. Others traded meat, fur robes, and horses to more sedentary planter tribes for foodstuffs their nomadic ways or horsemen's pride would not allow them to plant for themselves. They killed deer, pronghorn antelope, and smaller game for meat when the spirits were generous. But far and away their greatest dependence was upon the largest walking commissary this continent offered: the buffalo.

Whatever he might be called — *Pte* by the Sioux, *Coth-cho* by the Comanche — the buffalo furnished most of life's necessities: meat, robes for winter warmth and for bedding, skins for the outer cover of their tepees, leather for their moccasins and the almost-impenetrable medicine shields that protected them in combat, sinews for sewing, glue for binding together what could not be sewn. Bones made cooking and eating utensils, sewing implements, and the foundation for saddles. Buffalo hair was woven into ropes or used to stuff saddlepads, cradleboards, and whatever else needed cushioning. The Indians threw little away.

During the uncountable generations before they had the horse, hunters stalked the herds on foot, covering themselves with buffalo robes or wolf skins so they could move within arrow range. They drove bison into entrapments. They stampeded them off cliffs and into deep arroyos.

Once they had the horse, hunting became more methodical and the rate of success far higher. Techniques developed that became standard from the northern ranges to the Concho River of Texas. Most tribes had soldier societies to police the chase and ensure that every hunter was granted a fair chance. Though Indians could venture out hunting anytime fresh meat was needed, the biggest organized hunts usually came in fall. Large supplies of meat had to be put away to carry the people through the long, cold time ahead, when they would be confined to their large winter encampments, and game would be scarce.

Most often the hunt would be preceded by a buffalo dance, calling upon the spirits to be generous. If herds were not already known to be grazing nearby, scouts were dispatched to locate them. Families followed the hunters but stayed to the rear and downwind. Though the buffalo's eyesight was poor, its sense of smell was strong.

The soldier society saw to it that hunters remained in formation until a signal was given to rush the herd. Any riders rash enough to hurry ahead risked stampeding the buffalo and spoiling the hunt for others. They were subject to severe punishment by the soldiers. At the very least, they would be publicly shamed, the animals they killed confiscated and given to widows or the old who had no able-bodied man to hunt for them. At worst the offenders might be whipped, their horses killed, themselves banished.

As the line of hunters burst upon the startled bison, the first goal was to set the animals running in a circle, creating what was called a surround. This confined the kill to a limited area, a convenience for the women, who would do the principal butchering. If the buffalo stampeded out of control, the chase went on, but the downed animals might be scattered for hundreds of yards, even for miles.

Most seasoned hunters prized special horses they had trained to move in close so the arrow or lance could be driven accurately. Such mounts learned to respond to the pressure of a knee or a shift in the rider's weight, signaling it to narrow the distance or to dodge away and avoid the angry thrust of a horn.

When the chase was finished, a signal was given for the families to move in and commence the harvest of meat. Sometimes hunters helped, especially on large bulls too heavy for their wives to handle. But for the most part, the butchering was left to women and larger children, who relished a chance to sample the raw hot livers while they carved up the carcasses, wrapping the meat in the fresh hides and loading it onto travois for the trip back to camp.

It was considered proper to thank the Great Spirit for the meat and the buffalo for sacrificing their lives to the needs of the people.

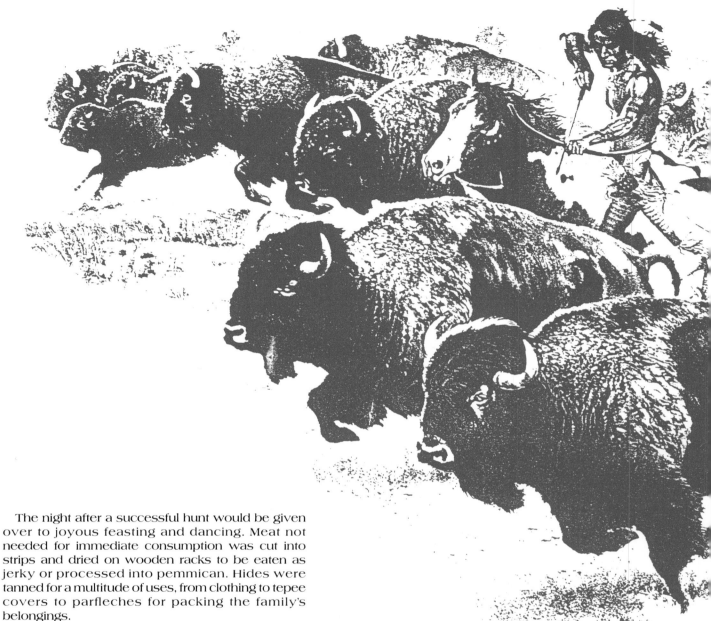

The night after a successful hunt would be given over to joyous feasting and dancing. Meat not needed for immediate consumption was cut into strips and dried on wooden racks to be eaten as jerky or processed into pemmican. Hides were tanned for a multitude of uses, from clothing to tepee covers to parfleches for packing the family's belongings.

From the time a boy was large enough to be placed upon a horse's back and remain without being held, he was training for the two major responsibilities of his life: warfare and the search for meat.

Given a tiny bow, he learned first to hunt birds, rabbits, and squirrels. Starting on a small pony, he learned the essentials of horsemanship. He played at war and hunting with the other boys. These fun games were directed toward a serious purpose: molding the growing youth into a hunter-warrior who could feed his people and outfight their enemies.

When he was considered old enough, he might be assigned to help watch over the grazing horse herd. After proving trustworthy at this task, he might be allowed to accompany mature hunters in pursuit of the buffalo. But before he could venture out on a raid, he was obliged to undergo the most important single rite of passage into manhood: his vision quest.

Though details differed from tribe to tribe, the purpose and general outlines of this solemn occasion were similar wherever the Plains Indians roamed. When a boy was considered ready for his trial of faith and endurance, he was purified in rites conducted by a shaman, or medicine man, then sent out alone to seek guidance of a guardian spirit. In total solitude he repeated designated rituals while he fasted for four days and nights, waiting for a spirit to manifest itself.

The spirit might take the form of a bird or an animal. It might speak to him in human voice, or its message could be as ephemeral as a sighing of the wind. Sometimes the vigil failed and had to be repeated until a vision finally came. When it did, the young man never questioned its reality. Whatever guardian spirit had visited him became his personal totem. In many ways it dictated his actions and attitudes the remainder of his life. Its requirements of him might be incredibly complex, but he lived up to them or risked losing the

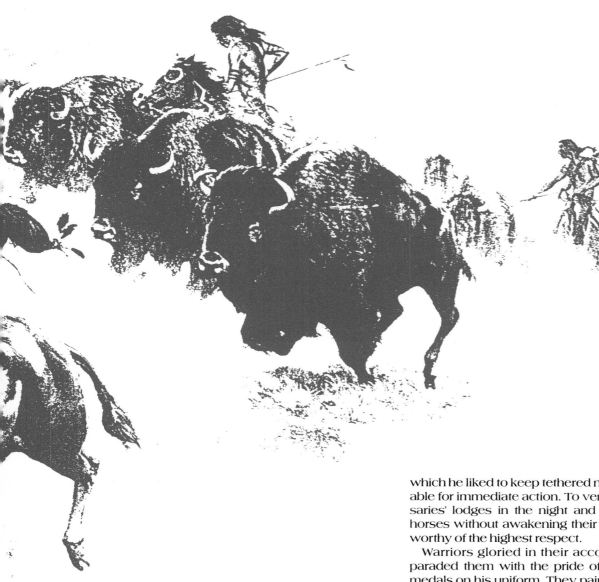

power the spirit had bestowed upon him, his individual medicine. If it carried taboos — and most did — to violate them placed him in peril.

Moreover, it could imperil his family or those who rode with him, even his entire band. Therefore each warrior respected the medicine of his companions and did not expect them to go against it. If a warrior recognized a bad omen or felt that his medicine was not right, he was free to withdraw from a raiding party or a hunt lest his presence jeopardize them all.

Courage was paramount in the warrior code. It was honored most often in the counting of coups, a word derived from early French-Canadian trappers who moved among Indians of the North. It meant literally to strike a blow. To bring down an adversary in hand-to-hand combat, at high risk to oneself, rated higher on the scale of honor than to do it at a distance with arrow or bullet. The first to strike a blow earned the greatest credit, though others might touch the enemy afterward and derive a lesser honor.

Stealth in the presence of great danger counted highly. Every warrior had his favorite war-horse,

which he liked to keep tethered near his lodge, available for immediate action. To venture among adversaries' lodges in the night and make off with the horses without awakening their owners was a feat worthy of the highest respect.

Warriors gloried in their accomplishments and paraded them with the pride of a soldier wearing medals on his uniform. They painted their own bodies and those of their horses with the symbols of their deeds. Scars from war wounds were badges of honor, often accentuated by paint or tattoos to make them more visible. Stripes daubed on a warrior's arms and legs denoted coups he had taken. Horse tracks painted on a war-horse signified successful horse raids. A red hand on the horse denoted that its rider had fought in hand-to-hand combat.

Only in the hunt and in warfare could a young man hope to be elevated in the eyes of his people. Even when offered a chance for peace, sometimes a tribe would turn it down. How else except in war, they asked, could their youths prove themselves? How else could a boy become a man?

Raiding for horses was something of a game, though frequently a deadly one. A raid by one tribe called for retaliation by the victims, to be followed by another foray and another, generating blood debts and animosities that continued generation after generation.

Too late would the many tribes recognize that they had a greater enemy than one another. *Much* too late would many join forces for their mutual defense.

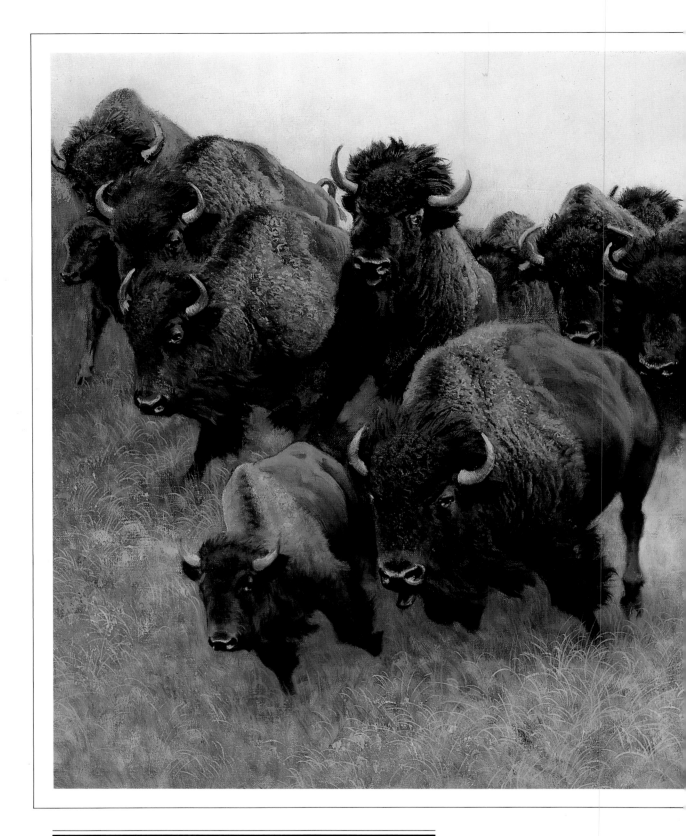

THE BUFFALO RUNNERS

The buffalo was the staff of life for Plains Indians, who developed a fairly universal system for group hunting, well organized and policed by soldier societies for fairness. The ideal, not always attained, was a "surround," running buffalo in a circle until hunters had all the meat they needed.

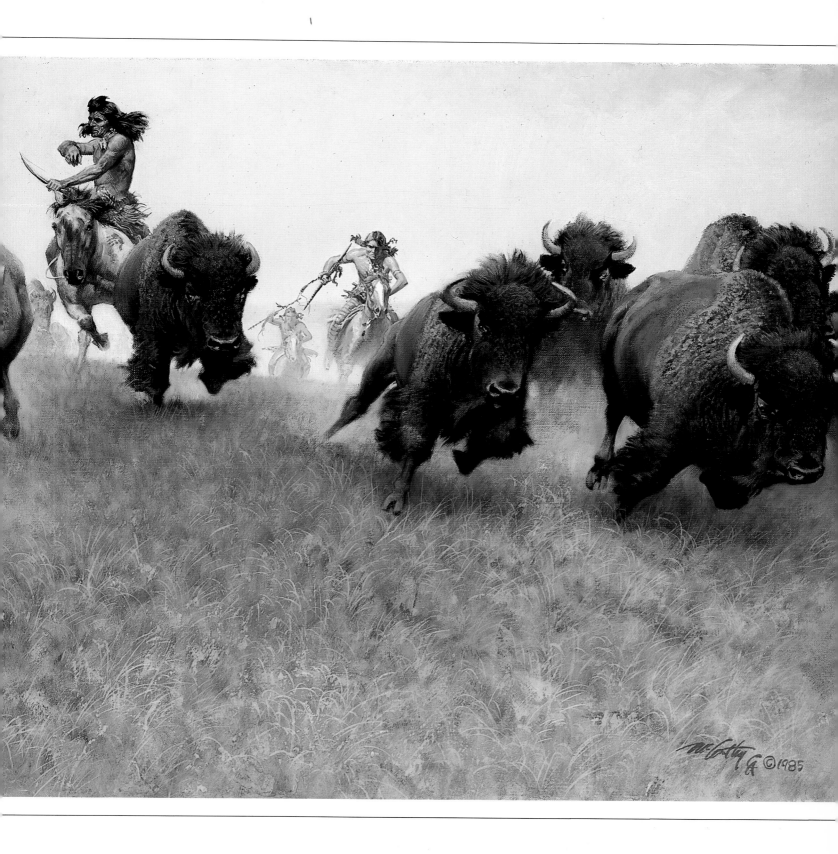

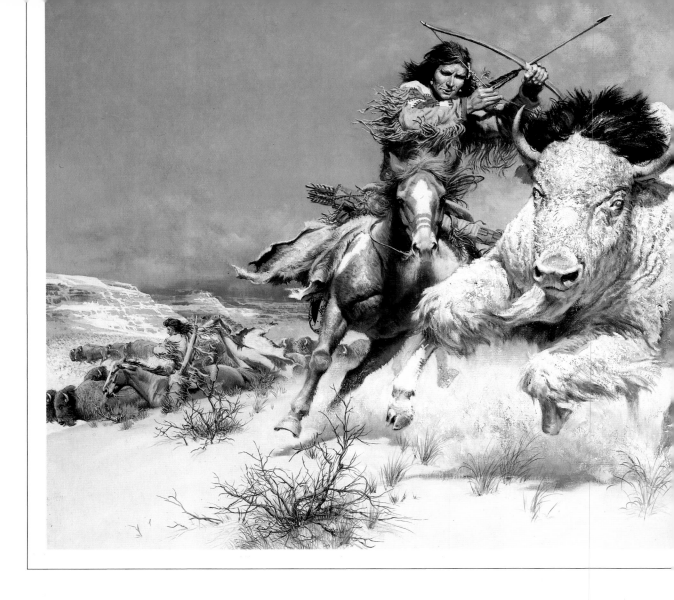
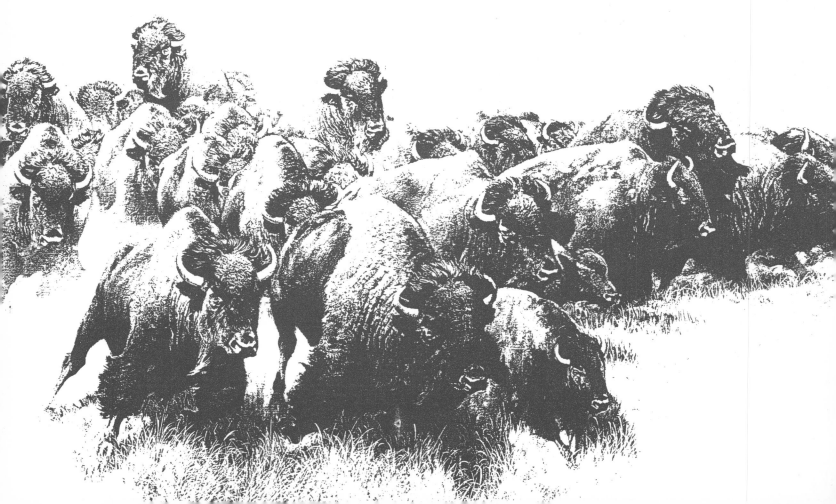

BIG MEDICINE

As white as the snow upon which it flees, this rare buffalo is pursued by Sioux hunters, intent on acquiring its hide for spiritual powers. Hide traders' records indicate that a white bison occurred only once in five million. That it fascinated the Indians is little wonder.

CHANCE OF THE HUNT

The Indian method of running buffalo was exhilarating but hazardous. A buffalo might suddenly turn under a horse, toppling it and the rider. Even if the hunter survived the fall without broken bones, he was on foot and in jeopardy of being trampled by panicked animals or gored by a wounded and enraged buffalo.

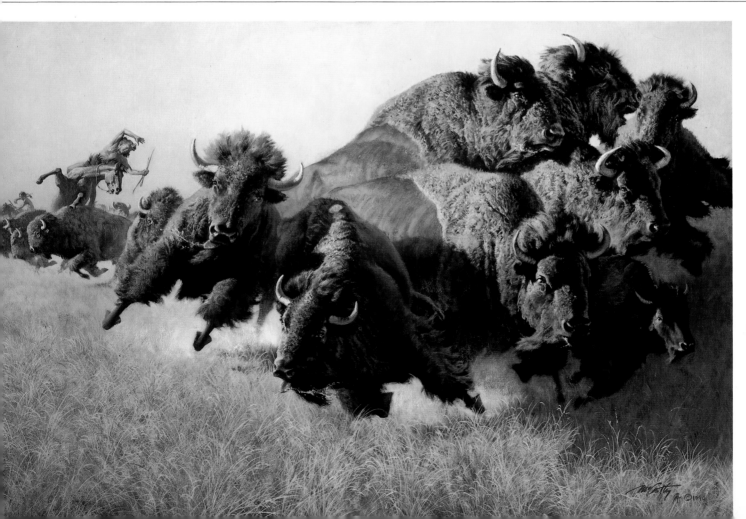

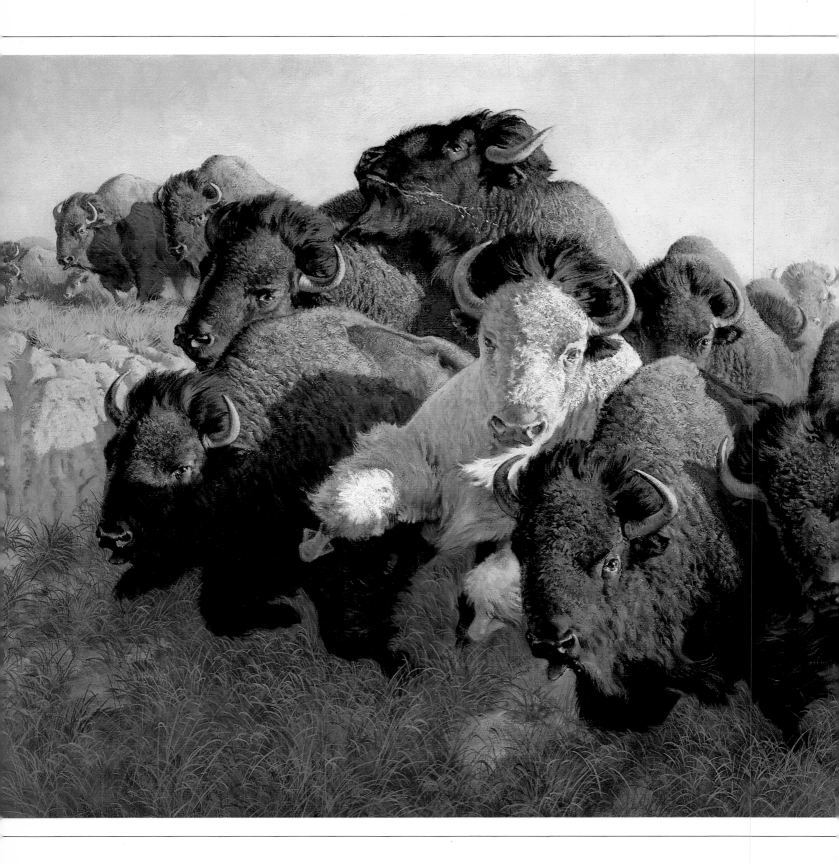

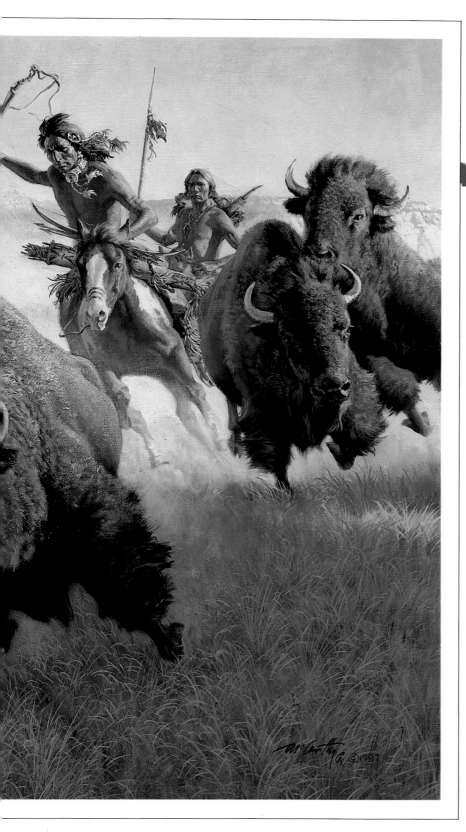

IN PURSUIT OF
THE WHITE BUFFALO

Sioux hunters continued their pursuit of a rare white buffalo, its robe considered big medicine to be passed reverently from generation to generation. It seemed to many that the animal was sheltered by the rest of the herd, as if the others had an instinctive sense that its color difference made it somehow special.

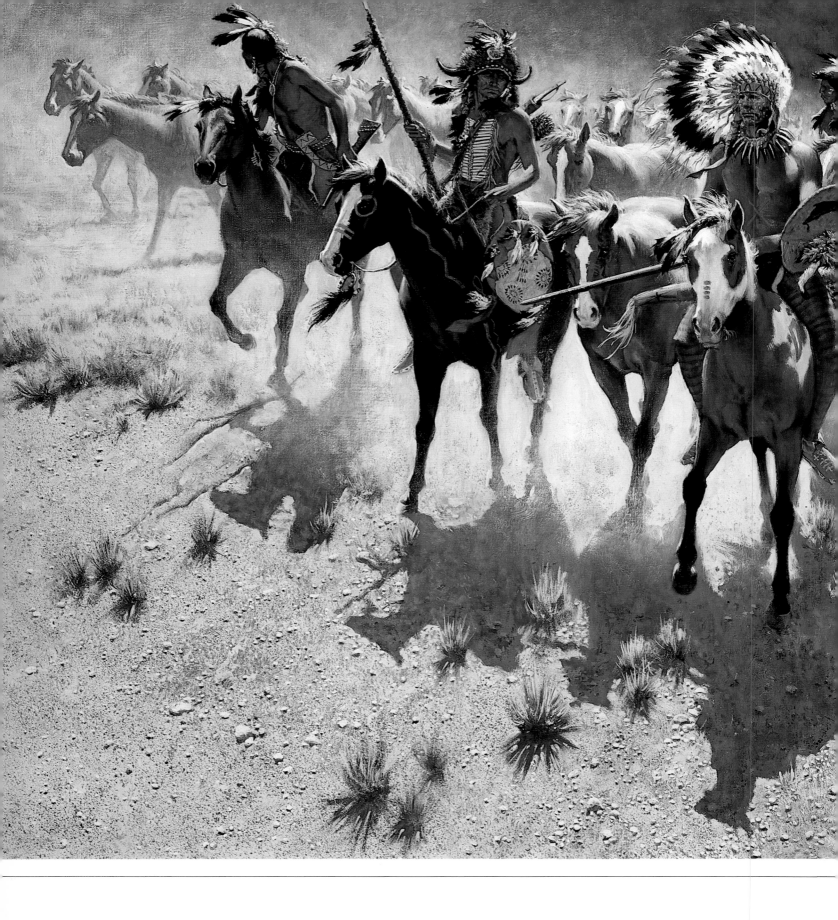

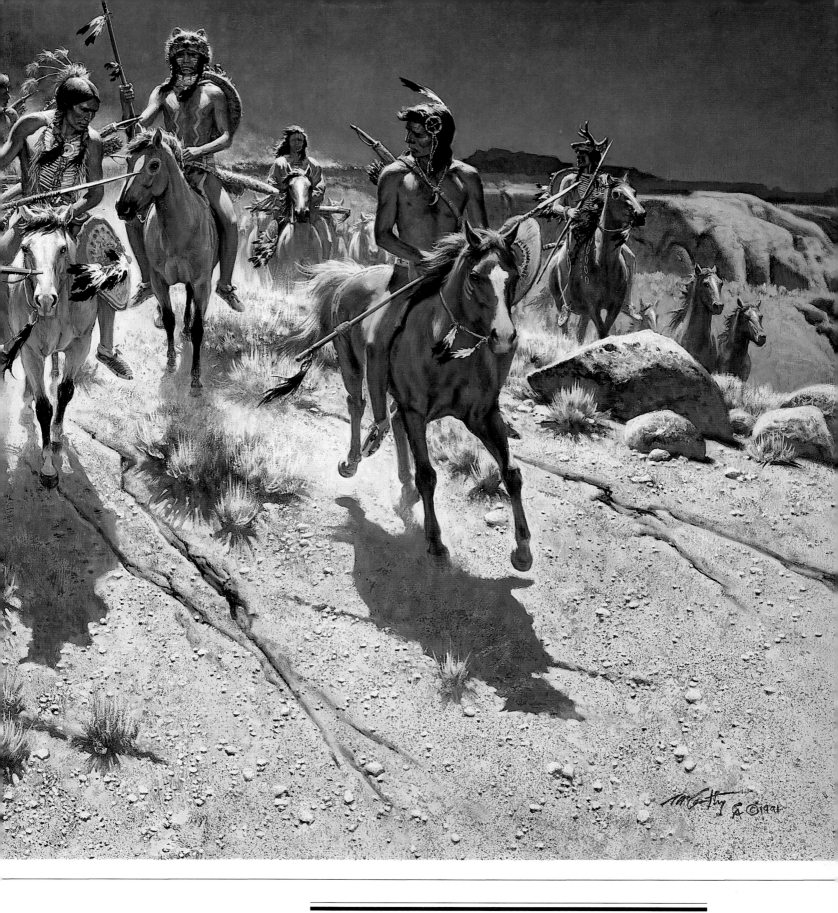

BREAKING THE MOONLIT SILENCE

A fire blazing on the skyline behind them tells that these Sioux warriors have been successful in a raid that has cost a ranch or stage station dearly. Making their escape in the bright moonlight with a band of stolen horses, they will be miles away before any effective pursuit can be mounted at daylight.

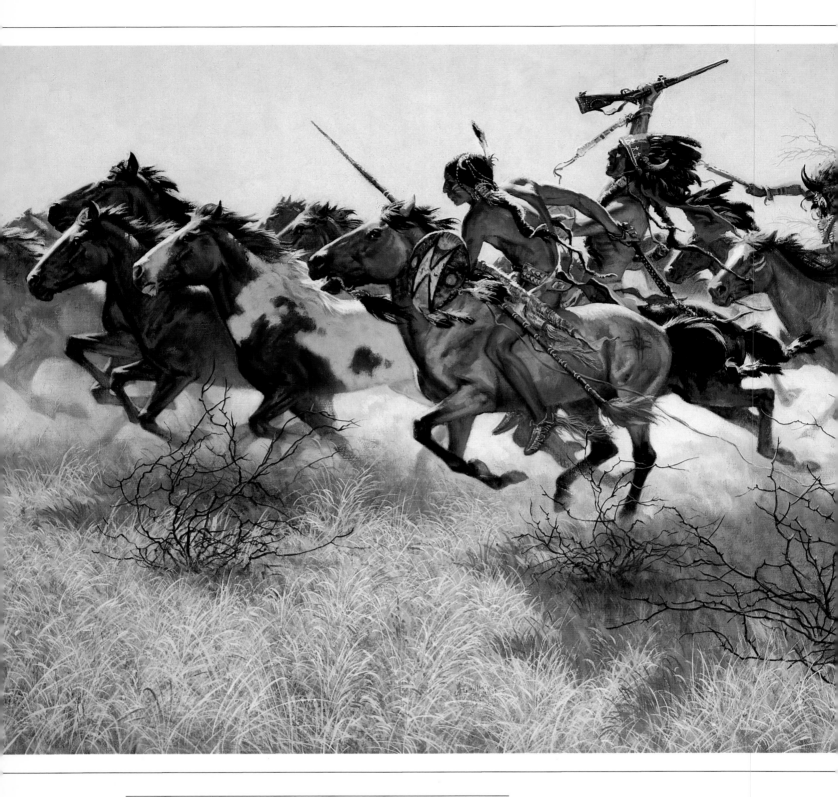

COMANCHERIA

Stealing horses from enemy tribes or from whites was a favored means for warriors to demonstrate their bravery, as well as add to their personal wealth. Indian eyes saw such theft not as a crime but as an honorable undertaking. The greater the risk, the louder the cheers raised for the victors.

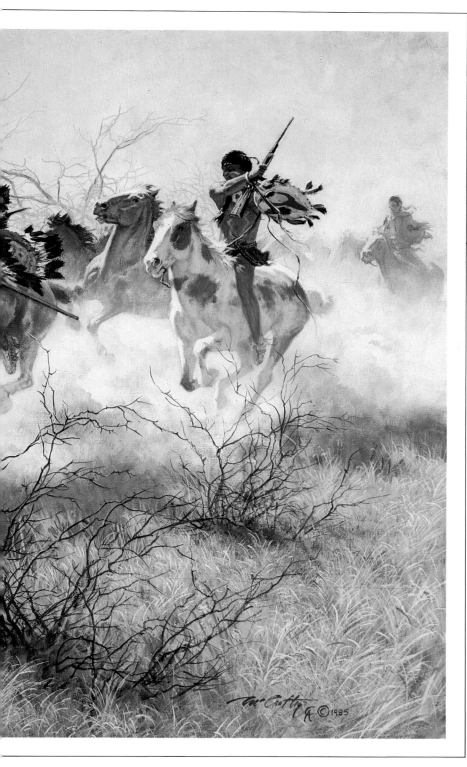

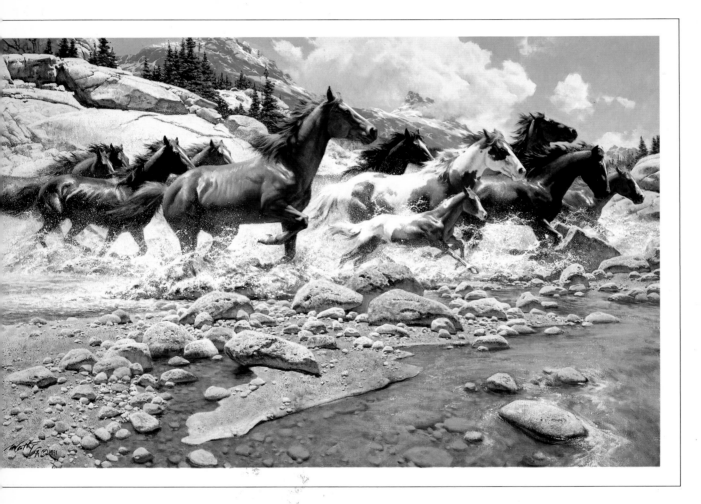

THE WILD ONES

Wild horses splash across a Montana mountain stream, running for the sheer joy of it. Most wild herds descended from Spanish animals, strayed, stolen, or traded, sometimes with infusions of Eastern blood from larger stock. Natural selection in a rugged environment let the strong survive and multiply.

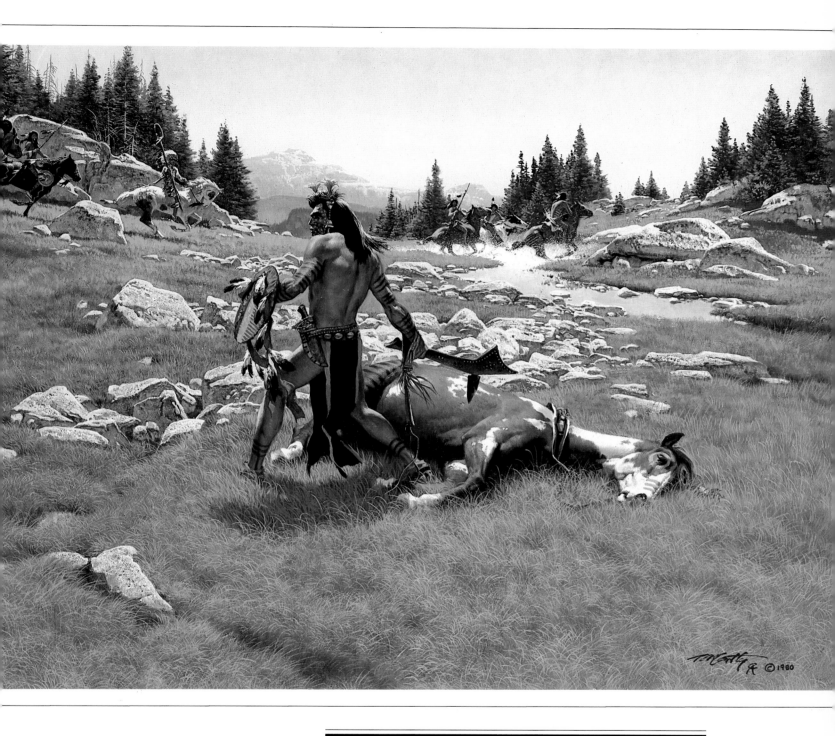

SURROUNDED

His horse down, his arrows used up, a surrounded Crow warrior turns to face the enemy Sioux. His colorful medicine shield over his left arm, he brandishes a war club in his right hand, silently signaling that he expects his foes to come at him in hand-to-hand combat, which will lend honor to them all.

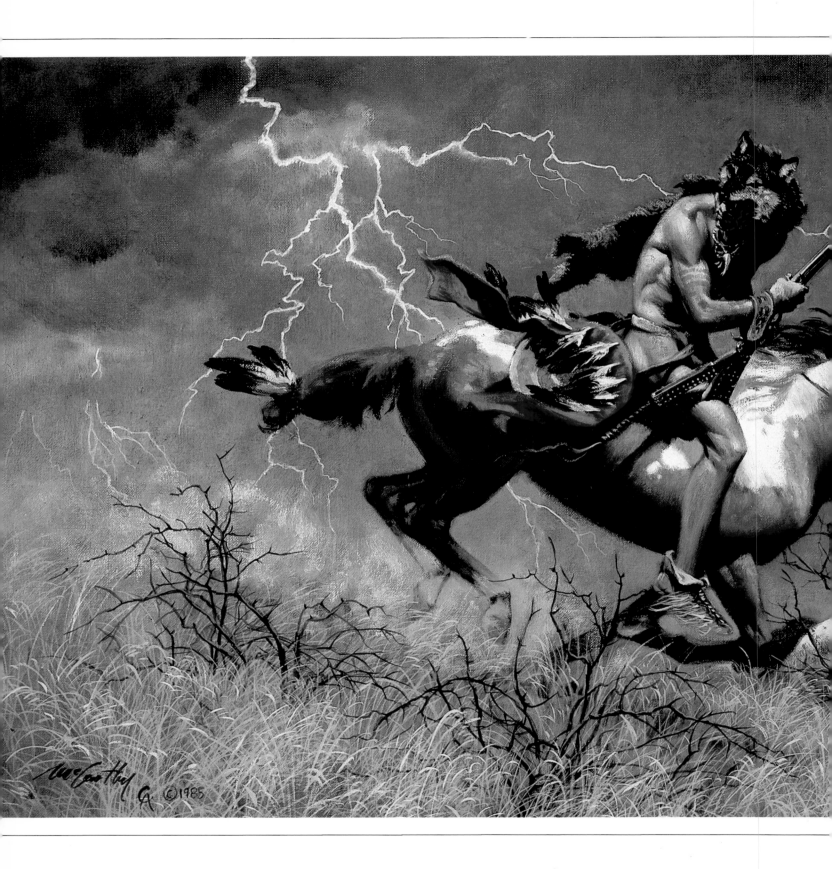

WHEN OMENS TURN BAD

A Comanche war chief turns his raiding party back toward camp after encountering what his dreams have told him is a bad omen, a violent storm that sets the night sky on fire. Brave warriors who would not flinch before a human enemy were often awed by thunder and lightning, a force they could not control.

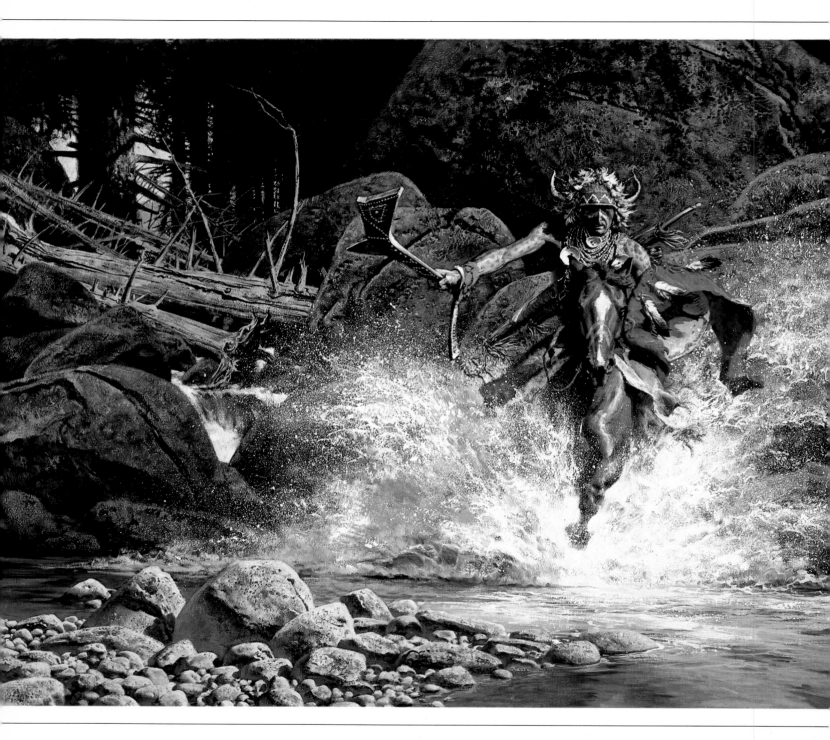

WHIRLING, HE RACED TO MEET THE CHALLENGE

A sight to make the blood run cold, a resplendent Blackfeet warrior swings a deadly war club and dashes his war pony into a boulder-strewn creek to meet his enemy head-on. The fight will be hand-to-hand, as befits a man whose existence has centered around warfare and to whom honor means more than life.

CHARGING THE CHALLENGER ▶

Carrying a fur-wrapped lance, dangling the scalp of a past adversary, a Northern Plains warrior charges across a disputed creek to battle a challenger. He carries into this fight his personal medicine, given him in a long-ago vision quest by some guardian spirit, symbolized in the painting on his war shield.

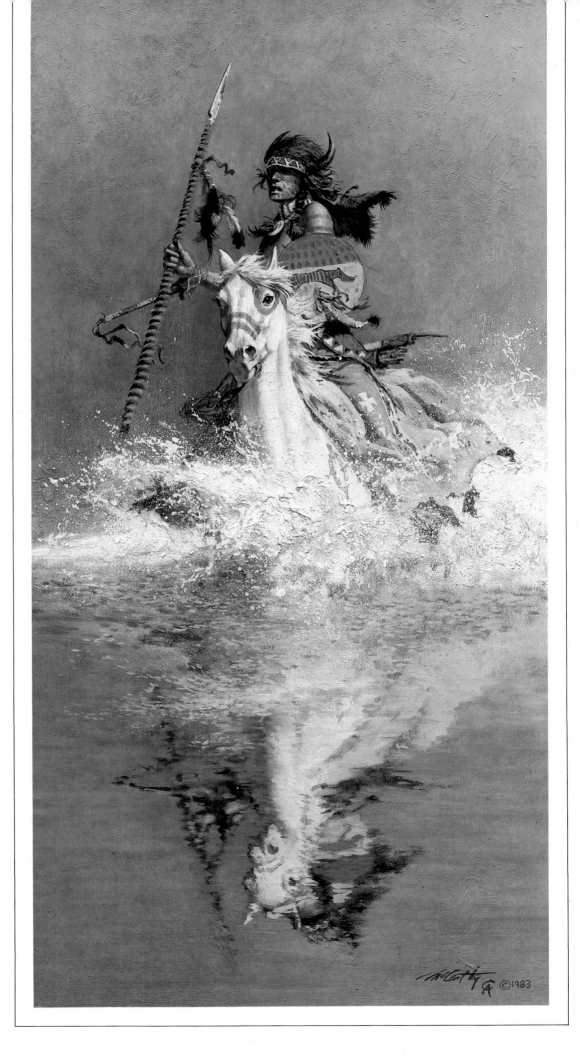

THE CAVALRY

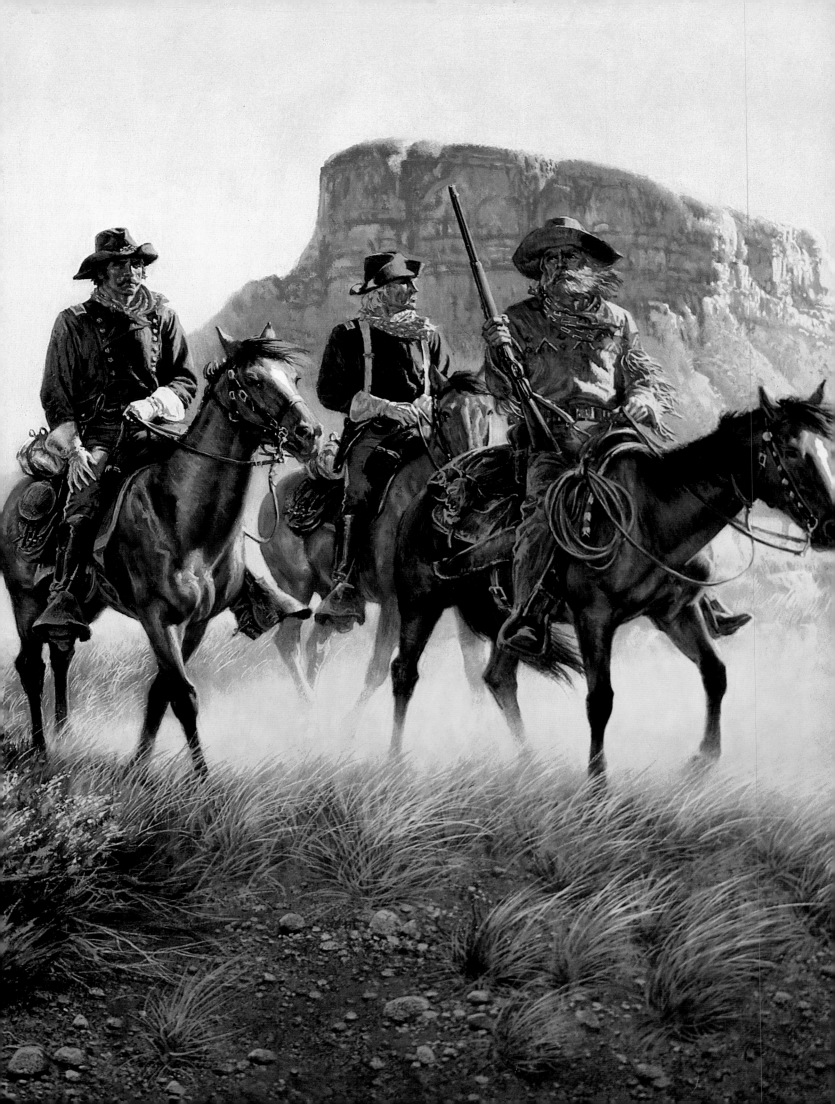

THE CAVALRY:
ON BEANS AND HAY

"Forty miles a day on beans and hay," the frontier cavalrymen used to sing. In the main, theirs was a harsh, thankless life: long days and weeks of drudgery and hardship, interrupted by occasional bursts of action. If a soldier were lucky, he might enjoy a few moments of glory in a long career. If unlucky, he might be buried on a lonely prairie without so much as a headstone to mark his place of rest.

The cavalry on the Western frontier traced its origins to the First Dragoons, established in 1833. It fought in the Mexican War. It protected forty-niners traveling overland to the California goldfields and immigrant wagon trains bound for Oregon.

After Appomattox a war-weary Congress slashed the size of the army, leaving posts undermanned, their units too thinly spread for the peacekeeping mission they were assigned. But underpaid, underappreciated officers and men did their best, against heavy odds, to bring Indian troubles to an end.

With few exceptions, Western forts were roughly built of natural materials close at hand — adobe, stone, logs, or pickets, the gaps plastered with mud. Buildings were drafty and cold or stifling and hot. It was said that poor food and bad water killed more soldiers than Indians did.

For a private soldier, the pay was thirteen dollars a month in paper money, discounted when he spent it at the sutler's store, or in the rowdy whiskey villages and "hog ranches" that always seemed to spring up like a pestilence just beyond the post commander's jurisdiction.

Officers lived only marginally better than the enlisted men. On the march they shared their troops' discomforts. A frontier army wife described the existence as "glittering misery," its military pomp and ceremony offset by dirt, mud, pain, and privation.

As if to add insult to injury, the soldiers were held in low regard by many of the citizens they were sent to protect. In Texas, where the army battled fierce Comanches and Kiowas, most residents were ex-Confederates who resented the troopers, viewing them as Yankee invaders. Even in Western states loyal to the Union, the general public often derided them as misfits and ne'er-do-wells who had joined the army as a last resort. They hooted when a cavalry troop came in empty-handed after an Indian chase but were quick to call upon the soldiers when they saw or imagined they saw a feather.

Given the hardships, and lack of support by both the public and a penny-pinching Congress, the army of the West accomplished an amazing feat in the twenty or so years between the end of the Civil War and the closing of the Indian wars. Though there is ample cause to question the rightness of its assignment — the subjugation of the native Americans and their confinement to soul-killing reservations — the army faithfully carried out that mission against formidable odds.

In the early years, most officers and noncommissioned soldiers were veterans of combat in the Civil War. This was a mixed blessing because the challenge they faced on the frontier was much different, the enemy's fighting style a far cry from that of the Confederate army. It took many officers years to understand the Indian's approach to warfare, and some never did.

There were no fixed battle lines, no front and no rear. To the Plains Indian, war was a way of life, with no beginning and no end. Rarely did he ride into a battle bent on total extermination of his adversaries. In a strong sense, he looked upon war as a blood sport, a rough game played for glory and honor. When he had fought a good fight and decided he had won enough honor for the day, he was likely to withdraw and celebrate, letting some, or even all, of his enemies survive to fight him again.

The Indian did not share the white man's dogged determination for full and final victory. If he annihilated all his enemies, who would be left for him to fight? How could the young men prove themselves in the eyes of their people if not through combat? The Indian was often confused and dismayed when the soldiers continued to press him relentlessly, even after winning a good victory, or after being badly battered by the warriors' hit-and-run, slash-and-burn tactics.

Who were these blue-clad horsemen who persevered despite the danger, the suffering, the public ingratitude?

The officers were mostly graduates of West Point, established by President Thomas Jefferson in 1802 to educate the army's leadership in engineering and science, as well as military tactics. A notable exception to the West Point tradition was General Nelson A. Miles. He stood proud for having fought his way up through the ranks, sometimes subjecting troops and Indians to unnecessarily harsh treatment to prove that he was as good as any graduate of the Point and better than most.

In the army's severe downsizing after the war, most officers had to accept a drastic demotion from their temporary brevet ranks. Some who had commanded as generals gave up their stars to wear the insignia of captains and majors. The scrambling and fevered competition to hold any place at all led to rivalries and feuds that could be detrimental to operations. Sometimes good field officers were overruled by superiors whose rank was of higher order than their judgment. That they managed as well as they did was a tribute to their courage and determination to serve, regardless of their own feelings and the personal cost.

The enlisted men were a varied lot. Some were young fellows who fancied the West as a place of romance, adventure, and glory. Here and there might be found a former cadet who did not make the grade at West Point but hoped to fight his way up through the ranks as Miles had done. Hard times, such as, the money panic of 1873, brought a rush of unemployed seeking any job they could find that would feed and clothe them.

A significant percentage of enlisted personnel were immigrants — Irish in particular, Germans, French, and English as well — some of them veterans of service in European armies and already at home in the military life. There were ex-Confederate soldiers who found nothing left for them in the war-battered South. And, of course, there were men who enlisted under assumed names and to whom the army was a refuge from the law, from debts, or from family troubles.

Seldom did reality live up to the promises of the recruitment officers. Often the soldiers found themselves carrying picks, shovels, trowels, and hammers as much as or more than rifles, building new posts to which they were assigned, renovating older ones because the money-short army chose not to pay the higher wages of civilian artisans.

Much ammunition issued in the West was years old, surplus from the war, and misfired when sol-

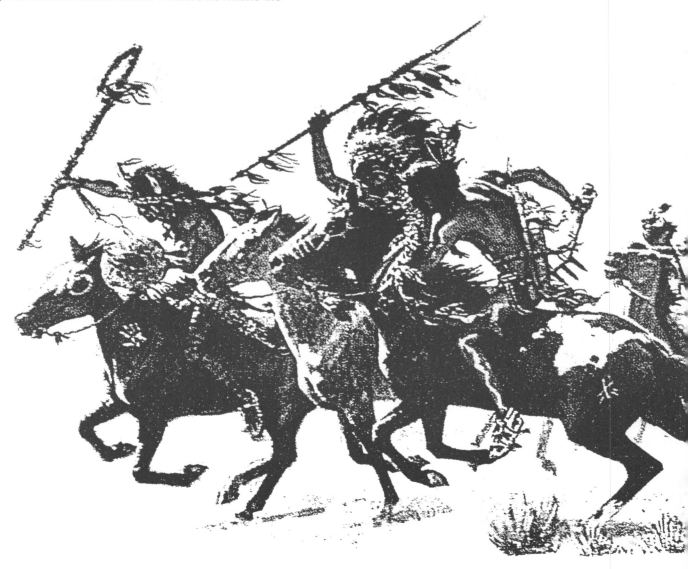

diers needed it most. Its scarcity and price made the army frugal in its use. Some frontier troops were obliged to do their target practice with empty rifles because their officers would have to pay for the ammunition out of their own pockets. The first shot some enlistees ever fired was in a fight with Indians.

Moreover, the Indians sometimes faced them with better rifles than those the army issued.

Nevertheless, most soldiers welcomed the opportunity to go on an extended campaign because it carried them away from the manual labor, the monotony, the tiresome garrison drills. It offered them at least a chance for action and excitement. And occasionally they got it, for the hostiles' young men were always eager to demonstrate their valor. They loved nothing better than to rush a soldier encampment at night, shouting, waving blankets or buffalo robes, driving off as many horses as they could stampede.

Often they dogged a column, watching for a chance to pick off stragglers, to hit supply wagons that lagged behind the main body. They could strike like a whirlwind and be gone in moments. They had the advantage of knowing the land, its hiding places, its water holes. They knew where they could lose their tracks and disappear like wisps of smoke.

For this reason, the army on the march usually took along civilian scouts, who presumably knew the country almost as well as the Indians. Some were veteran mountain men who had trapped and hunted over it and had learned to know not only the terrain but also the ways of the native people who lived on it.

Often, too, the army used trusted Indian scouts, usually of a tribe hostile to the one the soldiers sought. Crows, Shoshonis, and Pawnees in particular often allied themselves to the whites to fight traditional enemies, such as, the Sioux, the Cheyennes, the Arapahoes. Tonkawas and Seminole-Negro scouts were especially efficient in tracking down Comanches and Kiowas on the lower plains.

General George Crook believed it took an Apache to catch an Apache, and he used intratribal enmities to set scouts of one band against hostiles of another.

Ironically, many officers and men saw the Indian side and sympathized with their foe, even as they carried out orders from a higher authority which did not share that sympathy. Some of the better officers, such as, Crook and Ranald Mackenzie, took no pleasure in killing Indians and made an effort to limit Indian casualties, though they did what they had to do to bring them under the power of the United States government.

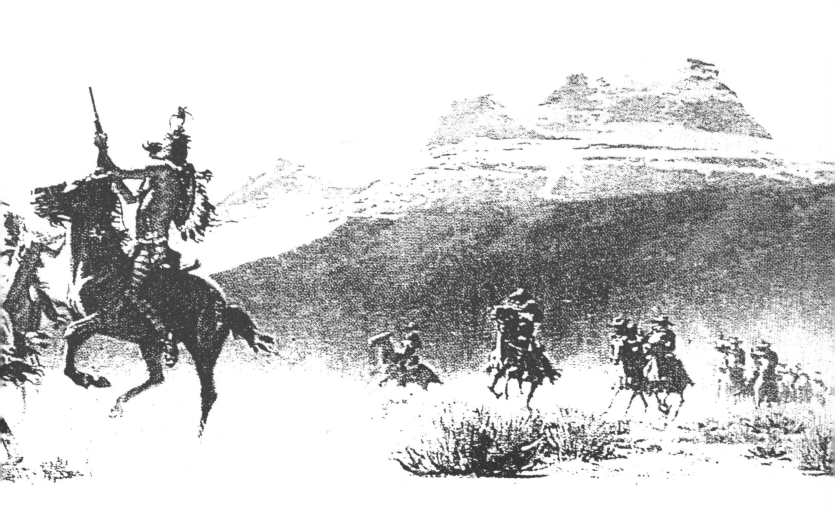

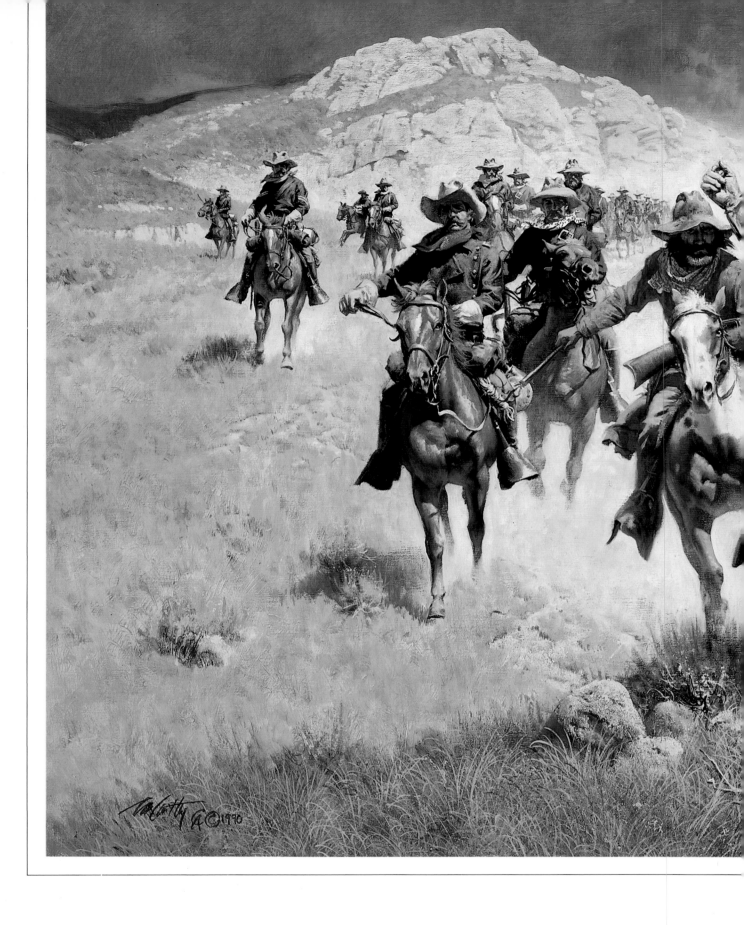

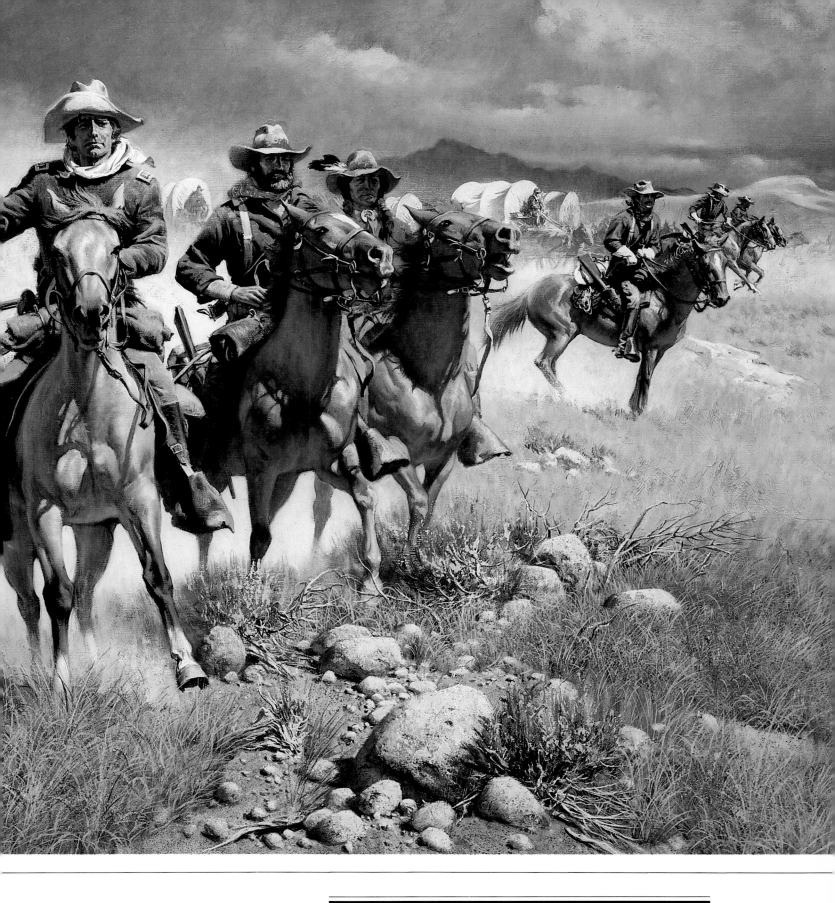

IN SEARCH OF THE HOSTILES

A cavalry unit traverses the plains, its supply wagons indicating a lengthy campaign. Two scouts, one white and one Indian, ride behind the officer. The army at times depended heavily upon both, the white because presumably he knew the country better than the soldiers did, the Indian because he knew other Indians.

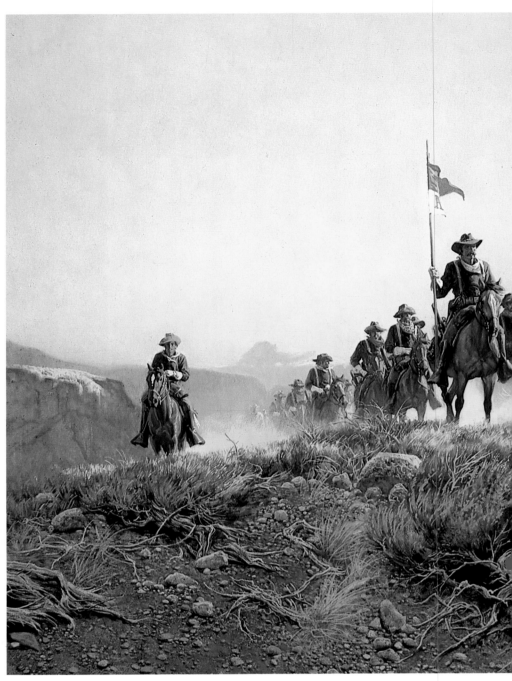

A CROOKED TRAIL —
ARIZONA, 1885

Dressed in buckskins, a civilian scout points the way for a cavalry troop, raising a golden pall of dust as it treks through the sparsely grassed sagebrush desert. For ferreting out the wary Apache in his own homeland, however, the army found white scouts less effective than the Indian scouts it recruited.

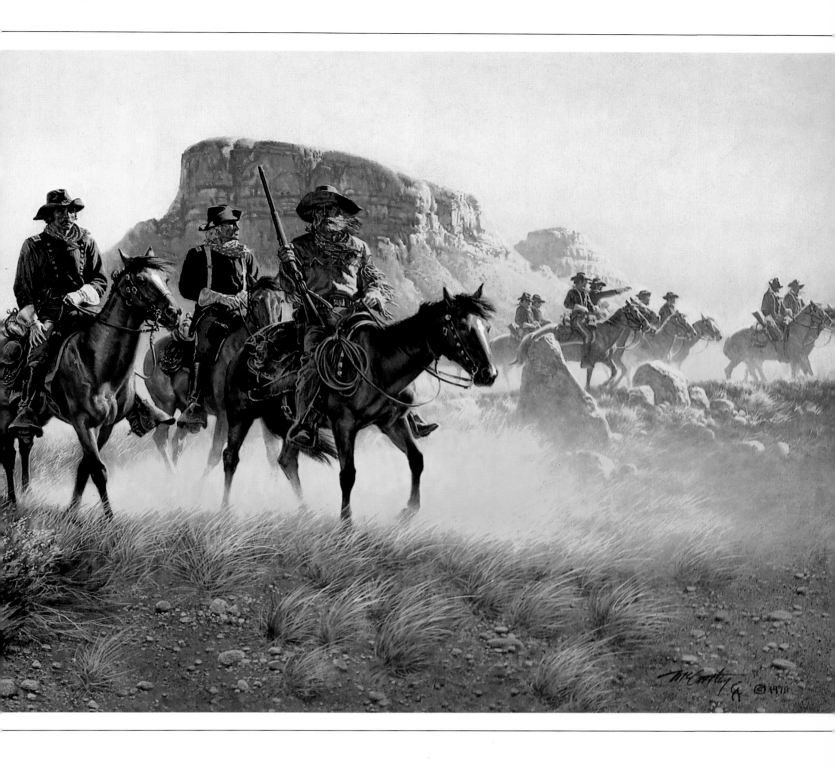

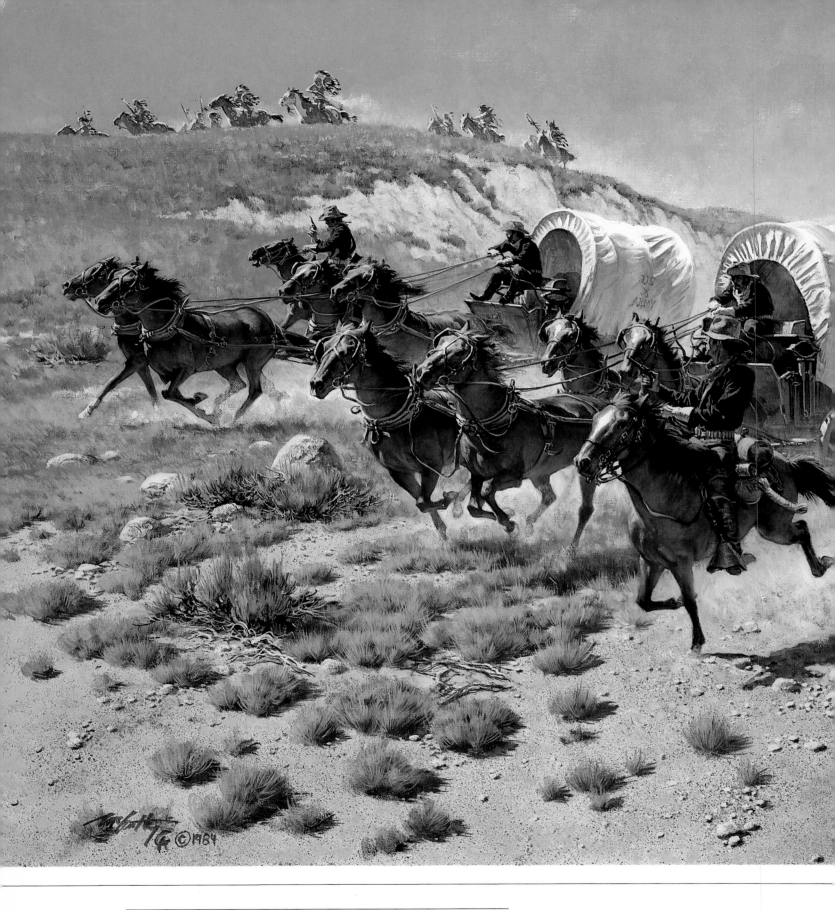

HOSTILES ON THE EAST RIDGE

Supply wagons and their cavalry escort fall into a running skirmish
with raiders suddenly swarming in from their right. Such attacks
were most often hit-and-run, meant to harass. If lucky, the warriors
might get away with some horses or add to their reputations by
counting coup on an unlucky soldier.

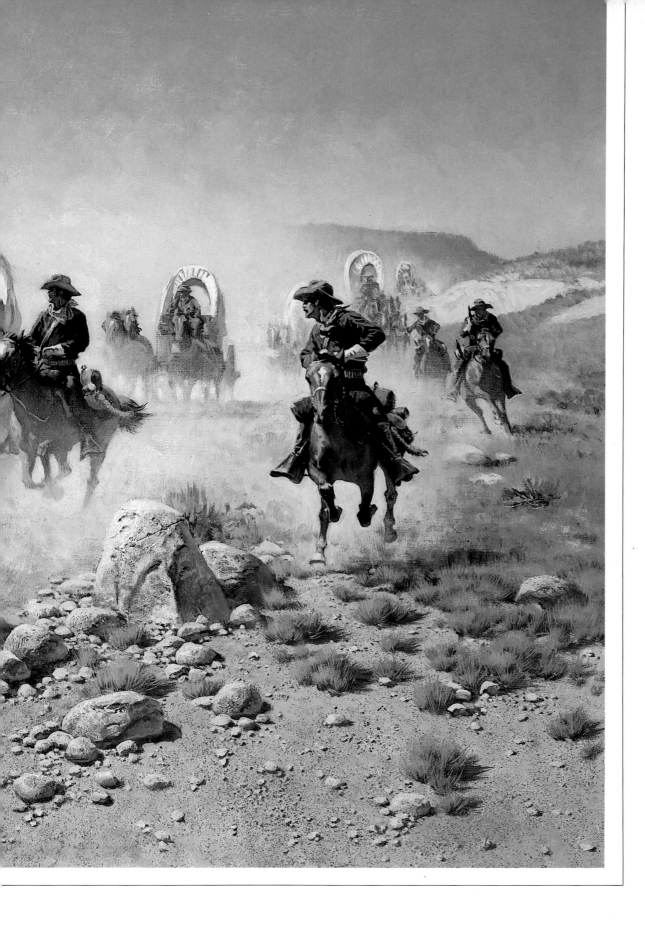

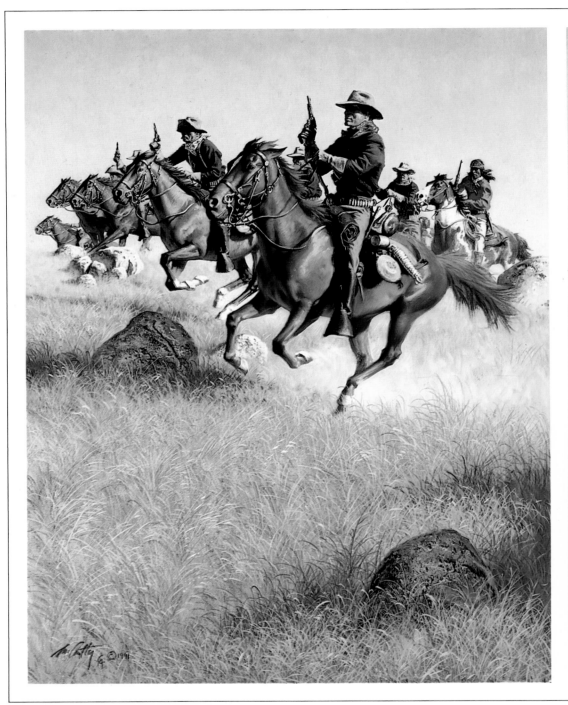

CAVALRY CHARGE IN ARIZONA TERRITORY

Spurring hard, pistols drawn for close combat, a cavalry troop answers the call for attack. Ideally a cavalry charge should hold a straight line, but on broken ground, skirting rocks half hidden by the short grass, horses become separated. An Apache scout rides near the left, helping the army corral his kin.

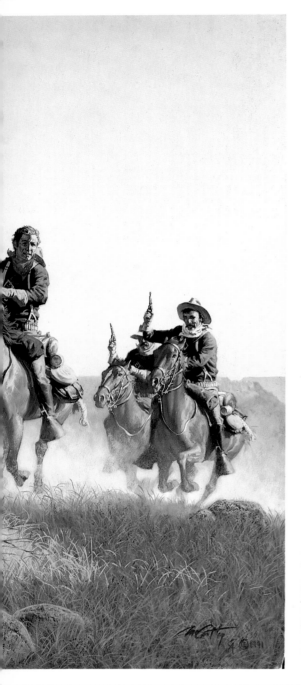
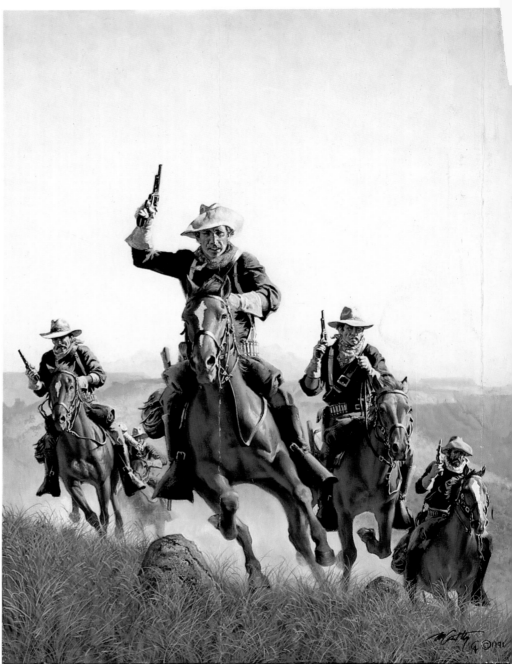

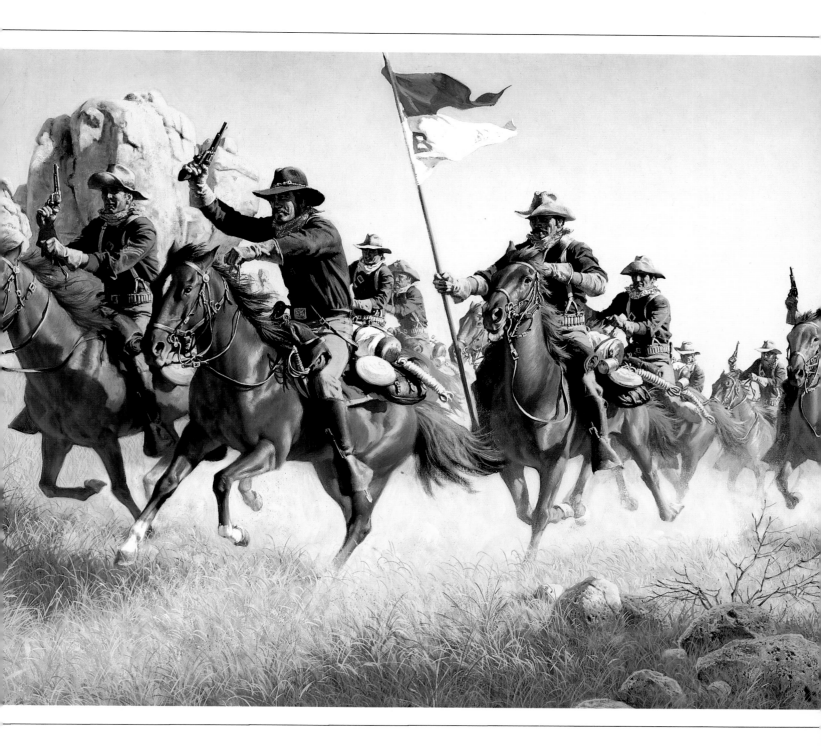

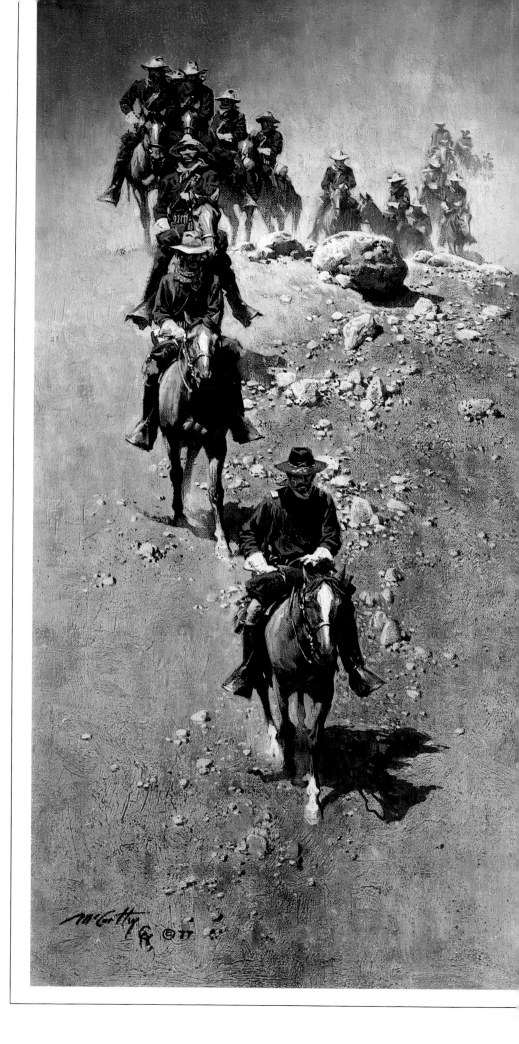

SINGLE FILE

In the bluish light of a full moon, a cavalry troop force marches to place itself closer to the hostiles by daylight. More than once in frontier campaigns, army units slipped out of camp in darkness and eluded Indian spies. Thus did Colonel Ranald Mackenzie surprise and rout a winter encampment in Texas's Palo Duro Canyon.

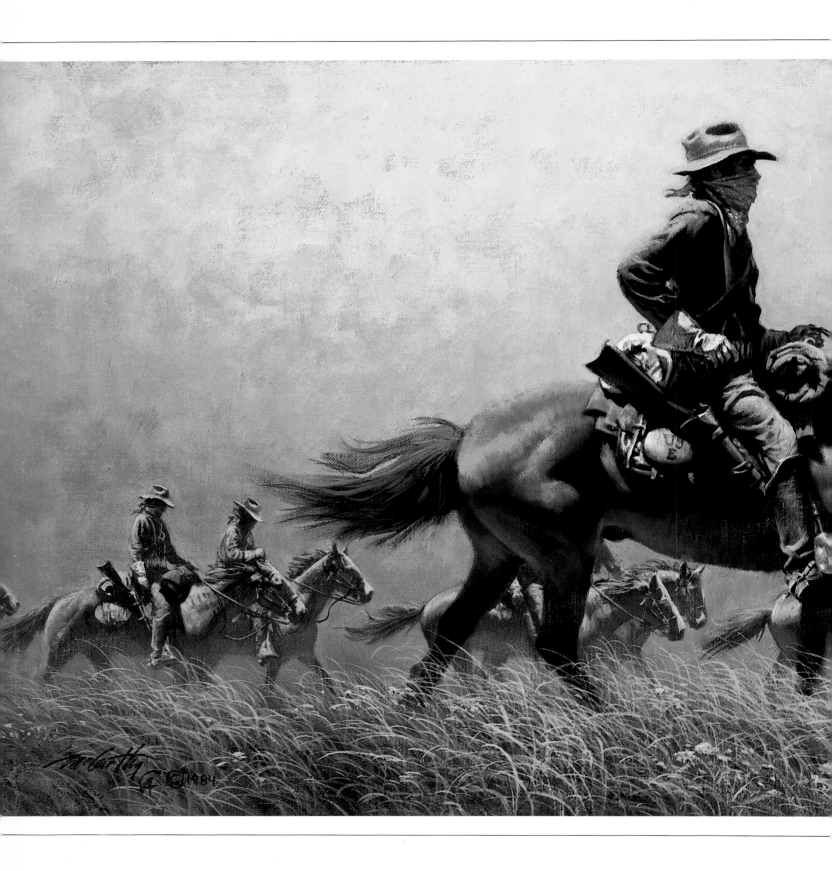

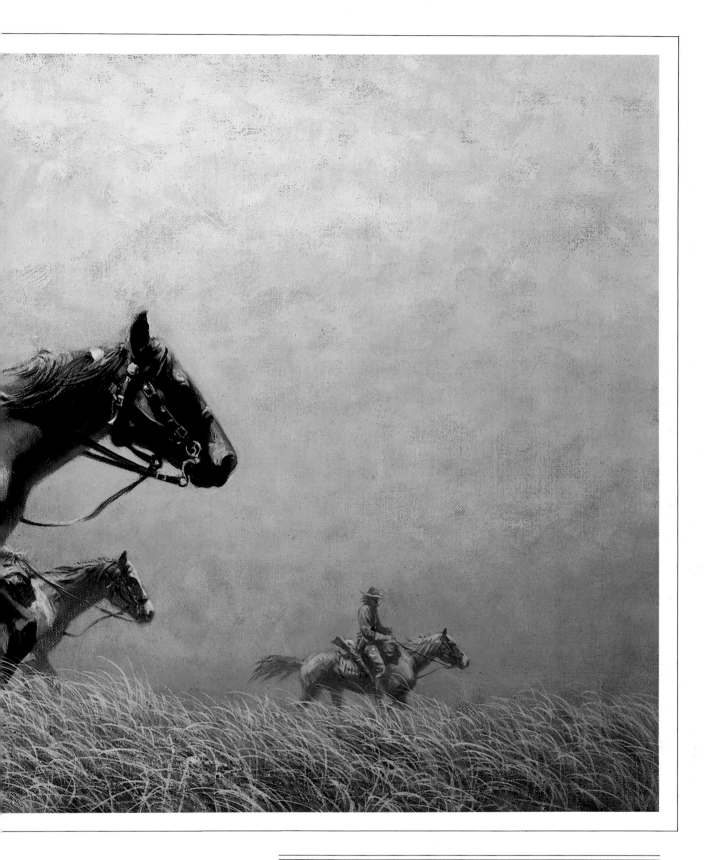

AFTER THE DUST STORM

A raging dust storm has forced the flankers in close to the rest of the cavalry column. Normally they would ride farther out, guarding against surprise, but in the dust's poor visibility they must reduce the distance or risk becoming lost. They can hope the Indians don't like the storm either and will not attack.

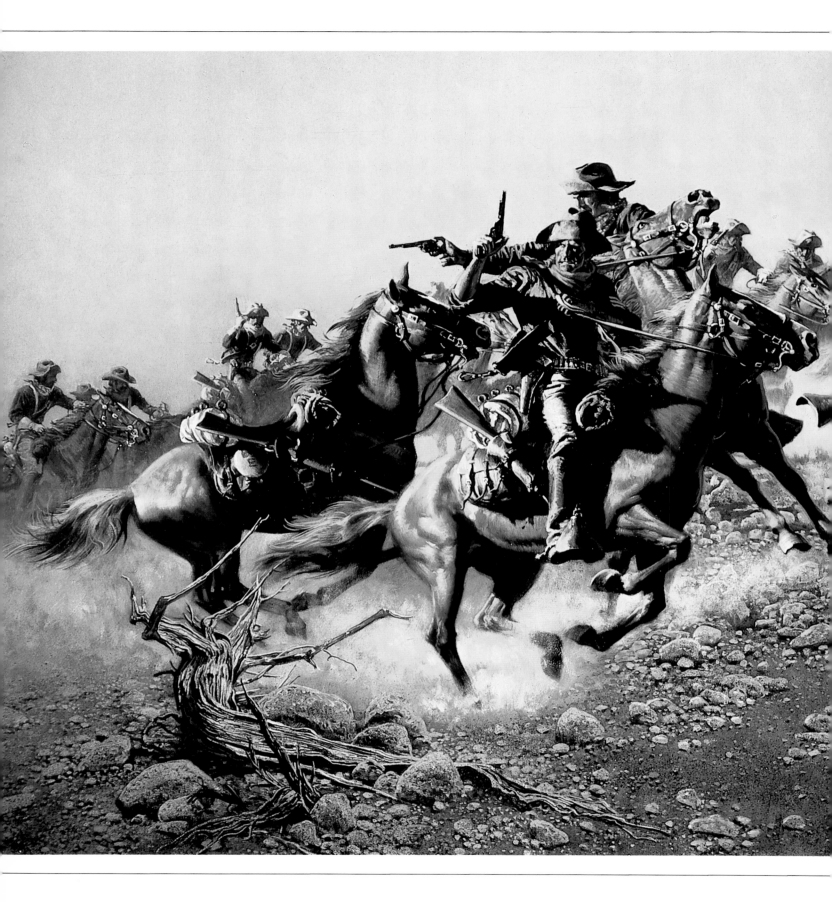

UNDER HOSTILE FIRE

Retreating under heavy hostile fire, cavalrymen fight a running skirmish while they attempt to reach a larger force or at least a defensible position. They have taken casualties, for two horses are riderless, one cutting across in panic. Cavalry mounts' response to gunfire was unpredictable and sometimes dangerous.

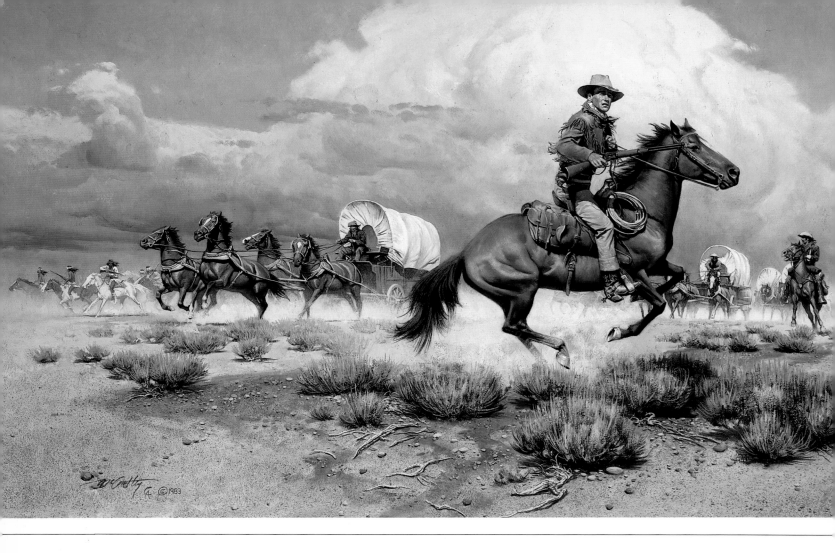

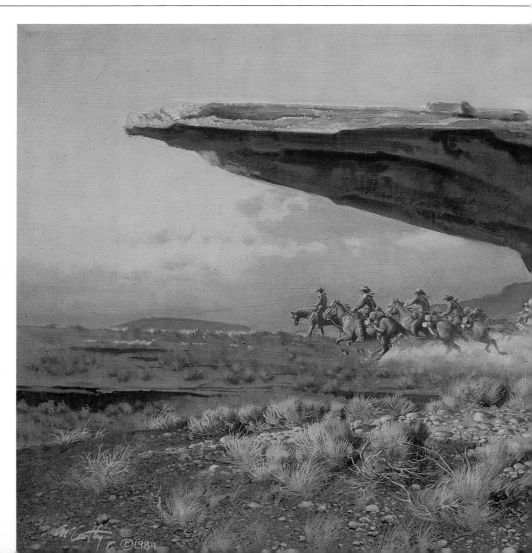

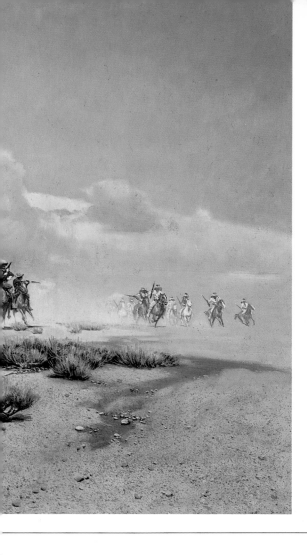

UNDER ATTACK

One of the rare Frank McCarthy paintings that portrays a specific person, this work features John Wayne in his motion picture role as Hondo Lane, leading civilian settlers and a cavalry escort through a gauntlet of Apache warriors. To millions, Wayne was an icon, a symbol of the Western pioneer spirit.

SCOUTING THE LONG KNIVES

Concealed behind an anvil-shaped remnant of an ancient red sandstone formation, an Apache spies upon a column of cavalry and supply wagons. To the Indians, the cavalrymen were sometimes known as "long knives" for the sabers they carried but seldom used in combat.

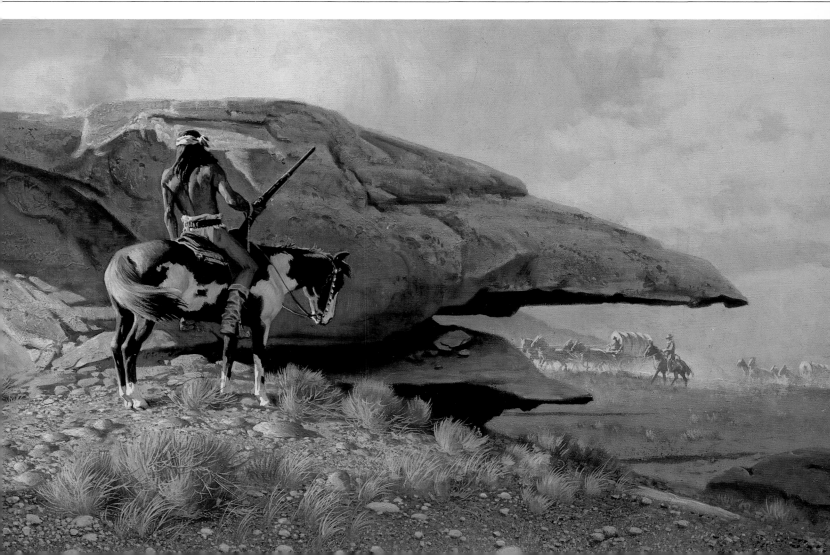

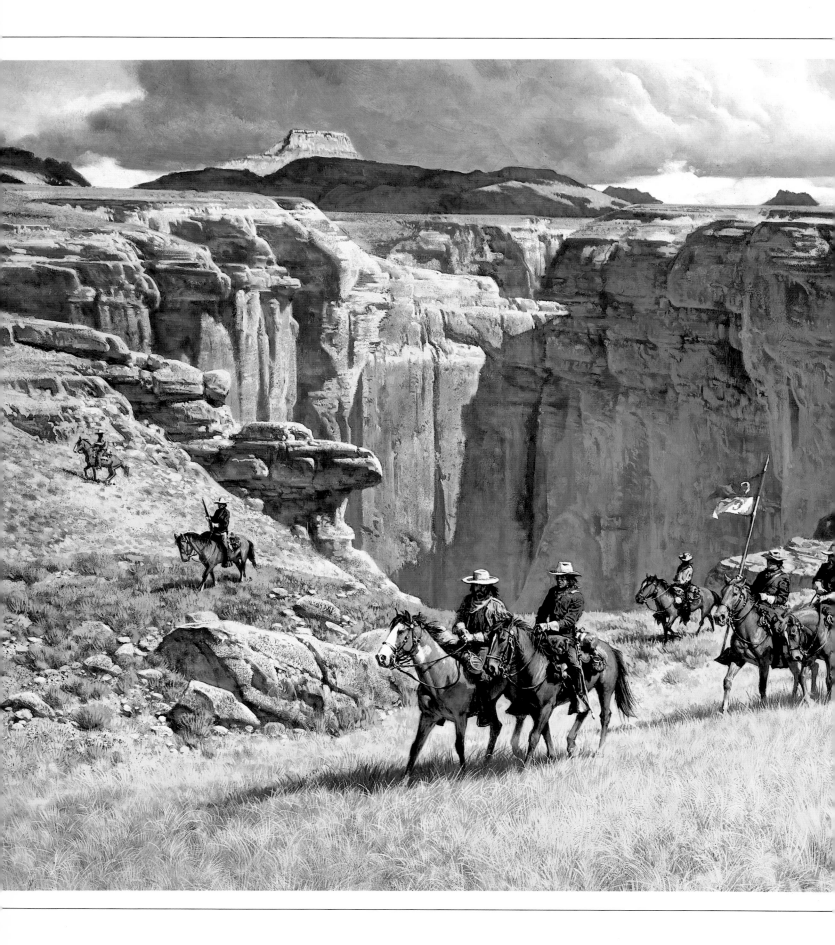

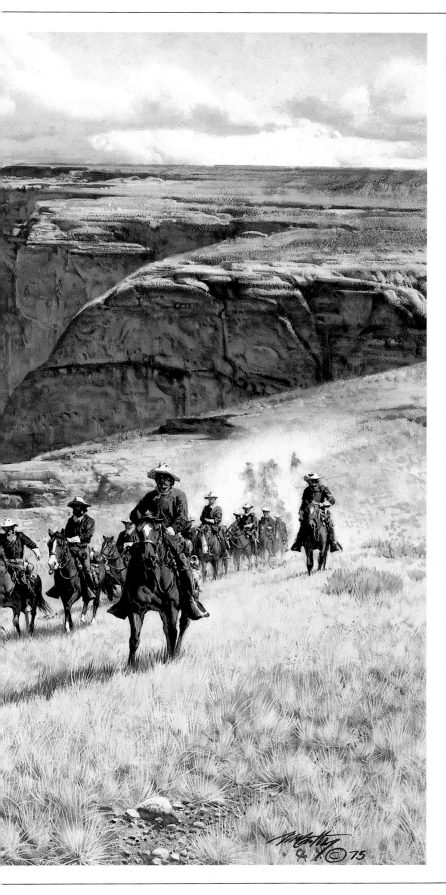

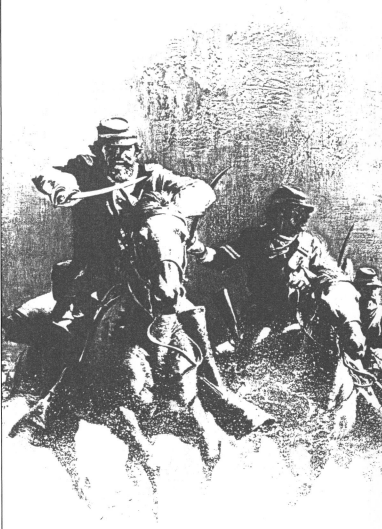

THE LONG KNIVES

An army patrol scours the dry and dusty but spectacular canyon country in search of hostiles, who hide easily in the endless labyrinths. Even if the troopers encounter no enemy, each patrol across unfamiliar land unwraps its mysteries. In this way the army mapped vast regions previously unknown except to Indians.

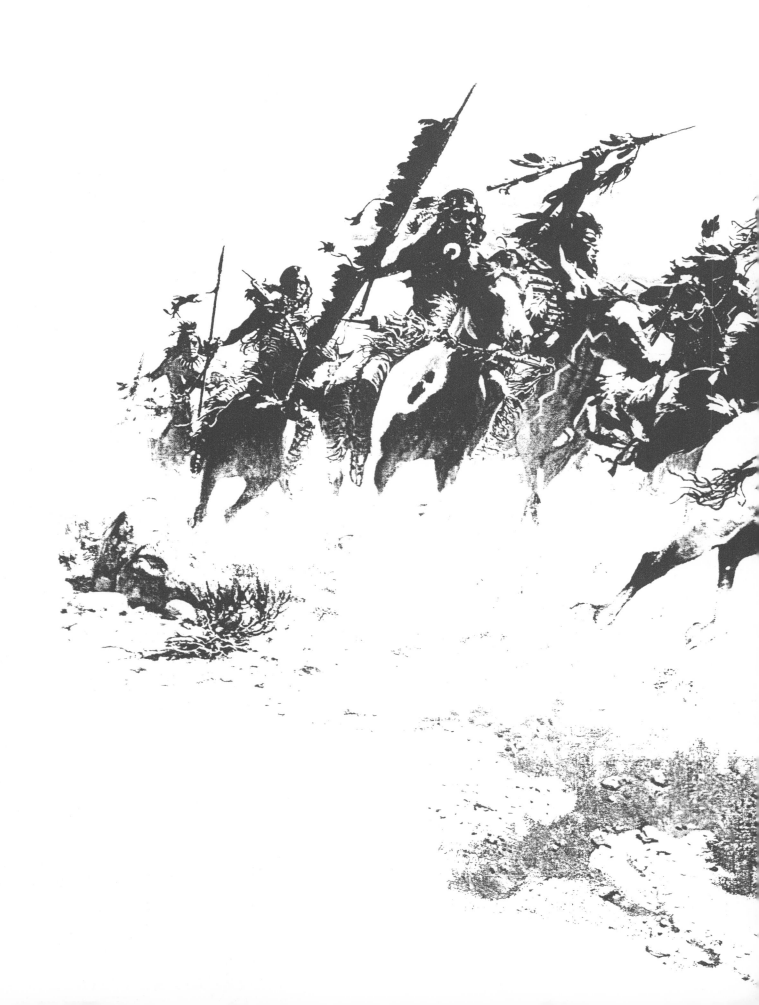

STORM OVER THE PLAINS

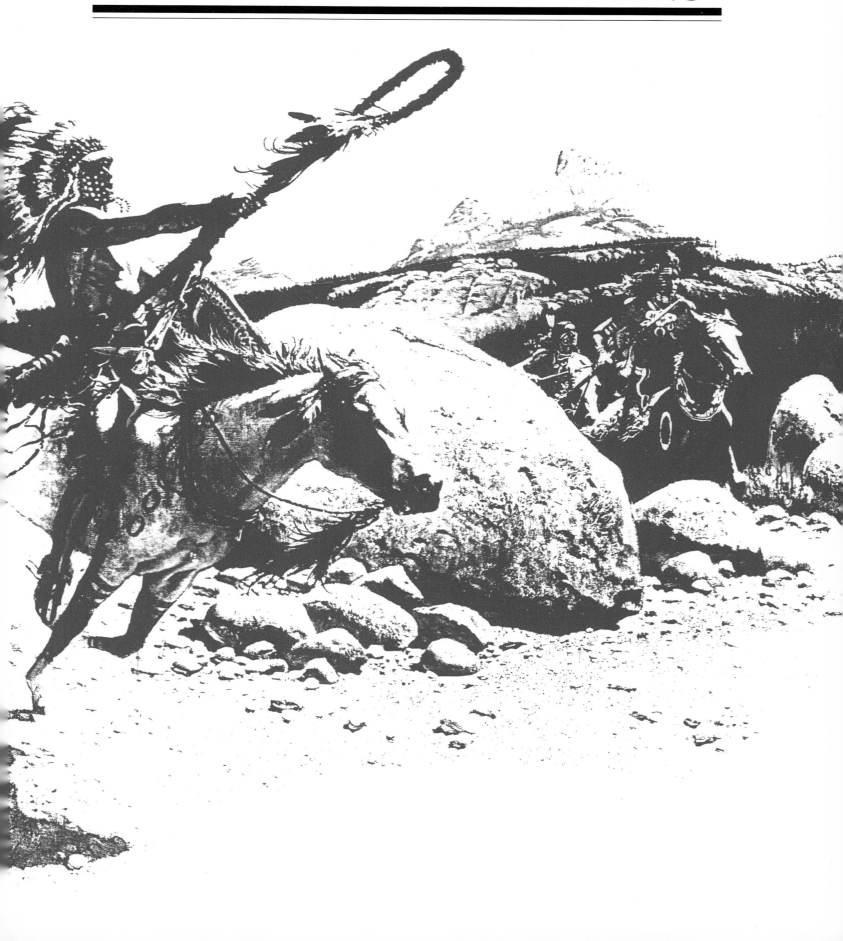

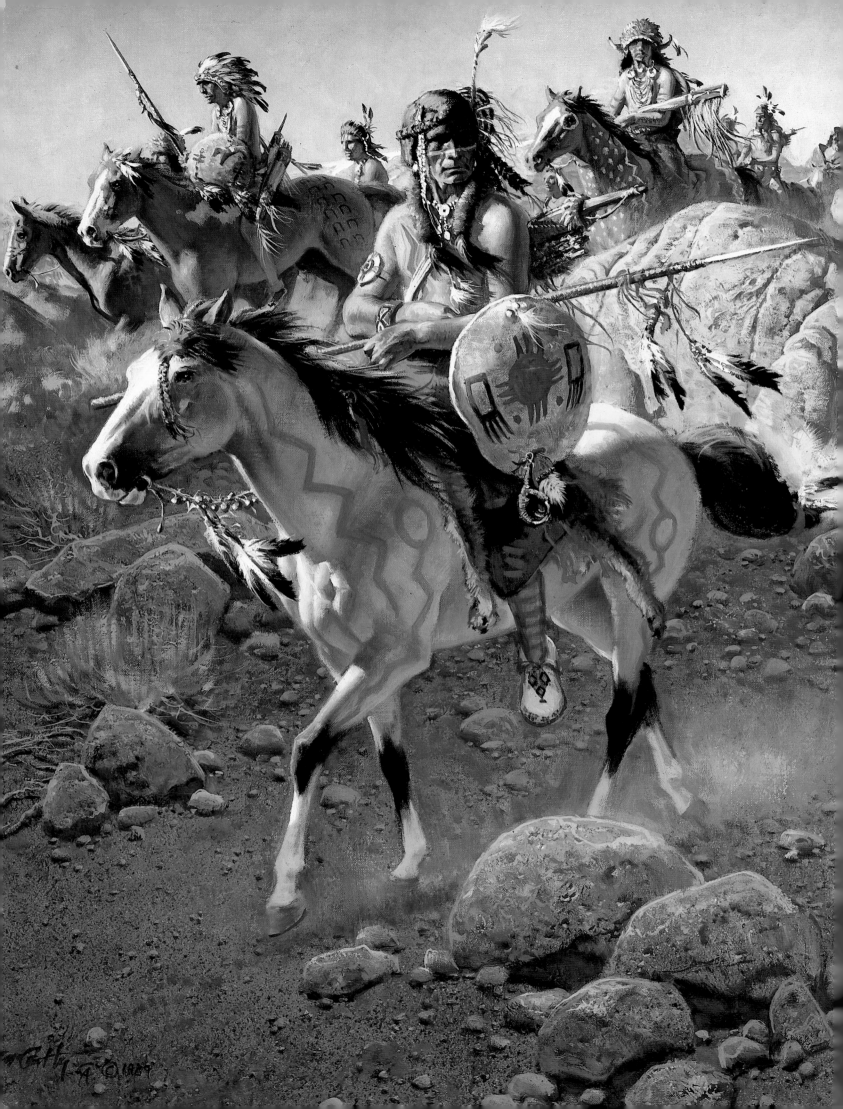

STORM OVER THE PLAINS: FIGHTING FOR THE OLD WAYS

As the Civil War was winding down, the Indian wars were heating up. One of the worst atrocities committed against the Indians, the Sand Creek massacre of 1864, was by Colorado volunteer militia, not by the regular army. But it was the army, civilian travelers, and settlers who bore the brunt of Indian retaliation, and the army which had to do the major fighting for another generation in an effort to end hostilities.

It was often caught in the middle between land-seeking Westerners impatient to take over Indian lands and a rising tide of Eastern sympathy for the Indians.

The opening of the Bozeman Trail through the Sioux Powder River hunting grounds touched off a series of hostilities led by Red Cloud, an Oglala Sioux. Bitterest conflict centered around Fort Phil Kearny, established in 1866 and one of the few Western posts surrounded by the sort of log stockade common to earlier Eastern forts. From the beginning of its construction under Colonel Henry Carrington, the resentful Sioux, with help from allied Cheyennes and Arapahoes, harassed its soldiers.

On December 21, 1866, they attacked a wood train and lured out a relief column of eighty cavalry and infantry led by Lieutenant Colonel William J. Fetterman. Disobeying orders not to move beyond sight of the fort, the eager Fetterman allowed a war party to decoy him into a well-planned trap. Hundreds of Indians suddenly swarmed around him like hornets and wiped out his command.

The following August, the fort's troops fought off another wood-train attack in what became known as the Wagon Box Fight. It was so named because the defenders protected themselves in wagon boxes that had been set off onto the ground so the wagons' running gear could be used for hauling logs.

Indian opposition remained so intense that an 1868 peace commission agreed to abandon Fort Kearny and Forts Reno and C. F. Smith. Red Cloud set the Kearny buildings on fire so the fort would not be used again.

One of the more notable Indian battles of that period began on September 17, 1868, at a place later named Beecher's Island in honor of a lieutenant killed there. On the Arikaree fork of the Republican River in Colorado, Cheyennes and Sioux attacked fifty volunteers under the command of Major George A. Forsyth. Despite heavy losses, the desperate men beat back three strong charges upon their tiny redoubt, the last led by the noted Cheyenne, Roman Nose. It broke when he was shot from his horse. Though the Indians did not attempt another charge, they kept the defenders under siege until black troops of the Tenth Cavalry came to the rescue on September 25. Forsyth's men suffered casualties of almost fifty percent. Nevertheless, when the siege was lifted, the men of the Tenth found the wounded Forsyth calmly reading *Oliver Twist*.

It was said that Roman Nose had inadvertently broken a taboo of his personal medicine, and he had predicted his own death.

General Philip Sheridan contended that the time to hit the Indians was in winter, when their horses were weak and the people were concentrated in vulnerable winter encampments. In bitter, early-morning cold on November 27, 1868, Lieutenant Colonel George Armstrong Custer, with some seven hundred men, attacked Black Kettle's peaceful Cheyenne camp on the banks of the Washita River, in what would become Oklahoma. Black Kettle, who had always preached peace, had survived the Chivington massacre, but he did not survive Custer's charge. Neither did more than a hundred other Indians, including many women and children.

Custer made two major tactical mistakes: dividing his forces and doing inadequate reconnaissance. He did not know that the camp he struck was but one of several along the river. Shortly he found himself in peril as Indian reinforcements came rushing down upon him. Had a quartermaster not come to his rescue with wagonloads of ammunition, his career might have ended that morning in the snow.

Even so, he allowed a detachment of eighteen men under Major Joel Elliott to be surrounded and killed, withdrawing without any effort to go to their aid or determine what had happened to them. The same tactical errors would kill him eight years later at the Little Big Horn.

Buffalo hunters by 1873 had finished off most of

the bison along the Arkansas and Republican rivers, so they turned their attention southward toward the Texas herd. Alarmed Comanches, Kiowas, and Southern Cheyennes banded together for a massive dawn attack upon the hunters' trading post at Adobe Walls on June 27, 1874. To their dismay, they failed to overwhelm the determined defenders and settled for raiding scattered hunting camps.

This triggered a stern army pincers movement against the Indians of the southern plains that fall. It was decisive, and much less bloody than Custer's wild sashay on the Washita. The Fourth Cavalry struck the first and hardest blow. It was commanded by irritable, hard-driving Colonel Ranald Mackenzie, who had to fight against constant pain from unhealed Civil War wounds. In 1872 he had led a successful secret mission into Mexico to punish Kickapoo raiders and stop their incursions into Texas from sanctuary across the Rio Grande.

At daylight on September 28, 1874, Mackenzie gazed down into the bottom of the deep Palo Duro Canyon at a three-mile-long winter encampment, mostly Comanches and Kiowas, some Cheyennes and Arapahoes. His men led their horses single file along a narrow game trail down the steep canyon wall. They surprised and routed the hostiles with only four Indian dead that Mackenzie knew about and one of his own men wounded. He destroyed the camp and captured most of the horses, setting the Indians on foot. Quietly but relentlessly dogged by soldiers, they had little choice but to walk to the reservation. Except for a few scattered outbreaks, Comanche, Kiowa, and Southern Cheyenne resistance was broken.

In the north, at about the same time, Custer was leading an expedition into the sacred Black Hills, guaranteed to the Sioux by treaty. His men found gold there and triggered a rush that violated the treaty and infuriated the Indians. Their attempts to drive the white men out led in 1876 to a three-pronged army offensive planned by Sheridan. A part of that plan involved Custer.

On June 17, General George Crook's troops fought a hard battle on the Rosebud, costly to both sides. On June 25, Custer's penchant for rash actions

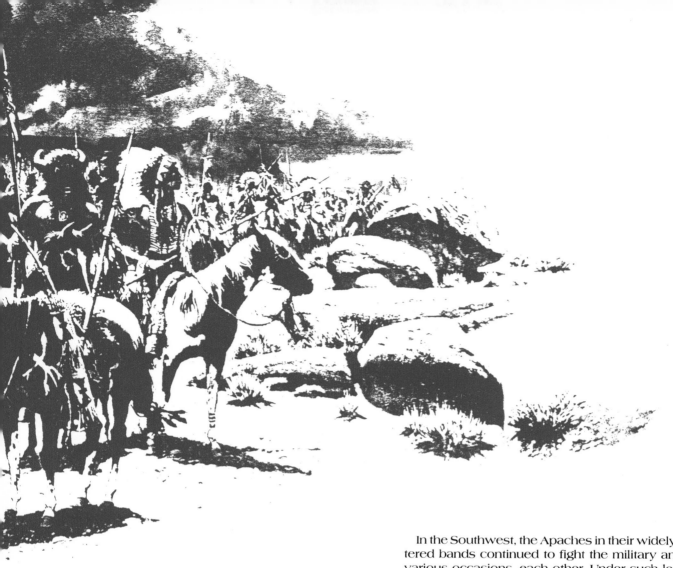

brought him to catastrophe on the Little Big Horn. For that one dizzying day of victory, however, the Indians of the northern plains would pay dearly.

Galled by Custer's defeat, the army was relentless. Crook fought again at Slim Buttes. Nelson A. Miles continued to press the Sioux until Sitting Bull fled to Canada and Crazy Horse surrendered at Nebraska's Red Cloud Agency in May, 1877. Both Indian leaders were later killed under what must, at the least, be described as questionable circumstances.

Like their allies to the south, the Indians on the northern plains were vanquished, except for occasional outbreaks, such as, those by Cheyennes under Dull Knife and Little Wolf in 1878, and the tragic Ghost Dance movement, which climaxed in the massacre of Sioux at Wounded Knee in 1890.

In the Northwest, the Nez Percé made a break for freedom under Chief Joseph in 1877. They traveled a zigzag course totaling some seventeen hundred miles, fighting repeated engagements with pursuing troops and suffering heavy loss of life, only to be stopped thirty miles short of the Canadian border and the sanctuary they sought. It was there that Joseph made his heartbroken surrender declaration: "From where the sun now stands, I will fight no more forever."

In the Southwest, the Apaches in their widely scattered bands continued to fight the military and, on various occasions, each other. Under such leaders as Mangas Coloradas, Victorio, Loco, and Nana, the more intransigent among them sternly resisted reservation life. Small parties of guerrilla-fighting warriors periodically set out upon long raids of farms, ranches, and mining communities, taking a toll of life and property far out of proportion to their meager numbers.

Most famous of their leaders was the medicine man Geronimo, who held out to the bitter end with relatively small groups of followers, most of the time in Mexico. Raiding from the Sierra Madres, he became a thorn in the sides of the whites.

George Crook, veteran of Indian campaigns on the northern plains, was assigned to bring Geronimo to heel. He enlisted almost two hundred Apache scouts to keep peace on the reservations and to track down the scattered holdouts, including Geronimo. Hard-pressed, Geronimo surrendered twice, then broke away. The tolerant Crook was replaced by an intolerant Miles, who assigned Lieutenant Charles Gatewood to the mission.

After much hardship, Gatewood found the wily Apache and his thirty-seven remaining followers and persuaded them to accompany him back to Arizona. Geronimo surrendered to Miles on September 3, 1886. Miles shipped him to prison in Florida, along with many other Apache hostiles — and, in a final stroke of scorn — the Apache scouts who had faithfully served Miles's predecessor Crook.

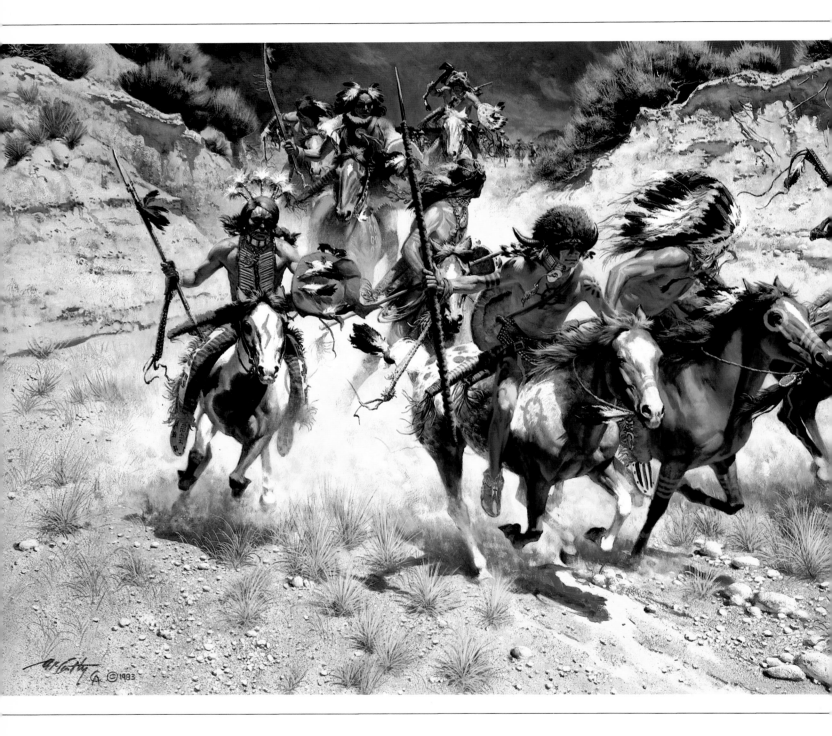

DECOYS

A small group of Sioux warriors lures a cavalry column into a narrow gap. When the trap is sprung, the soldiers will suddenly find a far larger Indian force surging up from both sides and sealing off retreat to the rear. The decoys will turn to block the front, and the troop will be in for a desperate fight.

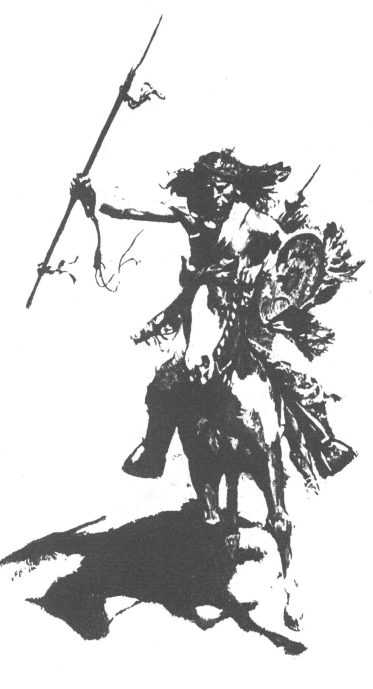

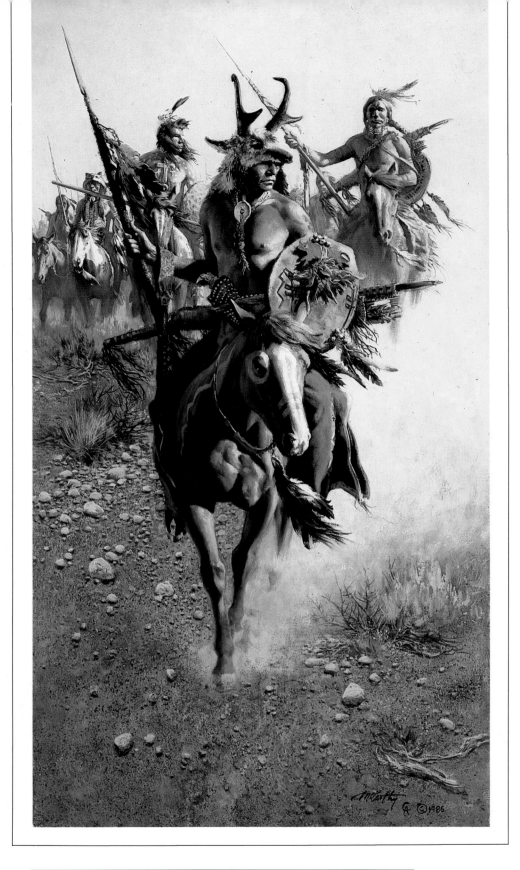

RED BULL'S WAR PARTY

Chief Red Bull, his buffalo-hide shield bearing the effigy of his personal totem, leads a band of Sioux warriors against their traditional enemies, the Crows. He wears the head of the pronghorn antelope to lend him agility and speed for battle. The Indians studied animals and borrowed much from their ways.

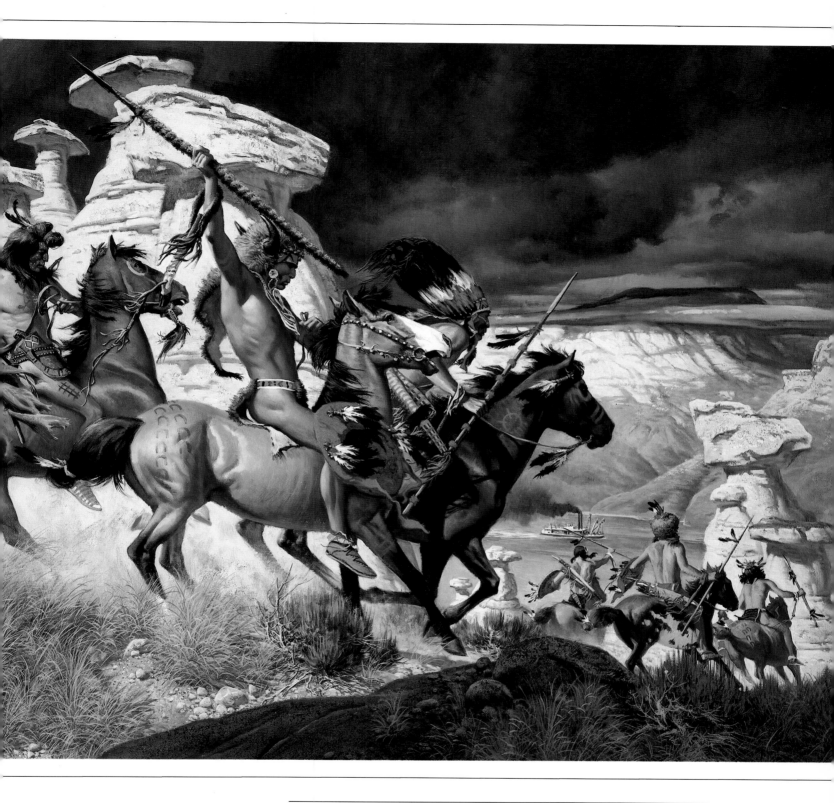

OUT OF THE WINDSWEPT RAMPARTS

Beneath a portentous blackening sky, a Blackfeet raiding party sweeps down from among the sandstone "hoodoo" formations high above the Missouri River in northern Montana. The object of their hostility is a steamboat, representing white intrusion into a land from which they have repelled all earlier invaders.

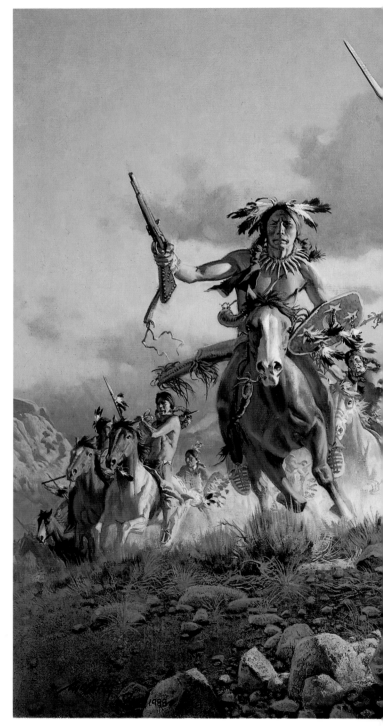

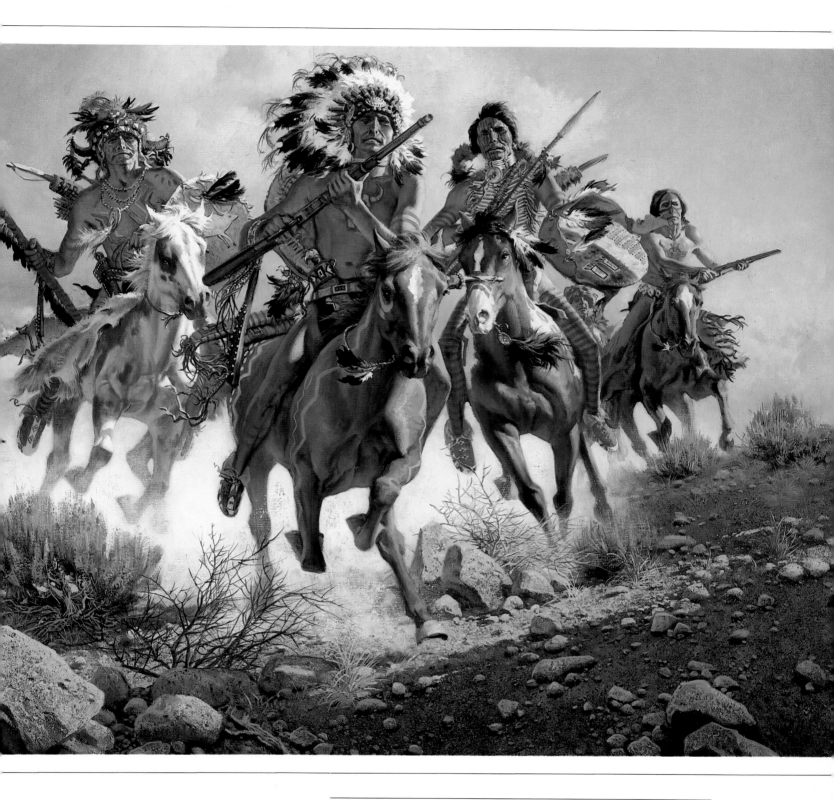

RAMPAGE

Even the objects of their wrath could sometimes be mesmerized by the colorful spectacle that Plains Indian warriors presented as they charged into combat. After the furious battle of Adobe Walls, buffalo hunter Billy Dixon admitted that he was so spellbound he almost waited too long to run for cover.

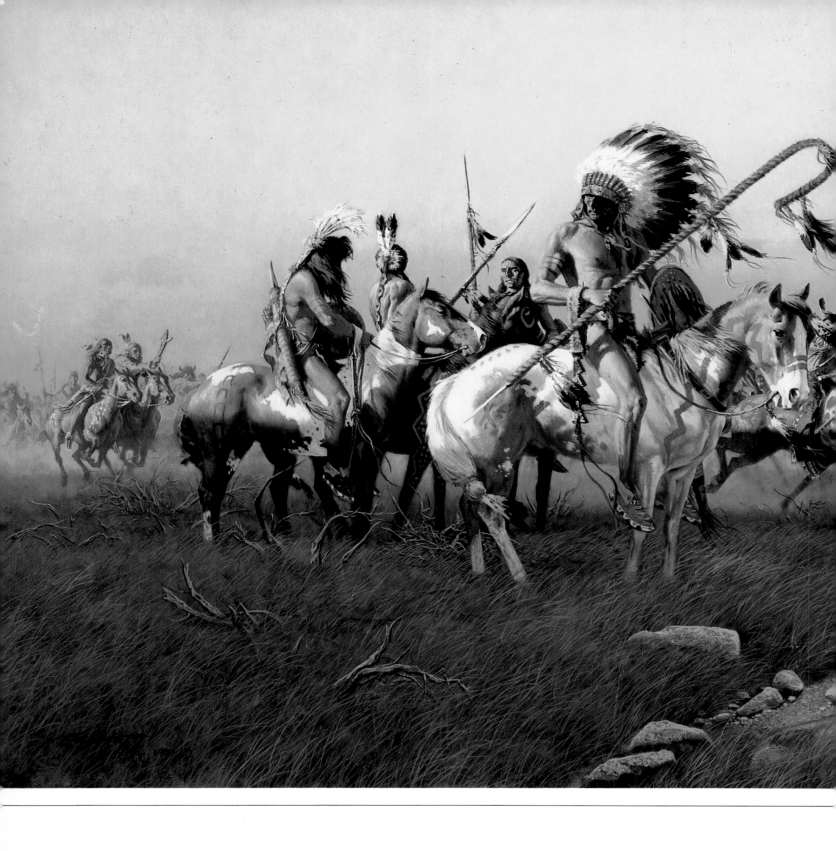

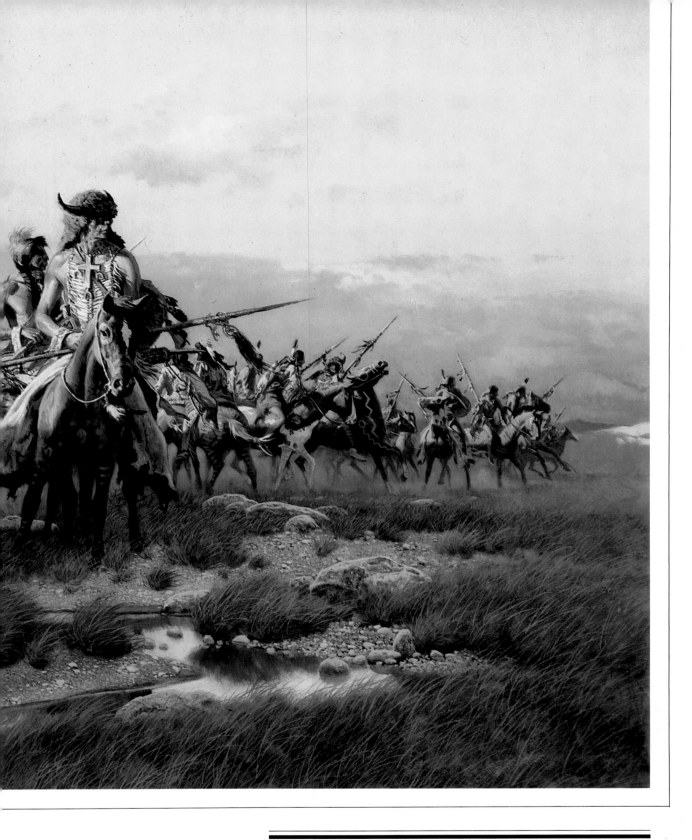

BEFORE THE ATTACK

Waiting for the rest of his warriors to bring up the rear, a war chief readies for battle, face painted black for vengeance. They will count on the bright sunrise at their backs to blind the enemy. The warrior in buffalo headdress wears a large decorative cross on top of a bone breastplate, but it does not denote peace.

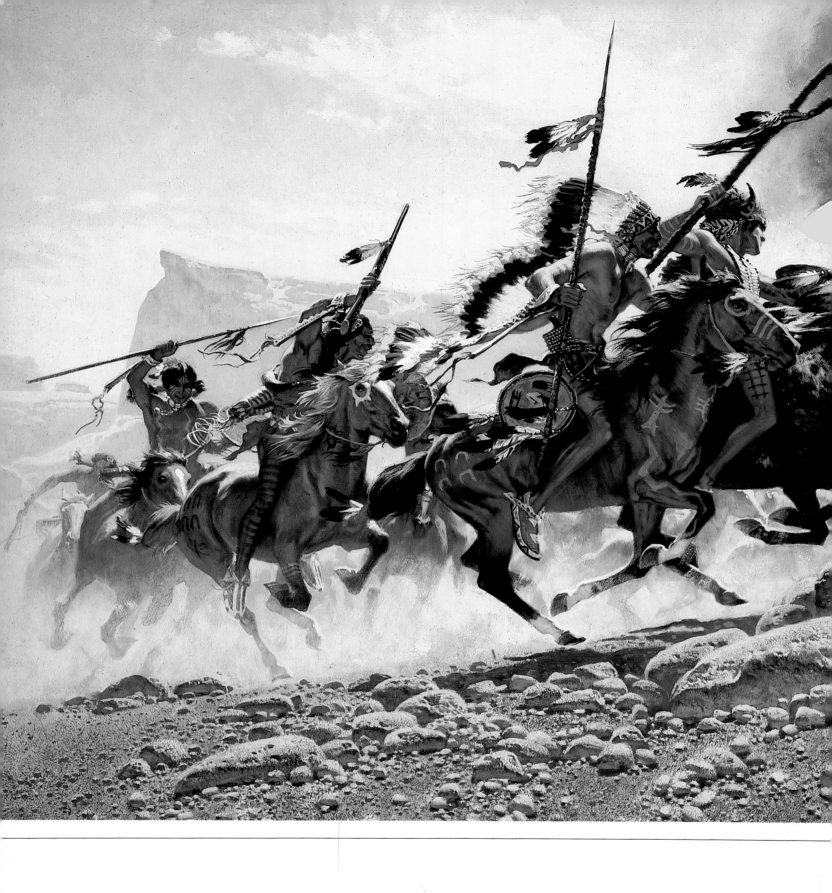

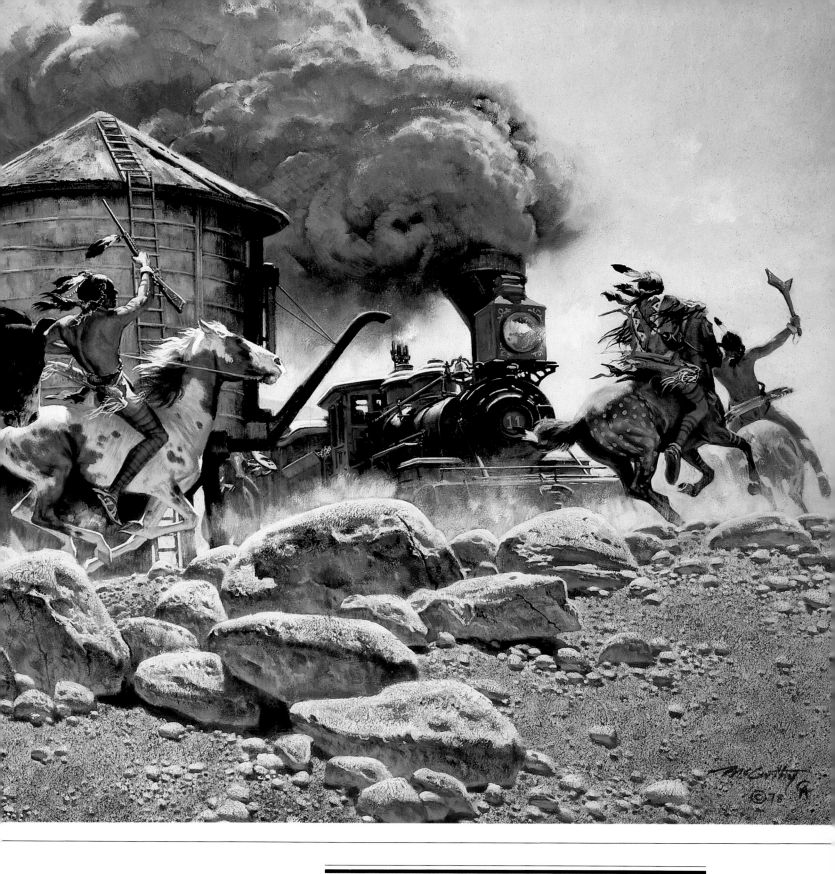

THE AMBUSH

Cheyenne Indians attack a train at a vulnerable time, when it has stopped at a water tank to refill its boiler. The Indians were quick to recognize that the iron horse carried soldiers, and it brought settlers who built houses on old camping grounds, plowing up the grass that belonged to the great buffalo herds.

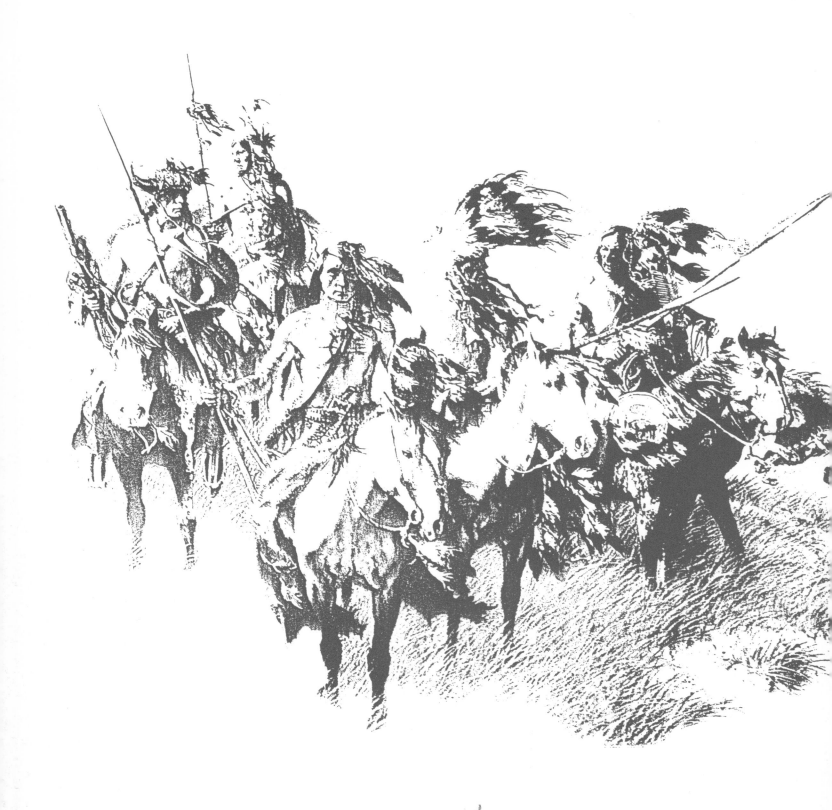

OUT OF THE RISING MIST

Magnificent in color and symbolism, a war-bonneted chief leads his men in a bold charge. From his fur-wrapped lance dangles the scalp of a past enemy. Every painted man and horse tells of other conflicts, other moments of victory. This is the last bright flash of glory before sundown comes for the free Indian.

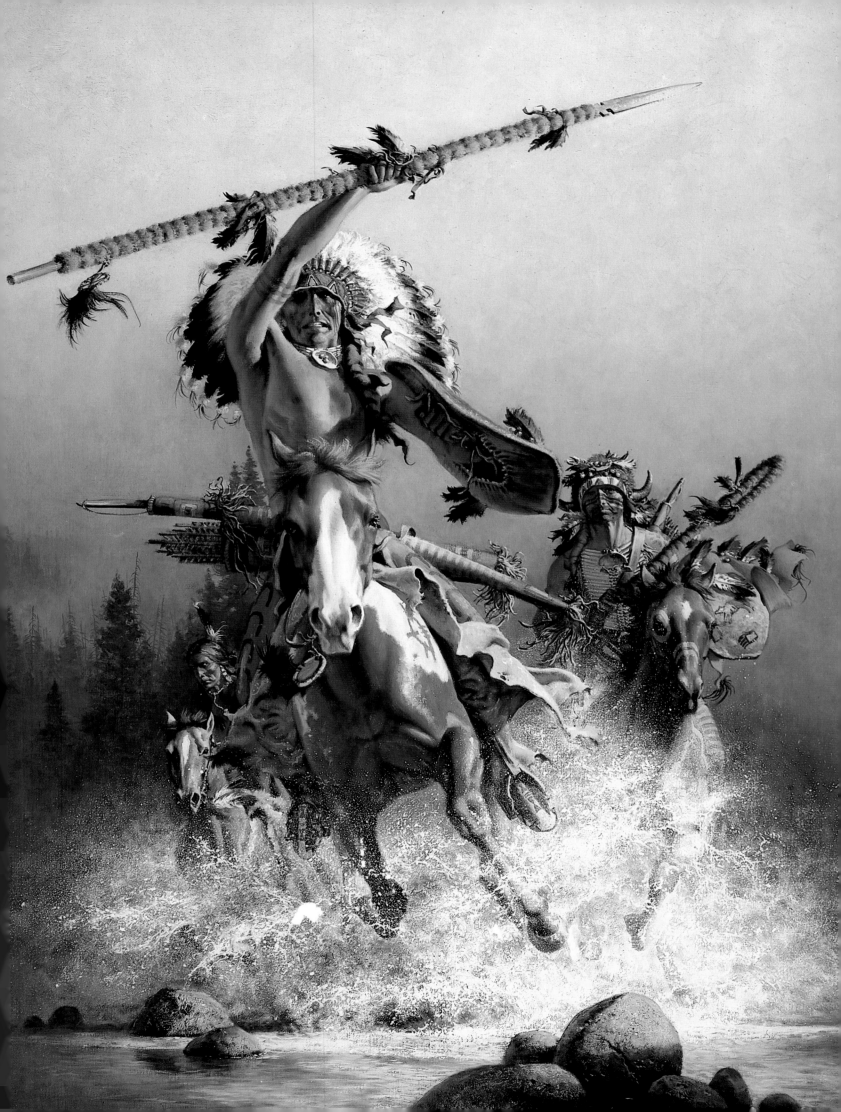

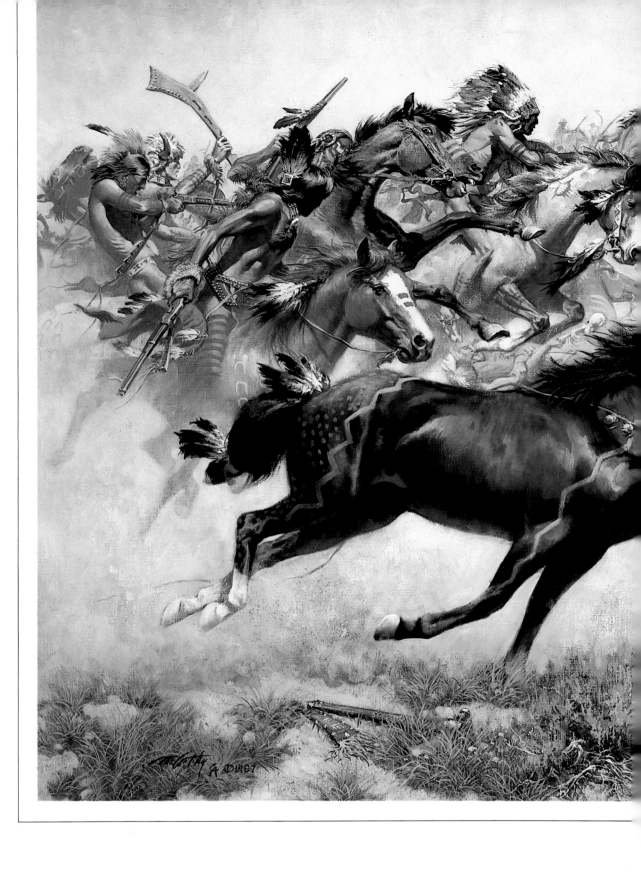

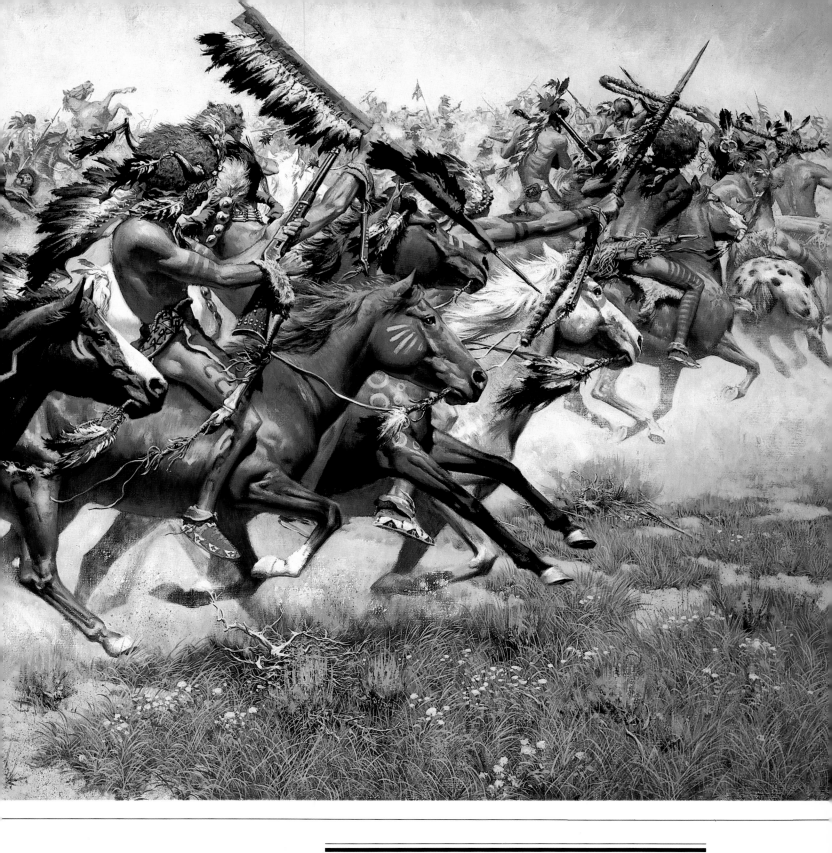

THE LAST STAND: LITTLE BIG HORN

In the center of this swirling ring of Indian fury are Lieutenant Colonel George Armstrong Custer and soldiers of his Seventh Cavalry. Their desperate situation results from one of the most tragic military miscalculations in the history of the West. But it would be the last great victory for the Plains Indians.

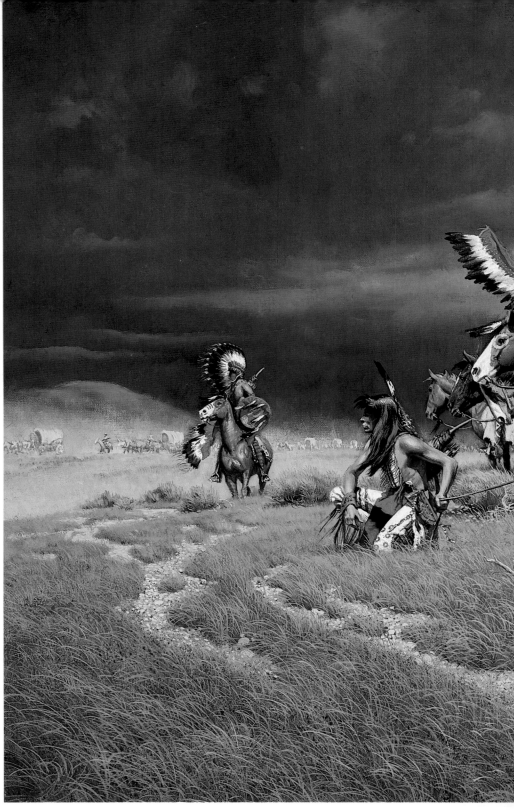

WATCHING THE WAGONS

Gathering storm clouds symbolize the approaching conflict as Indians worriedly observe settler wagons just beyond effective rifle range. In the beginning these were mostly just passing through, but as settlers increasingly dropped off to stay, it was clear that the Indians' claim to the land was threatened.

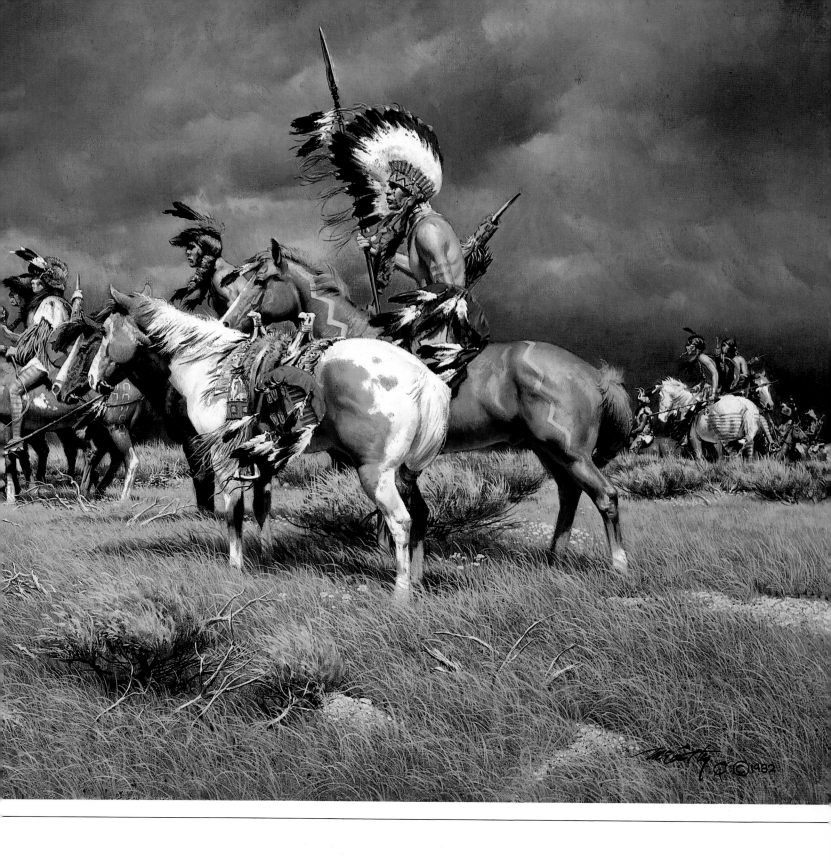

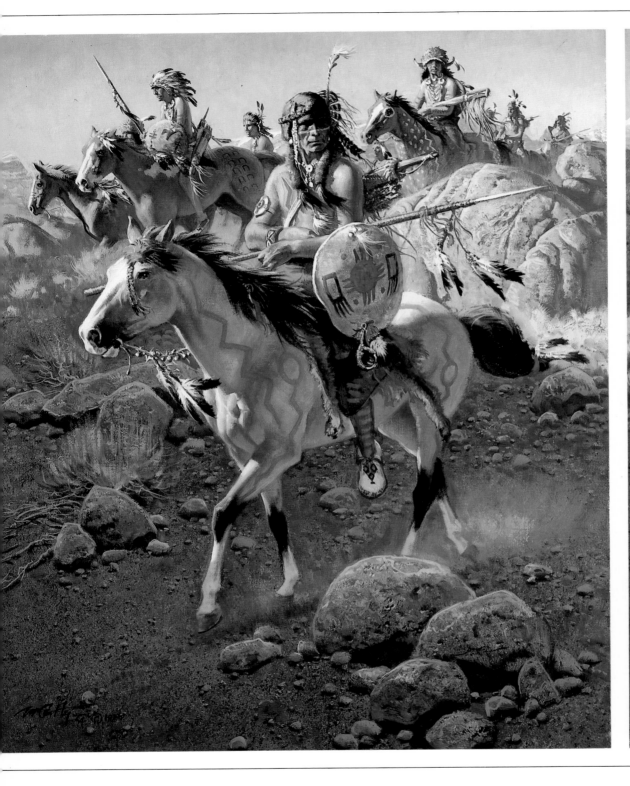

ON THE OLD NORTH TRAIL

In the long, dark shadows and the gold of early-morning sunshine rides a Blackfeet raiding party bearing the markings of war. The Blackfeet were particularly fierce in defense of their Canadian border homeland. The Old North Trail began in Alberta. Raiders of various tribes followed it as far south as Mexico.

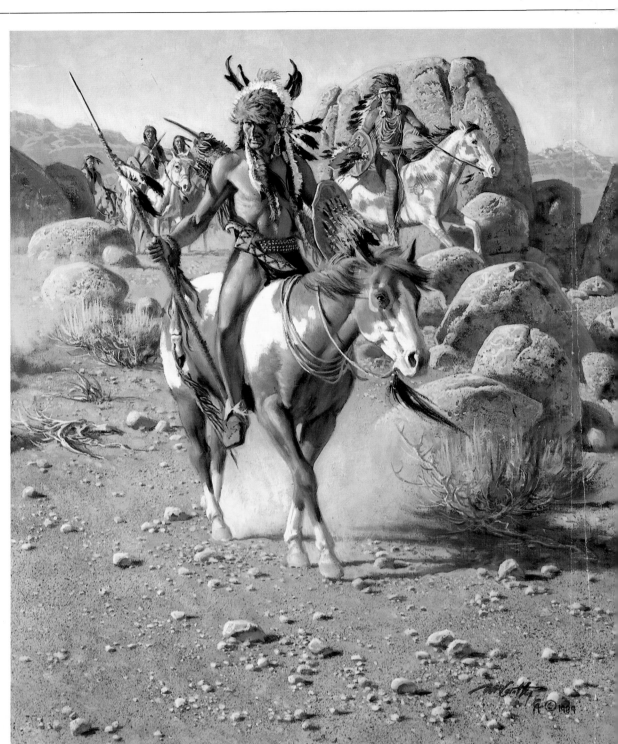

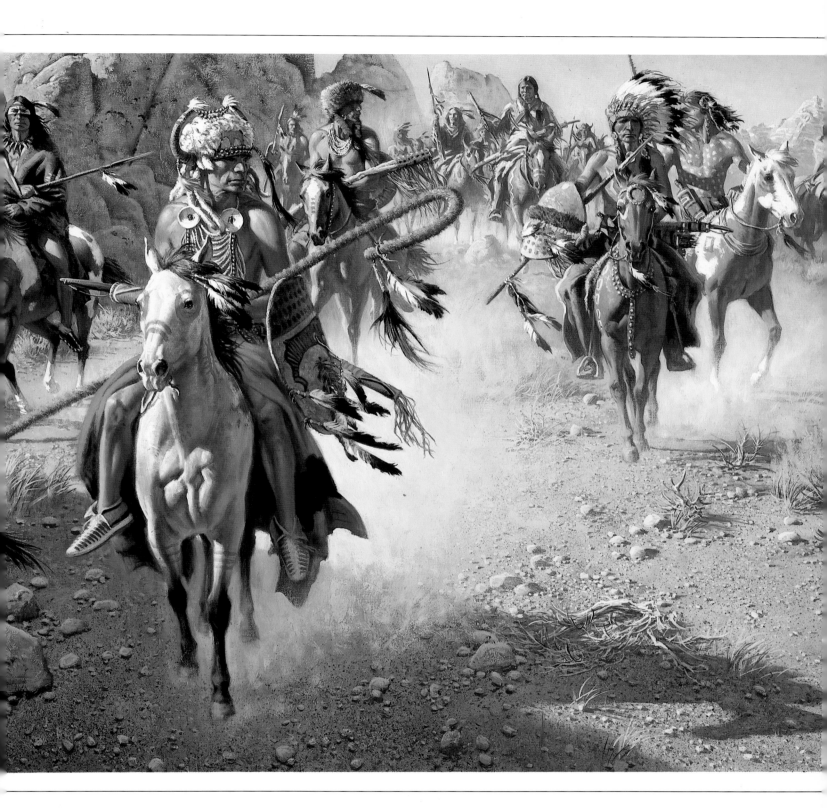

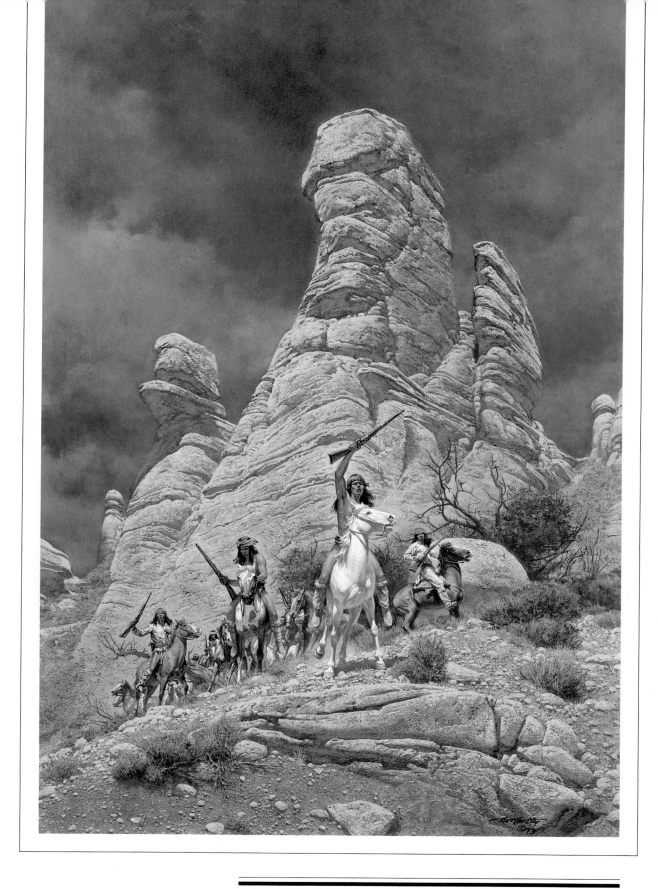

THE SAVAGE TAUNT

Beneath towering rock formations high in the Chiricahua Mountains, Apache warriors taunt an unseen foe, hoping to lure him into a trap. Hard to dig out of their thousand hiding places in the Southwestern desert mountains, the Apaches were the last of the horse Indian tribes subdued by the frontier army.

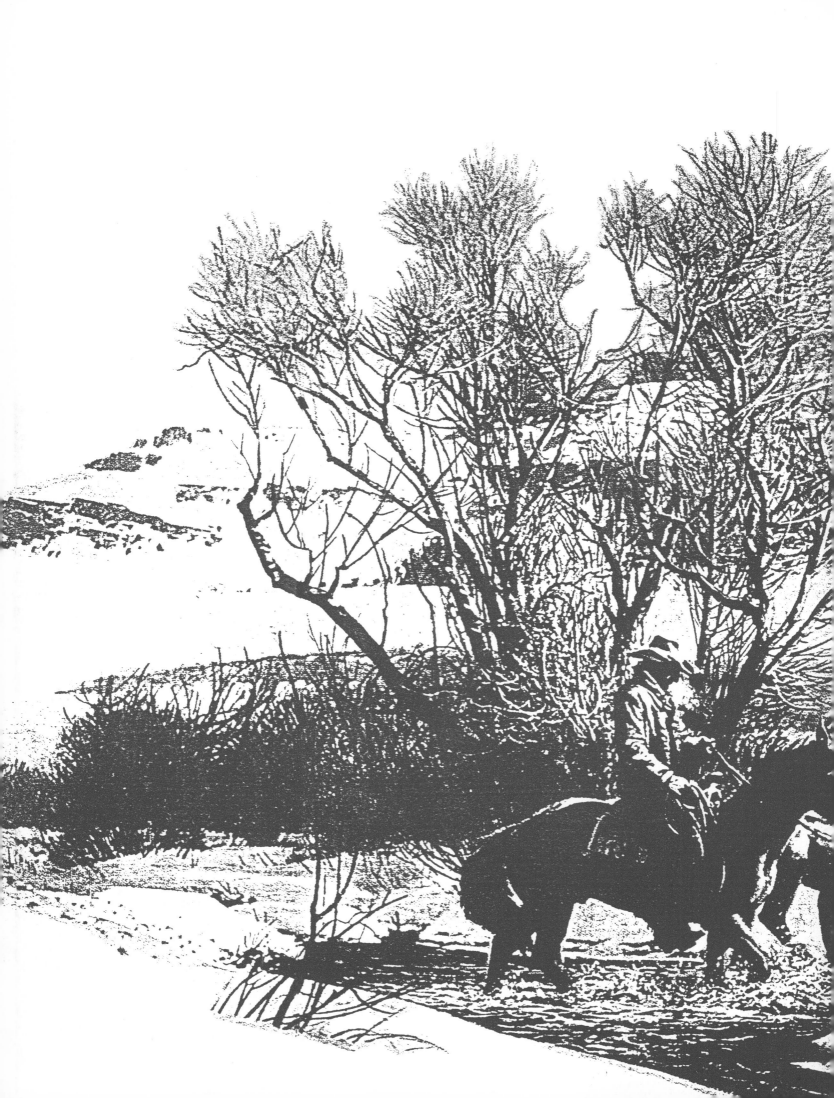

TRAVELING WEST

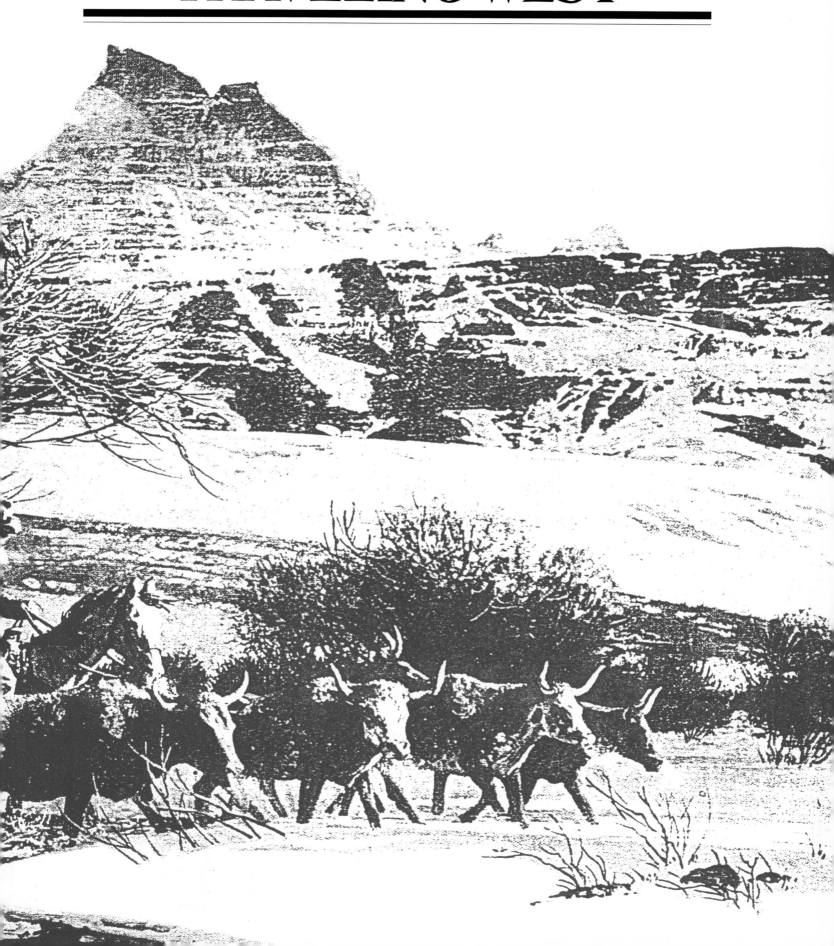

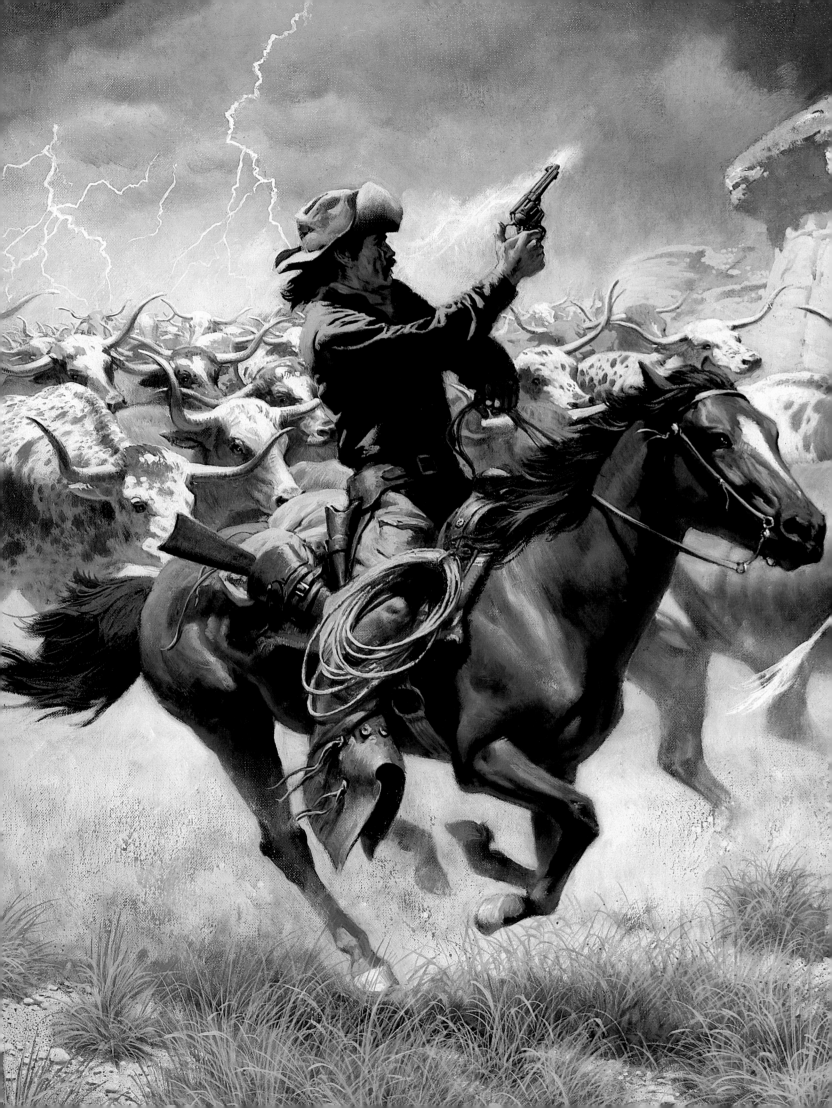

TRAVELING WEST: BOATS, HOOFS, WHEELS, AND RAILS

The first American explorers and trappers who ventured into the West traveled on its waterways, especially the Missouri River and its tributaries. The Lewis and Clark expedition started up the Missouri May 14, 1804, with a keelboat and two dugout canoes. Such dugouts, along with birchbark canoes, had long been a favored mode of transportation for *voyageurs* who moved among the Indian tribes of Canada and the northern United States to trade for fur. Sometimes they employed Indian bullboats made with willow framework covered by buffalo hide.

The keelboat came into wide usage on the Missouri, starting with trader Manuel Lisa. Because the trip up the Missouri was against the current, hard-working boatmen trudged treadmill-style along runways on each side of the boat, propelling the vessel forward with long poles set firmly against the river bottom. At times they walked along the shoreline, cordelling the boat with a long and heavy cable, or they rowed. On the return trip downstream the current carried the vessel most of the time.

The Missouri was a treacherous river of rising and falling water, shifting sandbars, and hidden driftwood snags that could stop a boat and even tear the bottom out of it.

Robert Fulton's development of the steamboat revolutionized river traffic as the nation's westward expansion was gathering momentum. Colonel Elias Rector put the *Independence* into the water at Saint Louis in 1819 and ventured two hundred miles upriver. In the same year, a military expedition bound for the Yellowstone put four steamboats into the Missouri. Three, transferred from the Ohio, were unable to overcome the swift current. The shallow-draft *Western Engineer* proved usable, though the muddy water clogged its boilers and chewed up its valves. The boat kept grounding and having to be pulled free by cordelle. The venture ended in failure, but much was learned from it.

The American Fur Company commissioned the building of the *Yellowstone*, which set out upriver April 20, 1831. It soon stalled because of low water. In its second year, it left during the spring snowmelt and traveled eighteen hundred miles to Fort Union. It came back with a good load of furs. After that, the steamboat was a fixture on the Missouri. Staying as much as possible in the deeper water, the "fire-canoe" was less vulnerable to Indian attack than the edge-hugging keelboats. Its cannons were a strong deterrent to the war-minded.

Once travelers had gone as far as the keelboat or steamboat could take them, they proceeded by canoe on the tributaries, or they moved overland on foot or on horseback. William Ashley broke the trappers' old tie to the rivers after an Arikara attack turned back his 1823 keelboat expedition up the Missouri. Traveling overland, horsemen could reach trapping sites denied to the boatmen. Soon trappers and traders were taking horses and mules into regions not before visited by white men. The adventurers often had the opportunity to match their mounts' speed against that of hostile Indians'. They won some and lost some. When they came out second, they usually lost their hair as well as the race.

The first wheels into that hotly contested country carried a cannon, which Ashley towed behind a packtrain up the Platte River and the South Fork to discourage Indian challenge. A few years later, the wheels of immigrant wagons would leave their tracks atop those of the cannon.

Farther south, huge freight wagons had been plying the Santa Fe Trail for years, but the terrain there was relatively benign. Many doubted that wagons could stand the punishment of the Rocky Mountains. William Sublette tried in the summer of 1830, taking ten wagons and two Deerborn carriages to the trappers' rendezvous in the Wind River Valley. They managed to reach their destination, but the trip was such a struggle that Sublette did not try again.

French-born Captain Benjamin Louis Eulalie de Bonneville in 1832 took loaded wagons through South Pass. He believed, as had Sublette, that wagons could carry far more trade goods and furs

than a packtrain using a similar number of animals and men. The biggest problems were rough, steep grades, canyons, and rivers. Bonneville proved the workability of wagons, but he lost money on his trading enterprise and gave it up after three years. The trail he blazed with his trade wagons would later be used by thousands of immigrants bound for Oregon and California.

The pony express inspired a lasting legend far out of proportion to the short time it existed. It was envisioned as a means of tying East and far West together with a fast mail service. It did so, but at substantial financial loss to its backers. William H. Russell, of the freighting firm Russell, Majors and Waddell, set up the pioneering enterprise between St. Joseph, Missouri, and Sacramento, California, despite the misgivings of his partners. He established 190 relay stations to keep riders supplied with fresh horses as they spurred to carry mail nineteen hundred miles in about ten days for five dollars an ounce.

The mail carriers were mostly youths, lightweight and wiry — preferably orphans — the employment ads said. Among them was fifteen-year-old William F. Cody, later to become known as Buffalo Bill. He once rode a double hitch, nearly a hundred and sixty miles, after finding his relief rider killed. He rested briefly, then made the same ride again. The most dangerous stretch was through Paiute country in Nevada.

The first run began April 3, 1860. The last was in October of the following year. Completion of the overland

telegraph had made the pony express obsolete after just nineteen months.

Stagecoach lines in the West followed general patterns set earlier in the East and in Europe, but poor roads, long distances, and the danger from Indians presented unique challenges and the need for a style of vehicle different from the European. The Abbott-Downing Company of New Hampshire developed the distinctively American Concord coach with leather thorough braces instead of steel springs. Many of these beauties plied the Western trails, though the average passenger was more likely to be consigned to the less glamorous but thoroughly practical "mud wagon," built for rough use under frontier conditions.

A regional stagecoach line was established in Oregon as early as 1846. The first to supply service across the country was John Butterfield's Overland Mail Company in 1858. Butterfield's example was followed by the Overland Mail and Express and the most famous of all, Wells Fargo and Company.

The coaches were vulnerable to Indian attack along their long, lonely routes. Isolated way stations were a favored target, their large numbers of horses

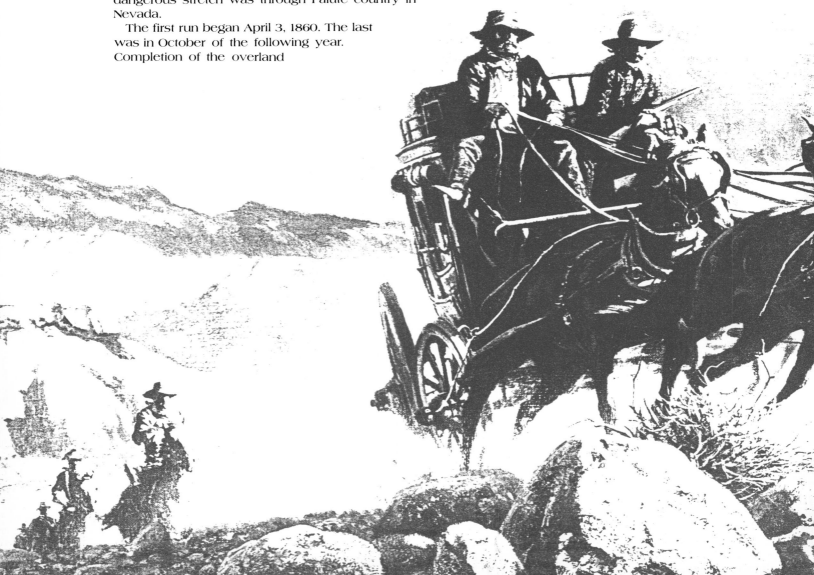

a special temptation. Stations were thinly manned and difficult to defend against a concerted effort. Though corrals might be sturdily built of stone or adobe, Indians found them not difficult to breach. Many a stagecoach driver rolled into a relay station and found that he had to make the next stretch with a tired team because the relief animals had been run off. Occasionally he found the buiding burned, its occupants killed.

As steel rails fingered out across the continent, they gradually relegated stagelines and freighters to shorter trails, reaching points the railroads did not serve yet.

As early as the 1840s, men envisioned rails that would tie East to West. Some military explorations, such as, Captain Randolph Marcy's in the 1850s, were designed to search out possible railroad routes. Not until 1869, however, would the dream of a transcontinental railroad come to pass with the driving of the golden spike at Promontory Point, Utah, joining the Union Pacific and Central Pacific Railroads.

Far-seeing Indian leaders recognized the many troubles the iron horse was to bring upon them. They fought surveyors and building crews of the Union Pacific all the way across the plains. Once, near Omaha, a Sioux and Cheyenne war party pried up rails and wrecked a freight train. They killed the engineer and fireman, then looted the cars, carrying off whiskey, sugar, tobacco, and cloth as the wreckage burned behind them.

The Union Pacific employed Pawnee scouts under the command of Major Frank North to protect its workers along the expanding right-of-way. Because the principal attackers were their traditional enemies, Cheyennes and Sioux, the Pawnees were not only efficient but eager at their task.

Ultimately, as the Indians had foreseen, the railroad was a potent factor in the loss of all their lands except the meager reservations the white invaders set aside for them, usually sites regarded as having little commercial value. The rails brought soldiers and settlers, and the supplies and implements that allowed the settlers to stay. They opened markets for farm produce, for cattle, for the hides of the buffalo upon which the Plains Indians had depended for the necessities of life.

A century and a half to two centuries earlier, the Spaniards' horse had given the Plains Indian speed and mobility, transforming his way of life. The black smoke of the iron horse signaled the closing chapter in that wild and free way of life, and a new era for an expanding nation.

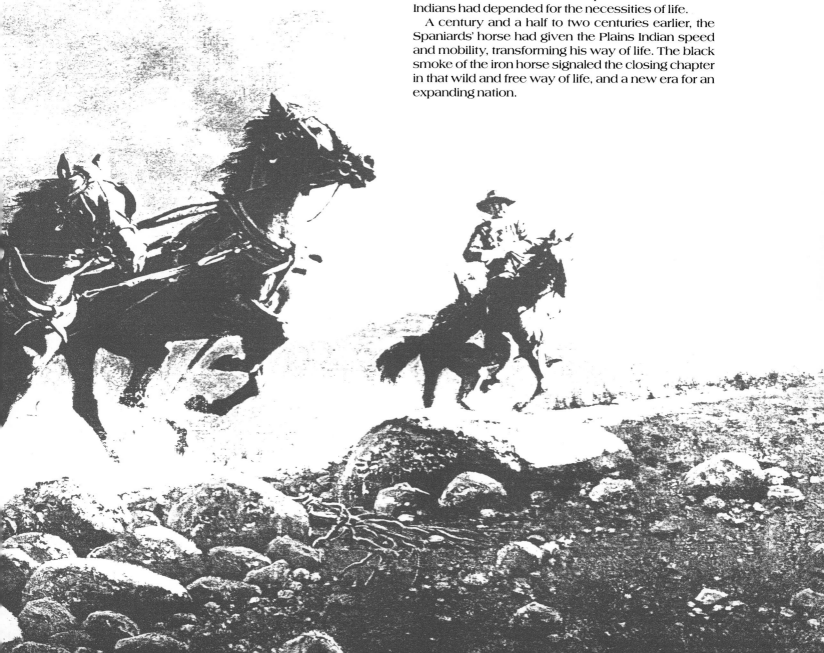

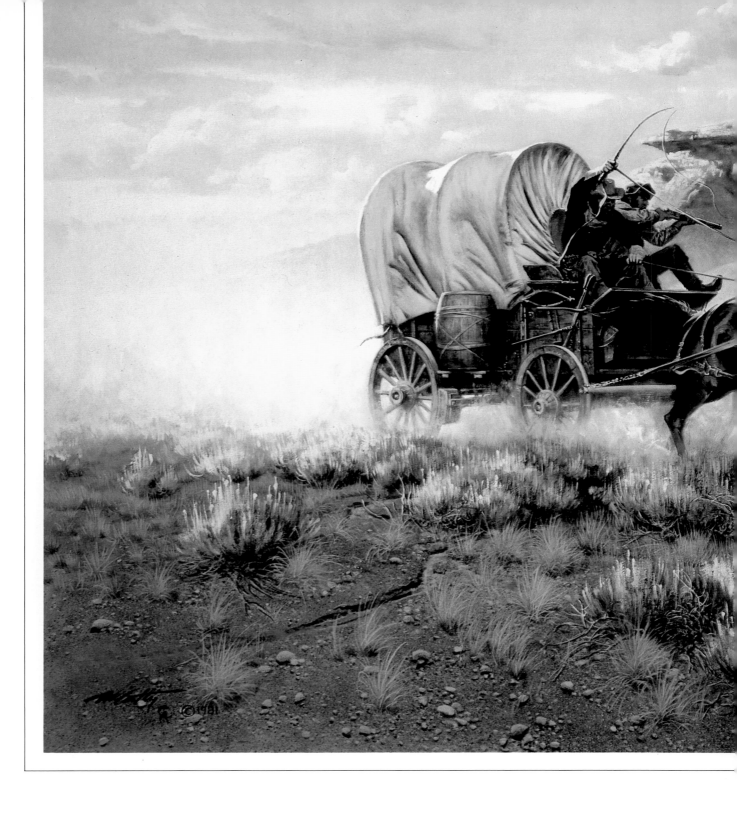

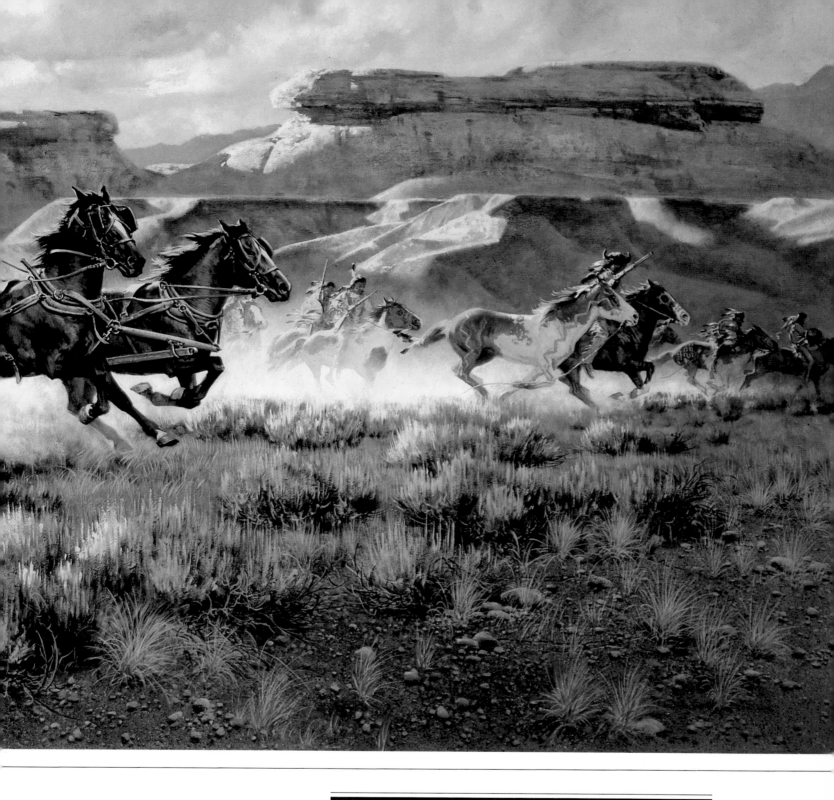

CAUGHT IN THE OPEN

Straight shooting has dumped one warrior from his horse, but the rest of the band is determined to stop this wagon and give its occupants a grim lesson in the penalty for trespassing. The easiest way would be to down one of the harness horses, but the Indians would prefer to get away with both of them.

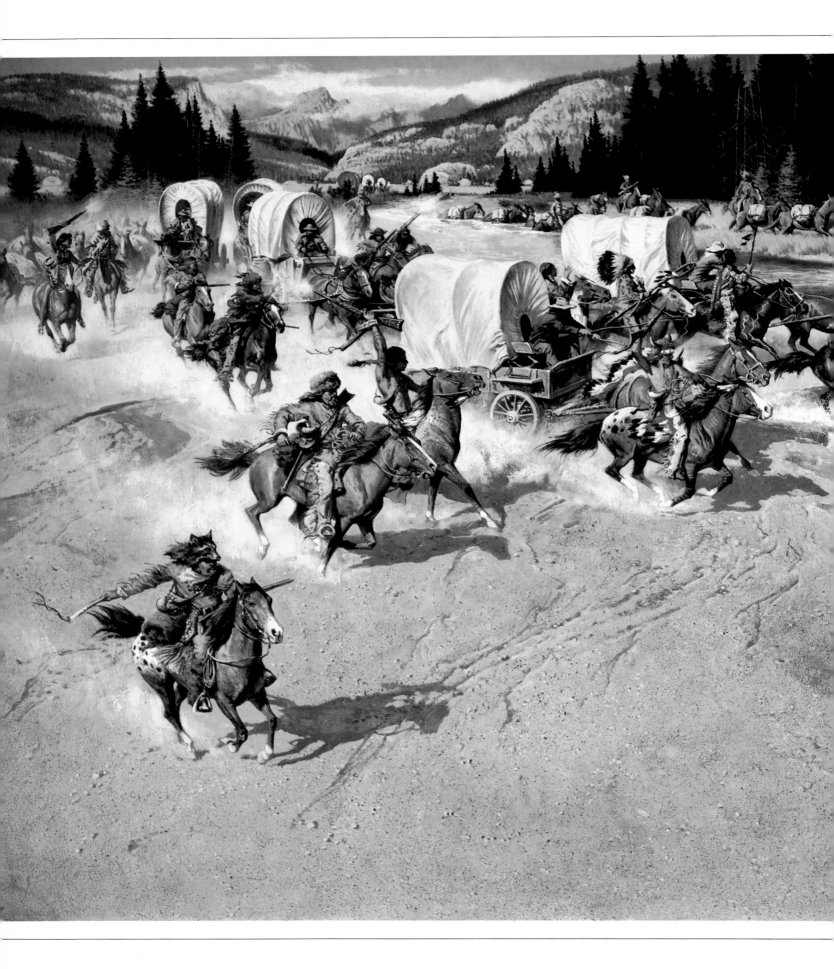

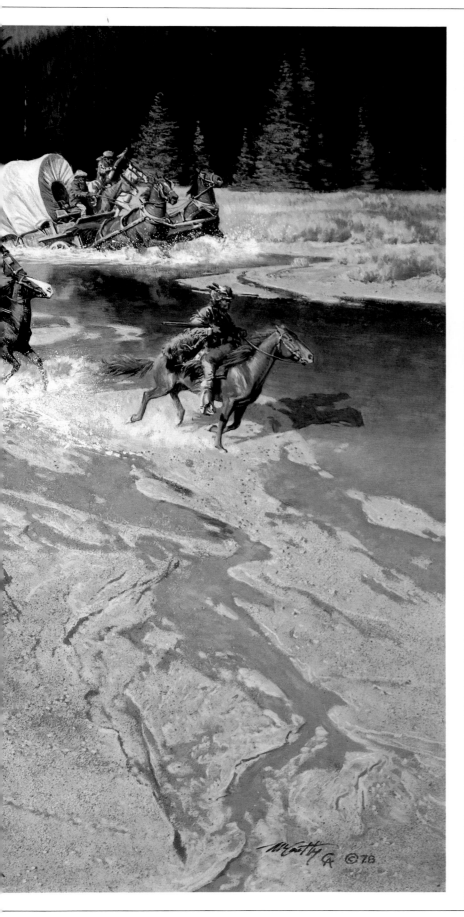

RENDEZVOUS

Mixed together in colorful pageantry, trappers and friendly Indians gleefully greet the arrival of trade wagons and pack trains at the site of the annual fur-trading rendezvous. These gatherings spared the mountain men the necessity of carrying their pelts all the way eastward to Saint Louis for sale.

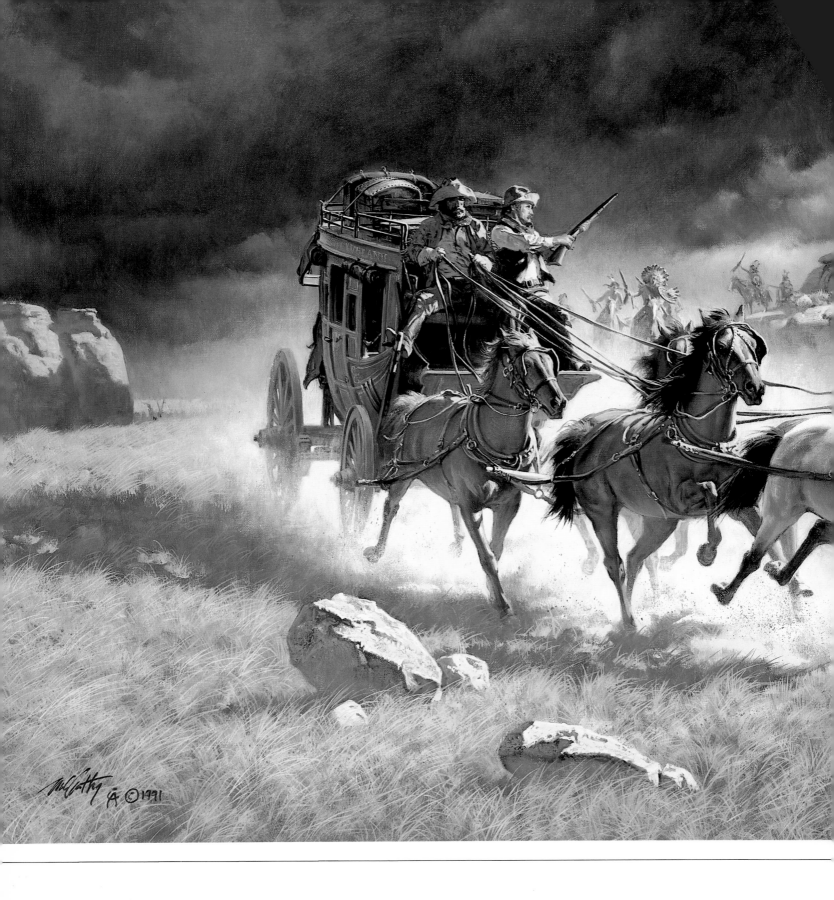

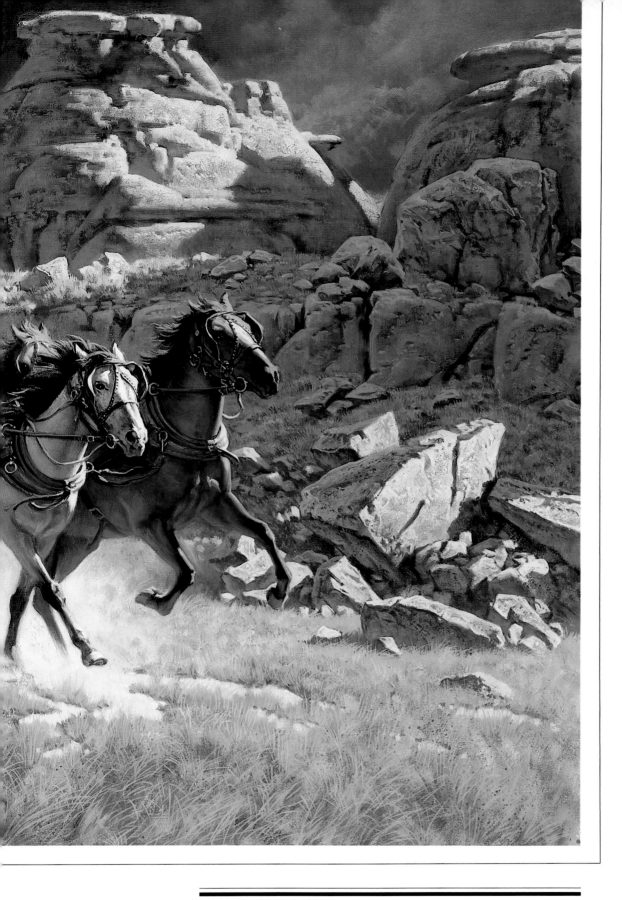

THE CHASE

Stagecoach passengers traveling through disputed lands were sometimes required to carry firearms in the event they ran into a dangerous situation like this. Ben Holladay, owner of the Overland Stage Line, once fought off a running attack from the top of his coach after finding two of his way stations burned.

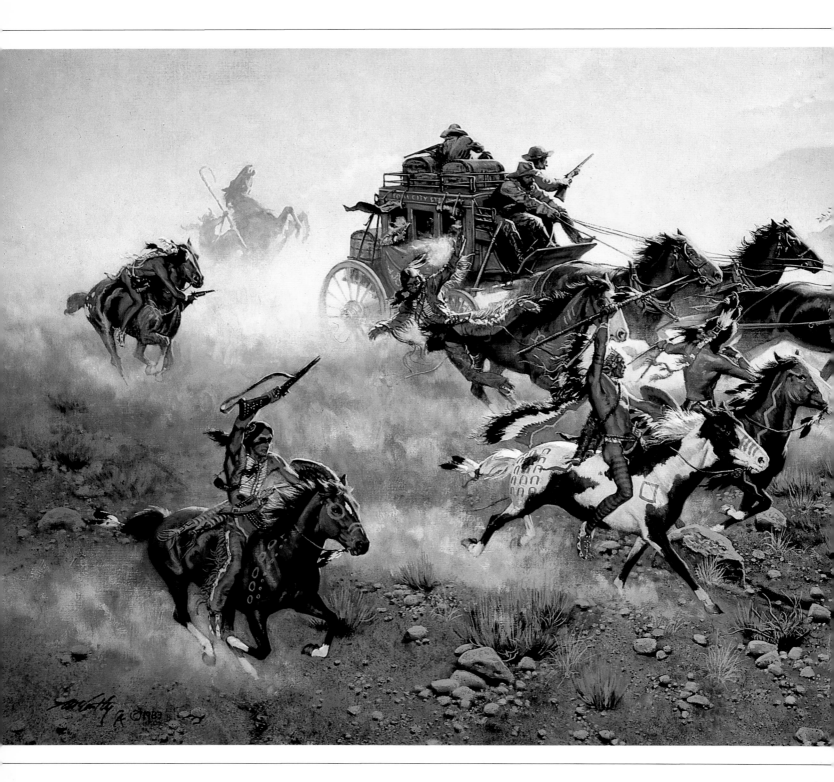

THE RUN TO THE WAY STATION

In a deadly race, a stagecoach's passengers fight for life, hoping to get through to the shelter of the next stage station. There, if they are lucky, a defensive detachment of infantry may be positioned. But the Indians may stop the race beforehand by bringing down a lead horse and piling up the coach.

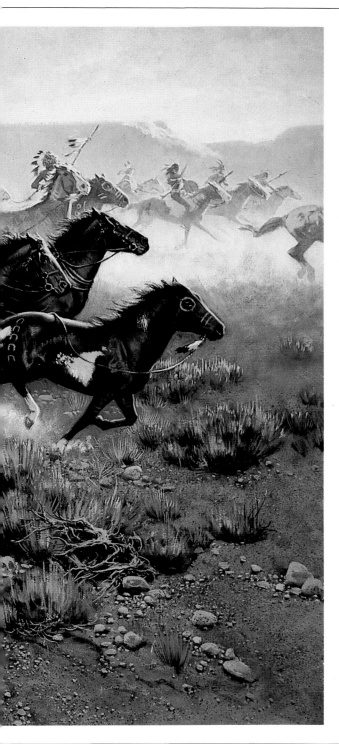

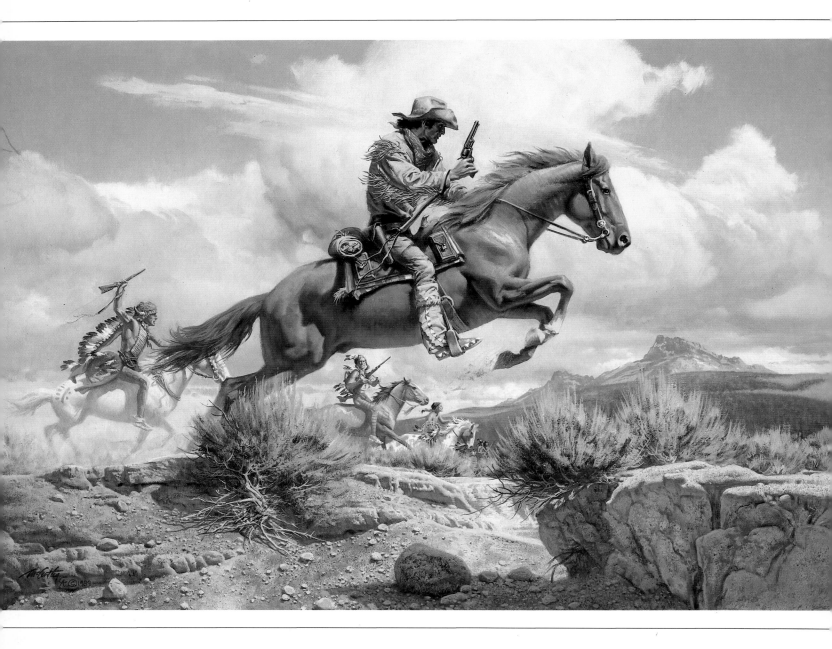

PONY EXPRESS

A lean pony express rider leaps his horse over a shallow arroyo in a race with challenging Indian warriors. By all odds his well-bred, grain-fed horse should outstrip the grass ponies. The pony express began in 1860 and lasted just nineteen months, but its legend is a rich part of the Western heritage.

COMING OF THE IRON HORSE

Huge migrating herds of buffalo could stall a train for hours. For sport, travelers sometimes took potshots at them from the cars while they waited for the procession to pass. Professional hide hunters in barely more than a decade reduced the buffalo from their uncounted millions to a few thousand scattered remnants.

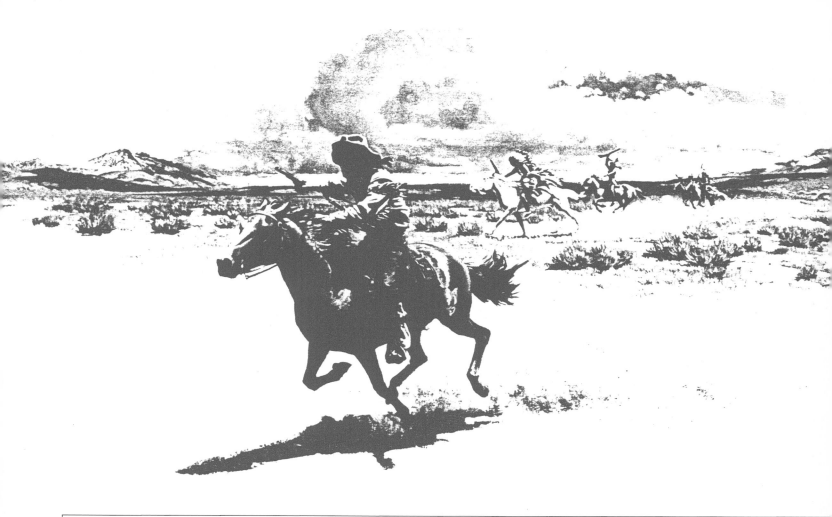

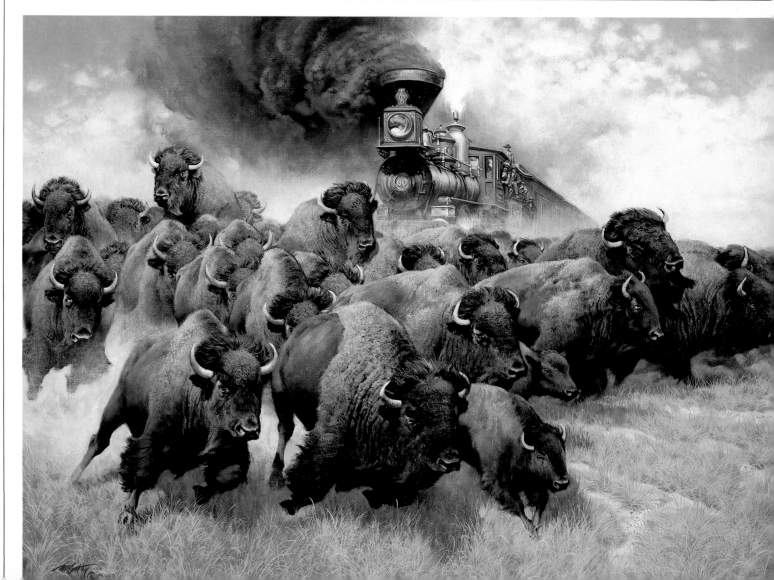

IN THE PASS

Guided by a buckskin man who probably learned these mountains during his days as a beaver trapper, canvas-covered immigrant wagons labor their steep way up through a high pass. Oxen were usually favored over mules for this type of travel. Though slower, they could maintain their strength subsisting on grass.

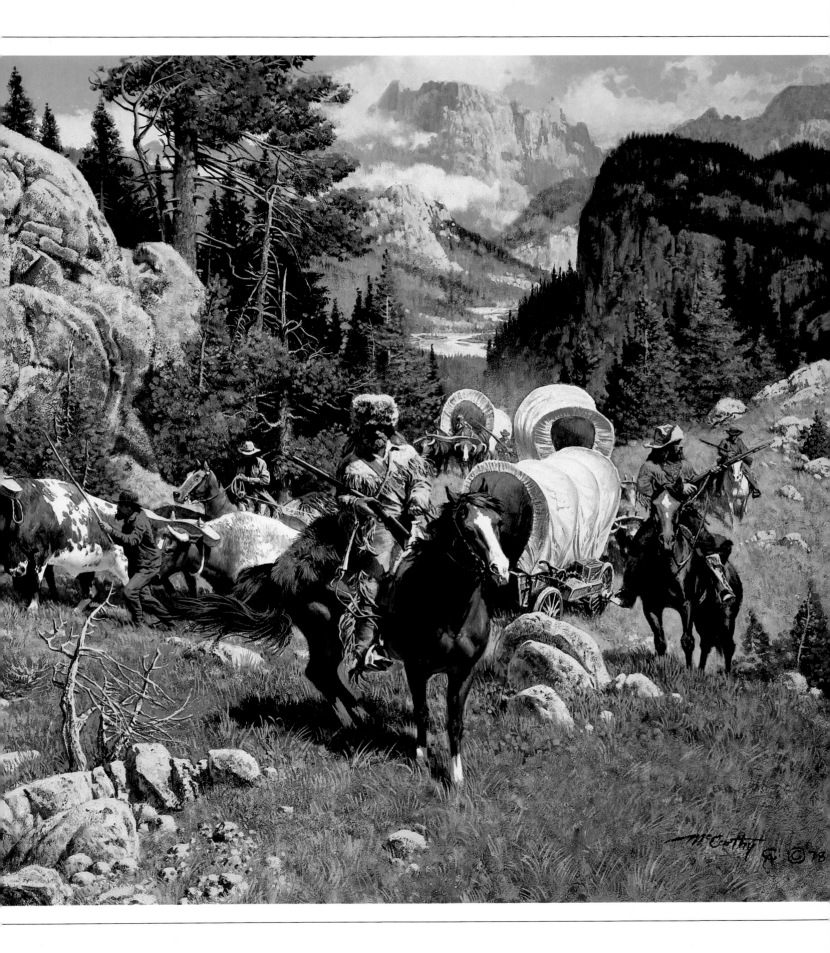

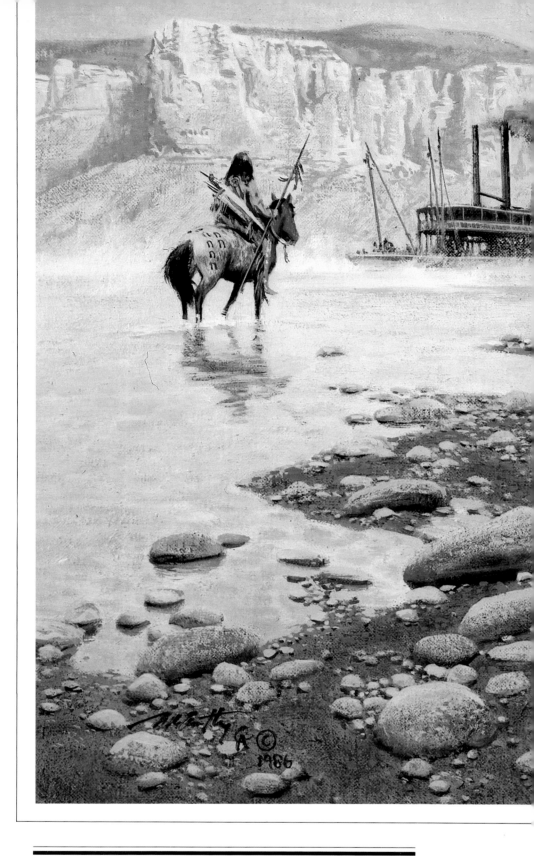

UP THE MISSOURI

Shallow-draft steamboats plied the Missouri River as early as 1819, in the wake of dugout canoes and fur traders' keelboats. Snags in the changing river and muddy water clogging the boilers were a greater hazard than Indians. The steamboat *Far West* carried the first news of Custer's defeat to the outside world.

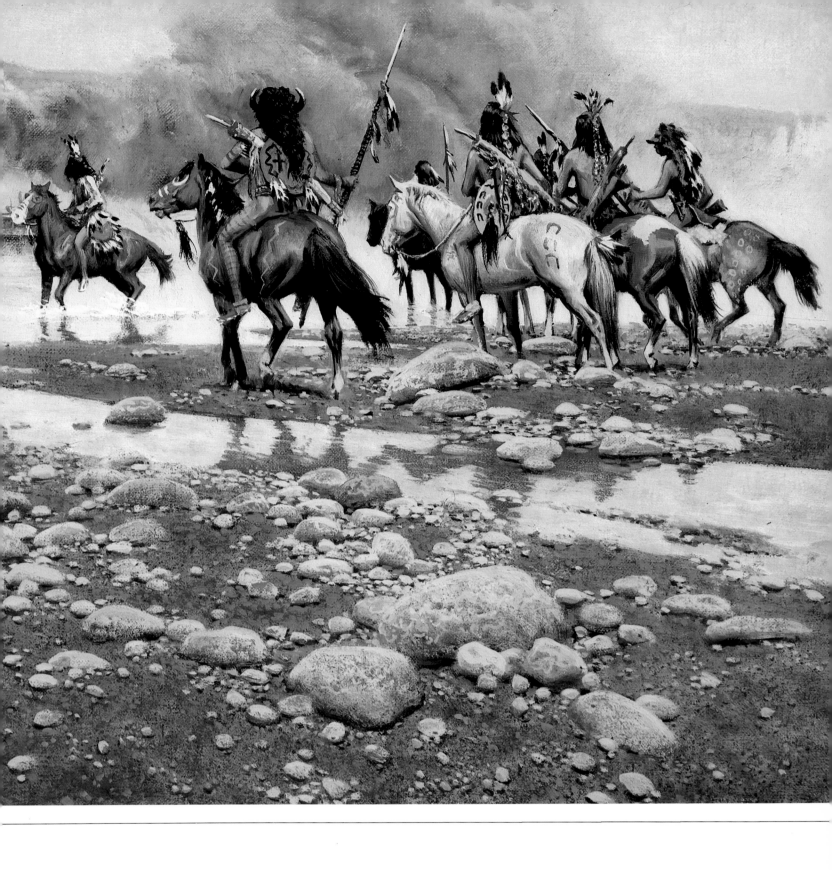

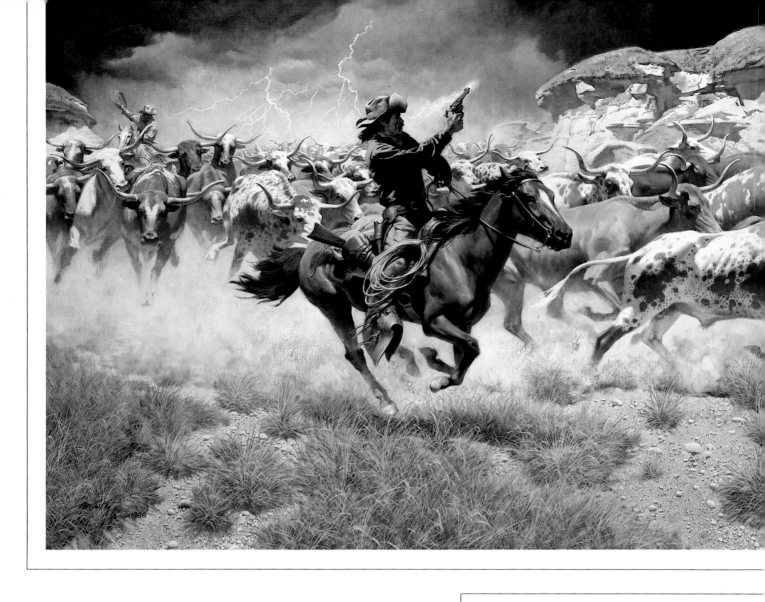

THE DRIVE

Guided by the swing men, a herd of Texas longhorns plods north toward the railroad at Abilene, Ellsworth, Wichita, or Dodge City. As soon as hide hunters decimated the buffalo herds and freed the grass on the Great Plains, cattlemen established open-range ranches from the Texas Panhandle to Montana.

TURNING THE LEADERS

Stampeded by thunder and lightning, fractious longhorn steers resist the efforts of cowboys to turn the leaders and begin circling the herd back upon itself. If unable to make them mill, the riders will try to see that they run in the general direction they have been traveling so the miles they cover are not lost.

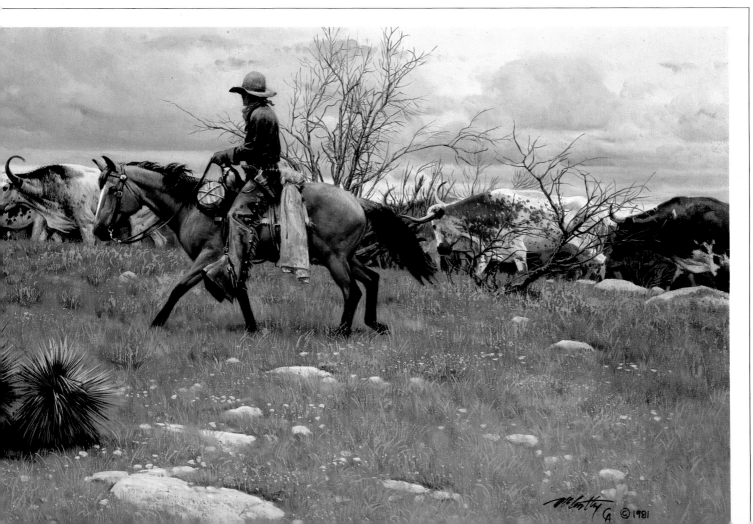

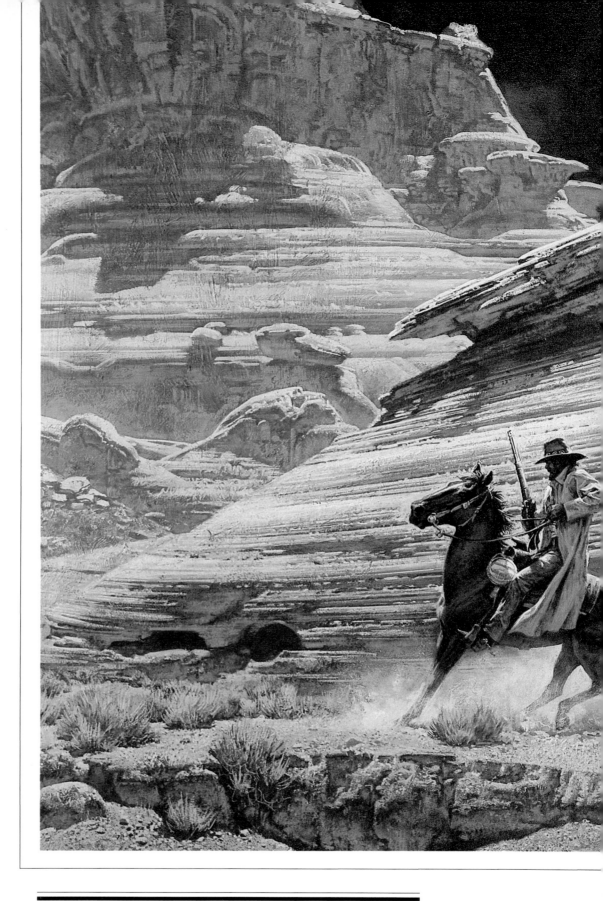

THE DUST-STAINED POSSE

The defeat of the Indians did not bring peace to the West. There remained a tough breed of white outlaws to be challenged by an equally tough breed of lawmen. Here a posse, some of its members wearing dusters, reins up for a wary study of the strange terrain ahead. It appears a likely place for a canyon ambush.

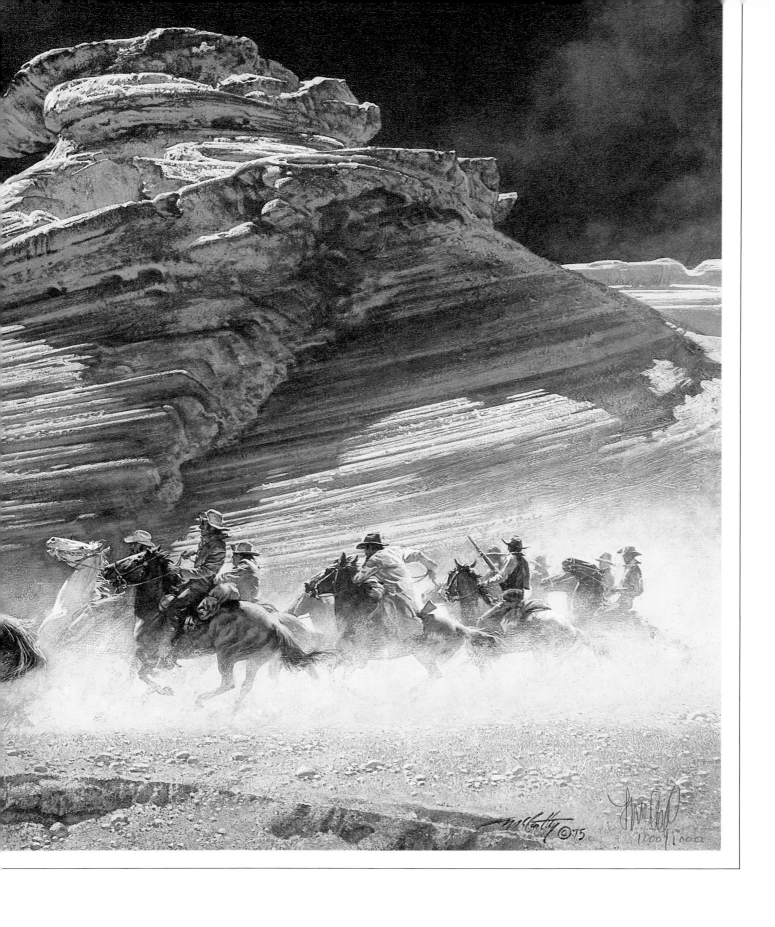

FRANK C. McCARTHY: MASTER OF WESTERN ACTION

Seeing a Wild West show when he was a small boy was an early contributing factor toward Frank McCarthy's becoming a highly regarded painter of Western historical subjects. The drama and emotion he experienced that day remained with him and are reborn in the vivid action, color, and splendor that burst from his canvases.

He was born in New York March 30, 1924. During his first four years of life, in Mount Vernon, New York, he learned to ice skate and swim, to make lead soldiers and paint them. A Wild West show excited him with its real Indians, cowboys, and stagecoaches. In 1929 his family moved to Scarsdale, New York, at that time still a small town.

Though times were hard and business bad, enough construction was being done that he and his friends were able to find scrap lumber to build tree houses. These went up and came down with some regularity as they were discovered by owners of the property. The walls were papered with drawings McCarthy copied from favorite comic strips, such as, Flash Gordon and Buck Rogers.

A progressive grammar school gave him time to draw and paint at an early age. His dinosaur drawings in the third grade became so large and numerous that they crowded teacher and fellow students toward a corner of the room. Scribner Classics illustrations by such artists as N. C. Wyeth and Will James stimulated his imagination and his desire to become a professional artist.

Because the family lived near a polo club, he became interested in horses. He photographed them from all angles and began to build the concept of horses in action that is so striking in his work.

Encouraged by his parents and art teachers, he enrolled at fourteen in New York's Art Students League for summer classes. His first summer he studied under dynamic George Bridgeman, a renowned anatomy teacher and author whose influence is still reflected in the strong muscular structure McCarthy gives to his subjects, human and animal. His second summer he studied under Reginald Marsh, well-known Depression-era painter, while taking care of a sailboat in New Rochelle Harbor and crewing on weekends.

After high school graduation he studied three years in Brooklyn's Pratt Institute with a major in illustration. He began an apprenticeship in a large New York City studio, doing such odd jobs as wrapping and delivering photos, paintings, and layouts. After a time he was elevated to mechanicals: laying out type and photos, pasting them down on the pages

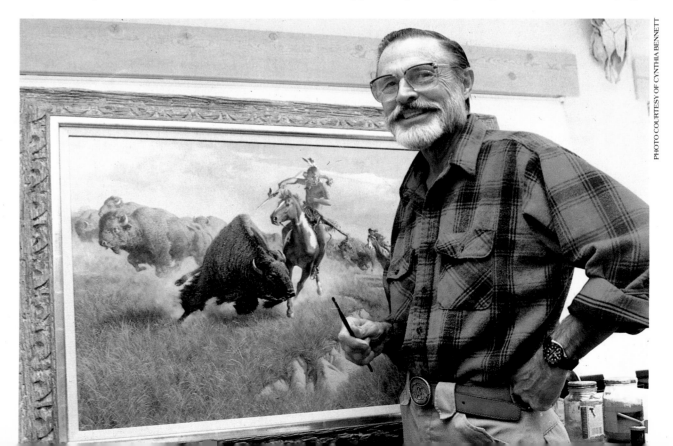

PHOTO COURTESY OF CYNTHIA BENNETT

for reproduction. His interest lagged, however, for this work did not yield the satisfaction his artistic nature demanded. When the staff artist left, McCarthy was promoted to that position.

He developed a lasting friendship with a fellow artist, retoucher Charlie Dorsa, who years later would become a catalyst in moving him away from commercial illustrations and into gallery painting.

After a couple of years on salary, he went freelance, working on movie posters and many small drawings and paintings. Then he and a friend made an extended trip, traveling more than fourteen thousand miles over many Western states and Canada. He took photos and sketched scenery he found overwhelming. That trip added fuel to his interest in the West.

Not long afterward he married Mary Fahrendorf, whom he had known in school and had dated off and on since he was fourteen. They later had three children: Jean, Karen, and Kevin.

Family responsibilities called upon him to work furiously and to seek out new opportunities for commercial illustrations. Painting covers for paperback books led him to illustrations for most of the period's national magazines. This in turn led to major works for movie studios. Advertising paintings done for large corporations gained him awards in twenty-four-sheet poster competitions and from New York City's Illustrators Club for paperback book covers.

His ambition for years had been to paint for galleries. A longtime artist friend opened that door for him. McCarthy says his career in Western art was shaped by two questions asked of him at propitious times.

"The first was from an art director of a publishing company, who asked me forty some-odd years ago if I would like to do a Western cover for his publication. From then on a good portion of my paintings were Western in nature.

"The second question brought me around to doing historical Western paintings to satisfy myself. It was asked in 1968: 'Can you do this kind of painting for me?' My close friend Charlie Dorsa took me to one of the most prestigious galleries in New York City and introduced me. Within months I was represented by that gallery, and ideas that were never brought to fruition in the commercial business were let loose."

As his interest in Western subjects grew, his research expanded and his collection of reference books increased.

After painting for galleries for a couple of years, he was able to make a transition from commercial work to fulltime easel work. He makes no apologies for his long years as an illustrator, however.

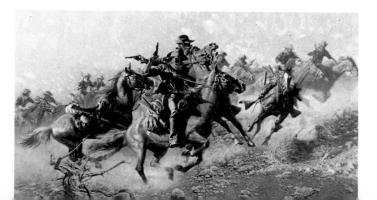

"An illustrator is a fine artist who has to design paintings of a given subject matter around the typesetting of a page or double page, cover, or ad layout for a publication," he points out. "Most painters from

A series of five photographs illustrates the progression of Frank McCarthy's *Under Hostile Fire* from the initial abstract sketch, which sets up a generalized pattern, through the several stages that lead to the finished painting.

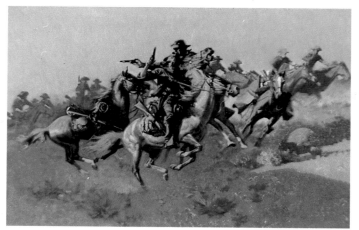

time immemorial have made their livings doing commissions of given subject matter. Portraits are a prime example. In the realm of American Western art, Frederic Remington, Charles M. Russell, Frank Tenney Johnson, Thomas Moran, and Albert Bierstadt, to name a few, did illustrations and commissioned works."

From 1969 to 1974 he spent many weeks traveling over the West, visiting museums and photographing scenery. One such trip carried him down Oak Creek Canyon into Sedona, Arizona. He and Mrs. McCarthy liked the place so well that they bought property there, hoping someday they could return to stay.

Ballantine Books in 1974 published a softcover collection of paintings he had done between 1968 and 1973. That same year the McCarthys moved to Sedona, into a hillside home that contains his studio. In 1975 he was invited to join the Cowboy Artists of America. In 1977 he had two retrospective shows, one at the Museum of the Southwest in Midland, Texas, the other at the R. W. Norton Art Gallery in Shreveport, Louisiana. One of his Western paintings was exhibited at L'Amerique Aux Independants show at the Grand Palais in France in 1980. In 1984 he had a retrospective show of forty paintings at the Gilcrease Museum in Tulsa, Oklahoma. In 1992 he had another retrospective at the Cowboy Artists of America Museum in Kerrville, Texas.

A second book of his paintings, *Frank C. McCarthy: The Old West,* was published in 1981 by The Greenwich Workshop, publisher of his hightly sought-after limited-edition prints. This large linen-boxed leather-bound book, containing seventy-six color plates, was limited to fifteen hundred copies.

He is often asked why an Easterner would do Western paintings. He believes seeing the Wild West show as a small boy, and feeling the visual and verbal impact of Will James's illustrated horse-and-cowboy books, along with Western movies he watched from childhood, were potent factors in arousing his interest. He also has a little Indian blood.

(Right) French resistance forces versus Nazi troops in a poster for the 1965 United Artists film, *The Train.* *(Below)* An underwater battle centers around James Bond in a poster for the 1965 United Artists film, *Thunderball.*

"My approach to painting is not to do a historical document," McCarthy says. "It is more a portrayal of an event or scene that has happened many times in many places in the West. I give the scene the most possible visual impact. The detail is as accurate as I can make it."

His backgrounds are the West's beautiful mountains, streams, lakes, deserts, and most of all its rocks. Into this setting he places the characters who roamed it: the Indians, the mountain men and free traders, the cavalry, the cowboys, and the vehicles that crossed it: immigrant and freight wagons, stagecoaches, trains.

His works are based on truth and have their set-

tings in reality, but the events are not specific. He prefers to leave the story to the beholder and never to end a situation in a painting. He likes to leave another hill to climb, another stream to cross.

"I've spent much time documenting as many artifacts as I can that are available in museums across this country and in Canada. I make the story expand from an idea, most of the time going directly to the canvas without sketches, other times from tiny *scribbles*, as my children used to call them. These are mostly abstract patterns, darn near indecipherable.

"I start a painting with paper towel wadded and loaded with burnt umber paint and turpentine. Laying in my abstract pattern, if I don't like what I see I wash it out. After reaching a desired effect, I use a large-bristle brush to rough in the action of horses, riders, and an idea of the background, making changes as I go.

"I never draw anything except with a brush. I break up the larger patterns and add detail. Sound simple? It's not! It's change and change again from beginning to end. Sometimes it takes several years to make a painting work.

"I use the words *abstract* and *pattern* often after many years of working paintings around type in

illustrating a story. The layout and the abstract pattern are the same. I feel it helps a great deal in making a painting exciting and dramatic."

The fundamental knowledge acquired over years of application became so ingrained that he uses it unconsciously in the course of his work. The story often grows and changes as it comes to life on the canvas. Characters and scenic objects are moved, added, or deleted until the picture seems right to him.

His paintings are realistic down to the finest particulars. He finds beauty in many things: the eroded, sometimes jagged, coarse rock, gnarled, bleached-out logs and stumps, the dirt and the sage, the play of light on muscles levering a carbine or wielding a war club or a horse galloping full tilt...all this, and the many variations of light, shade, and color.

The artist considers it important to get the right lighting into a painting. He photographs locations he might someday want to use in a painting. The light and the shadows change so rapidly that it would be difficult to sketch them in color before they are gone. He often returns to the scene before sunup, photographing it from many angles as the sun rises, return-

ing several times during the day and into early evening to photograph it in changing light, changing moods.

During his early career as an illustrator he used Whatman illustration board with Winsor & Newton designer colors. Later he turned to casein colors, a paint employed in a different manner by such old masters as Leonardo da Vinci. They are manufactured by souring skim milk, separating the curd from the whey, then washing and drying it and mixing it with pigments. The manufacturer Shiva added a sweet odor to the paint to offset the sour smell. When McCarthy used to ride a crowded train to the city to deliver his completed paintings to clients, he often noticed other riders turning their heads, trying to determine where the odor came from.

He always liked casein, using it for most of his illustration work and later during his early years of painting for galleries. He liked the surface of illustration board coated with gesso, so when he began gallery paintings he used masonite washed with weak ammonia water to take out any oil, then painted with several coats of gesso.

Since the mid 1970s he has used oil paints exclusively. Their slow drying allows him to change and move his compositions around as he works. When he began using oils, he eliminated preliminary sketches done in pencil and then in color. Going directly to canvas has allowed him a more spontaneous approach to painting.

He usually has several paintings in progress at one time, working on one a while, then another. As he returns to a painting after being away from it for a time, he can see it with a fresh and objective eye.

He declares: "After so many years of painting the West, I've never tired of painting it and the people who lived here in the 1800s. I have been a man of two careers, one profession."

In all, a dedicated artist.

LIST OF PAINTINGS